Celtic Art

Celtic Art

*Edited by Barry Raftery with the collaboration of
Paul-Marie Duval, Otto-Herman Frey, Gilbert Kaenel,
Venceslas Kruta, Michael Ryan, Andrew Sherratt, and
Miklós Szabó*

*Unesco Collection of Representative Works:
Art Album Series*

Unesco
Flammarion

ISBN 2-08-013509-0

Design by Thomas Gravemaker
Composed by Coupé S.A., Sautron
Map by Carto-plan, Paris
Printed by Imprimerie Clerc, Saint-Amand Montrond
Bound by Reliure Brun, Malesherbes

Contents

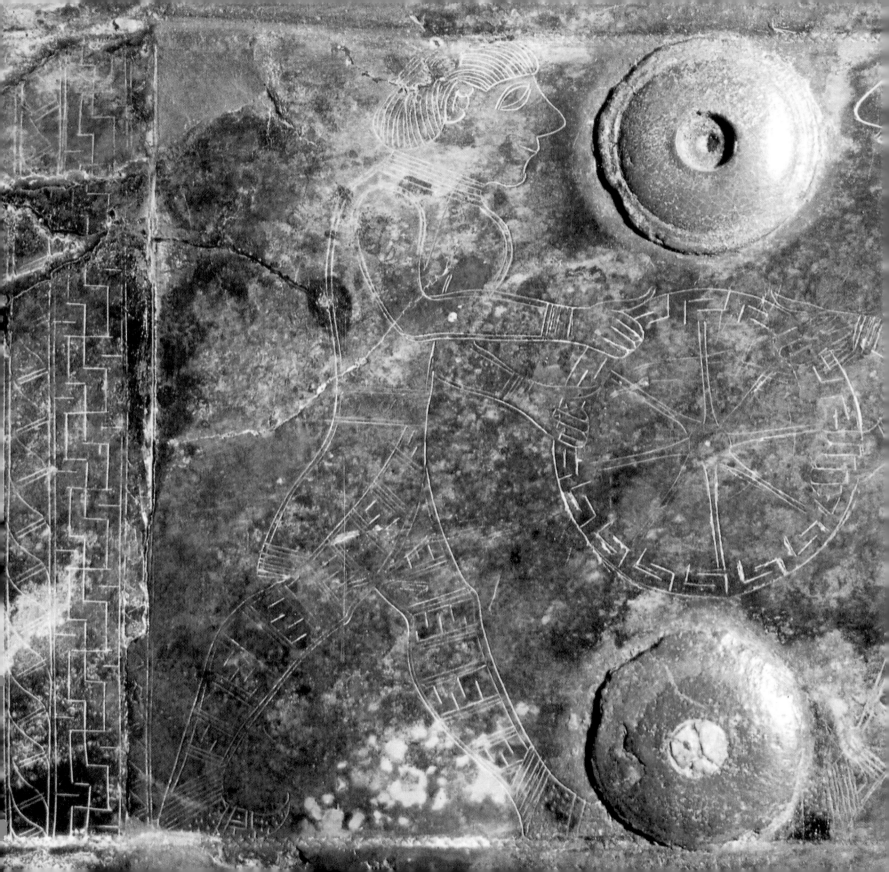

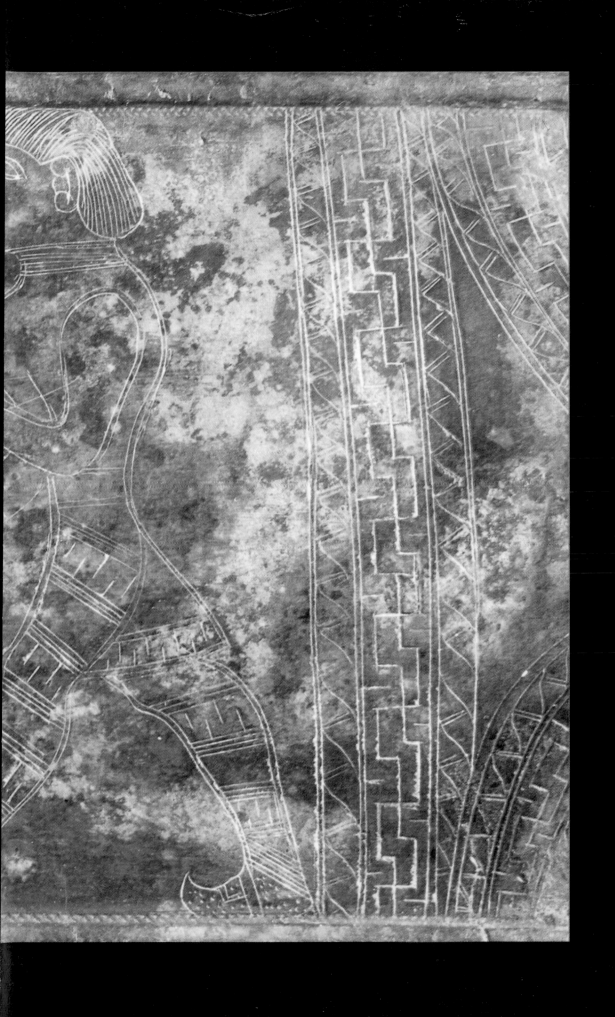

**Bronze scabbard decorated
with engravings** (detail)
Hallstatt, Austria
5th century BC
Vienna, Naturhistorisches
Museum

Introduction

An investigation of European population groups of direct Celtic ancestry reveals that they survive only in the western regions, namely in Ireland, Scotland, Wales, Cornwall and Brittany. The latter, however, have Celtic roots which do not predate the fifth century AD for it was at this time that their ancestors arrived as fugitives from Britain after that country was overwhelmed by invading groups of Germanic Angles and Saxons following the collapse of the Roman Empire.

It is only in parts of these regions that living Celtic languages survive and today there are no more than 1.5 million Celtic-speaking people. With such limited numbers not only is it difficult now to envisage the original extent of the area occupied by the Celts but also to comprehend their significance in the development of later European culture and tradition.

The earliest references to the Celts by Greek and Roman authors date back only as far as the sixth and fifth centuries BC. From these it is clear that the Celts occupied major areas of Central and Western Europe. The Greek Herodotus, for example, reports in the fifth century BC that the Celts inhabited the extreme west of Europe and that the source of the Danube lay in their territory. In fact, the early Antique writers knew of only two great population groups in the northern areas of Europe: the Scythians in the steppes of the east and the Celts in the west, while the existence of other peoples, such as the Germans, was recognized only later.

The Celtic peoples, from widely scattered areas of north Alpine Europe, in time advanced towards the Mediterranean, and also entered the Iberian Peninsula. There they soon mixed with indigenous Iberian groups but the early historical sources are silent about this. Also obscure are reports concerning the earliest incursions into north Italy and it is only with the Celtic occupation of large areas of northern Italy and central Italy east of the Apennines in about 400 BC that more detailed information becomes available. Contemporaneously, Greek historians refer to the intruders as Celts, while the Romans describe them as Gauls. The first securely dated event involving the Celts occurred in 387 BC, when they resolutely defeated a Roman army at the battle of Allia, near Rome.

The city of Rome was occupied for seven months by the barbarians and only the heavily-defended Capitol succeeded in withstanding enemy attack. The developing Roman state regarded this event as such a catastrophe that when Roman power was re-established by M. Furius Camillus after the withdrawal of the Celts, he was honoured as the second founder of Rome.

In the following years numerous military incursions by the Celts into Central and Southern Italy are reported and it was not until the early third century BC that the Romans succeeded in decisively defeating the Senones, a Celtic tribe who occupied the Adriatic coast. Later, in 225 BC, other tribes, the Boii and the Insubres from the Po Valley, along with their kinsmen from north of the Alps, were beaten at Telamon. After this, it was the Romans who pushed into north Italy and established colonies there, and despite a final upsurge of Celtic resistance during and after the second Punic War, the whole of Italy as far as the Alps was firmly under Roman control by the beginning of the second century BC.

Celtic warrior bands not only migrated southwards across the Alps around 400 BC but also spread to eastern and south-eastern Europe. Alexander the Great received a Celtic delegation in the Balkans in 335 BC before departing on a campaign against the Persians, while in 279 BC the Macedonian king, Ptolemaios Keraunos, was killed during a battle against a large Celtic army and in the same year the Greek sanctuary at Delphi was plundered by Celts. Shortly afterwards, three Celtic groups moved to Asia Minor and terrorized the local Hellenistic kingdoms there for the next century. Finally, they were overcome by the rulers of Pergamon who erected the famous carvings of the Dying Gauls as victory monuments. The decoration of the altar frieze associated with this monument compared the struggle against the Celts with the mythical victory of the Gods over the Giants.

Ultimately, the Celts failed to establish permanent kingdoms both in Asia Minor and on the Balkans. For example, the kingdom of Tylis, in what is today Bulgaria, had already collapsed by the end of the third century BC, while the great Scordisci, with their centre in Singidunum (modern Belgrade), increasingly came under Roman power in the last century BC. Even Gaul, one of the Celtic heartlands, flanked by

the Rhine and the Alps in the east and the Atlantic in the west, succumbed to Roman military might in the second and first centuries BC and between 125 BC and 118 BC the establishment of a Roman province and the Roman colony of Narbo (modern Narbonne) succeeded in isolating the area bordering the Mediterranean, where Celts, Iberians and Ligurians had intermingled. Following the famous campaigns of Julius Caesar in the middle of the last century BC the whole of Gaul finally was brought under Roman rule.

At about the same time in the east, the power of the Celts was being resisted by the emerging kingdom of the Dacians, and Caesar's *Commentaries* on the Gaulish campaign make it clear that Germans had come from the north to occupy several areas formerly under Celtic control. Finally, in 15 BC, the Alps and their northern foothills were incorporated into the Roman Empire by Drusus and Tiberius, the sons of Caesar Augustus, and in the eastern Alps the Norici, despite long and intimate contacts with Rome, nonetheless were engulfed by advancing Roman forces. Thus, by the birth of Christ, virtually all the original areas of Celtic occupation on the Continent were under foreign, mainly Roman, domination; circa AD 40, the conquest of Britain began under the Emperor Claudius and continued sporadically to the end of that century.

This brief outline of the early history of the Celts shows how for centuries these people, by means of their military conquests, were capable of shaking the very foundations of Mediterranean civilization. Their warlike character and their physical courage were constantly referred to by their commentators as was their willingness to fight even as mercenaries under foreign masters. However, their many military campaigns generally were undertaken on an individual, tribal basis without coordination or overall planning, and power depended upon personal allegiances. An organized state, encompassing not merely ruling nobles but also the broad mass of the population, did not exist, nor did permanent kingdoms.

This partly explains why the Celts in those areas conquered by Rome quickly abandoned important elements of their traditions. The Celtic religion, in which human sacrifice played a part, often was suppressed by the Romans, so that today we have little information about it. It is probable that local cults continued but in a romanized form, and gradually the Celtic languages were replaced by Latin. The speed with which the romanization of Gaul proceeded and the speed with which especially the Celtic nobles felt able to identify completely with the new state, is well illustrated by the fact that, having been granted Roman citizenship during the reign of Claudius, they then pressed for entry to Roman State office.

In contrast to the situation on the Continent, the romanization of Britain was far more superficial and beneath the surface the old traditions survived to a greater extent. Celtic culture continued to develop in those areas outside the Roman Empire but it is clear that gradually Roman influence and later the Christian religion came to such regions, Ireland for

example, from adjacent Roman provinces. Certainly, such influence brought about major changes, which did not indicate a cultural break but in fact heralded a fruitful new development. Subsequently, during the course of the Irish missionary activity, elements of Celtic thought and tradition were reintroduced into Continental Europe and the most important component of this is the large corpus of Celtic sagas, which enriched the European cultural heritage, and which was handed down throughout the Middle Ages and beyond.

Celtic art comprises predominantly objects of craftsmanship such as tools, weapons and ornaments which fulfilled a specific function both in religious and profane contexts. Large monumental sculpture is largely absent and instead we are concerned in general with small objects.

Valuable objects accompanying the dead in their graves constitute the principal finds dating to the period before the Roman conquest. Precious metals and bronze are the commonest materials, and although iron is, in general, poorly preserved, items made of glass, coral, amber, jet and the like are found in good condition. Pottery vessels, too, are frequently encountered in the burials while objects formed of wood, textile or leather rarely survive.

If the graves contain valuable objects which were meant to serve the deceased in the after life, only debris regarded as worthless by the occupants has been encountered in the surviving settlements. This consists mainly of broken potsherds or small metal objects which were lost and trampled into the ground. Architecture in stone did not develop among the Celts on the Continent and their houses, temples and even significant sections of their defences were constructed of wood.

Other finds, often of exceptional value, have been located in waters, marshes or in other special places and they probably were intended as offerings to supernatural powers. The few stone sculptures and the wooden carvings preserved in water can also be regarded as containing religious significance. In contrast to such clearly votive objects, items which were accidentally lost in rivers or hidden in the face of enemy advance, are very rare.

In Britain and Ireland the period of great artistic wealth occurred in the early Middle Ages. Stored in the monasteries were Gospel books and other valuables which reflect the refinement of Celtic art at its apogee. Besides these finely worked objects, stone churches and richly decorated stone crosses survive from this period, while grave treasures are entirely absent.

Where can we place the beginnings of Celtic art? Does it extend back to the period before the first Classical references to the Celts? The pre-Roman Iron Age in central Europe is divided into two principal phases, the so-called Hallstatt period, which lasted from about the end of the eighth century

BC to the early fifth century BC, and the La Tène period from the fifth century BC to the birth of Christ. The first period takes its name from a rich find-spot located in the Austrian *Salz-kammergut,* the second after a major discovery in Lake Neuchâtel in Switzerland. Although the Celts continued to occupy the west of central Europe from one period to the other, it is only with the beginning of the La Tène period that an unmistakably new artistic style appears, one which developed continuously in Ireland and Britain until the Middle Ages.

What historical reasons underlie the appearance of Celtic art in the fifth century BC? Undoubtedly, contacts with the more developed civilizations of the Mediterranean played a particularly important role in this regard. As early as 600 BC the Greek colony of Massilia (modern Marseilles) was established in France not far from the mouth of the Rhone and, contemporaneously, luxury goods which probably were traded northwards through this town appear in the Hallstatt graves of central Europe. The links between northern Italy and central Europe were possibly of even greater importance and in the late sixth century BC Etruscans from central Italy colonized extensive areas of the Po valley. But urban civilization also arrived in north Italy with the Greeks who settled the mouth of the Po river from across the Adriatic Sea. Thus large numbers of objects, showing the influence of these classical centres of northern Italy, are found in rich graves of the Early La Tène period.

Other neighbours of the Celts contributed also to the development of their art, and influences of the art of the Veneti from northeast Italy are sometimes detectable in Celtic works. In the sixth century BC Scythian horsemen from the south Russian Steppes appeared in what is today Poland and Hungary and the Celts absorbed decorative ideas from these people which then appear in their artwork. Finally, it is possible that occasional objects of Persian origin reached the Celts either through the intermediary of the Scythians or, perhaps, via the Thracians of the lower Danube, for their territory had formed part of the Persian Empire for a brief period in the late sixth and early fifth centuries BC.

From the late Hallstatt period onwards, the exceptionally rich graves in central Europe clearly attest to the existence of an elite stratum of society capable of acquiring luxury goods from afar. In the fifth century BC, for reasons as yet not fully understood, these Hallstatt graves, and the settlements with which they were associated, disappear. Replacing them at the beginning of the La Tène period in more northerly areas—mainly from the middle Rhine deep into France—are new chieftains' burials which are also rich in grave goods and which again indicate the presence of a Celtic ruling class. In these the deceased is often accompanied by his chariot along with a drinking service which may be of north Italian origin or may be a Celtic copy of an Italian model. These burials also contain ornaments in gold and other exceptional pieces which exemplify all the characteristics of early Celtic art. We can

conclude from such finds that a new division of power had taken place in the central European Celtic world and it is these new political arrangements, along with the altered nature of Mediterranean contacts, which gave rise to the unique, unmistakably Celtic art style.

Although Celtic art appears to have been influenced primarily by contacts with foreign regions, the Celtic migrations, mentioned earlier, and the consequent interaction with the more developed civilizations of the south also provided a wider context within which artistic exchanges could take place. Unfortunately, the full development of La Tène art cannot be followed through an analysis of grave goods, since, after the initial period, rich burials are rare and are geographically confined.

On the other hand, the introduction of settlements, culminating in the so-called oppida, which are directly comparable to towns in the Mediterranean world, points to how deeply the lifestyle of the Celts was altered by outside forces. This development can be followed particularly well in the case of Celtic coinage, where from the beginning the designs are based on Classical forms; slowly this led to a proper monied economy. The way in which the differing prototypes are reflected in the coins attests to the changing nature of the contacts with the southern world.

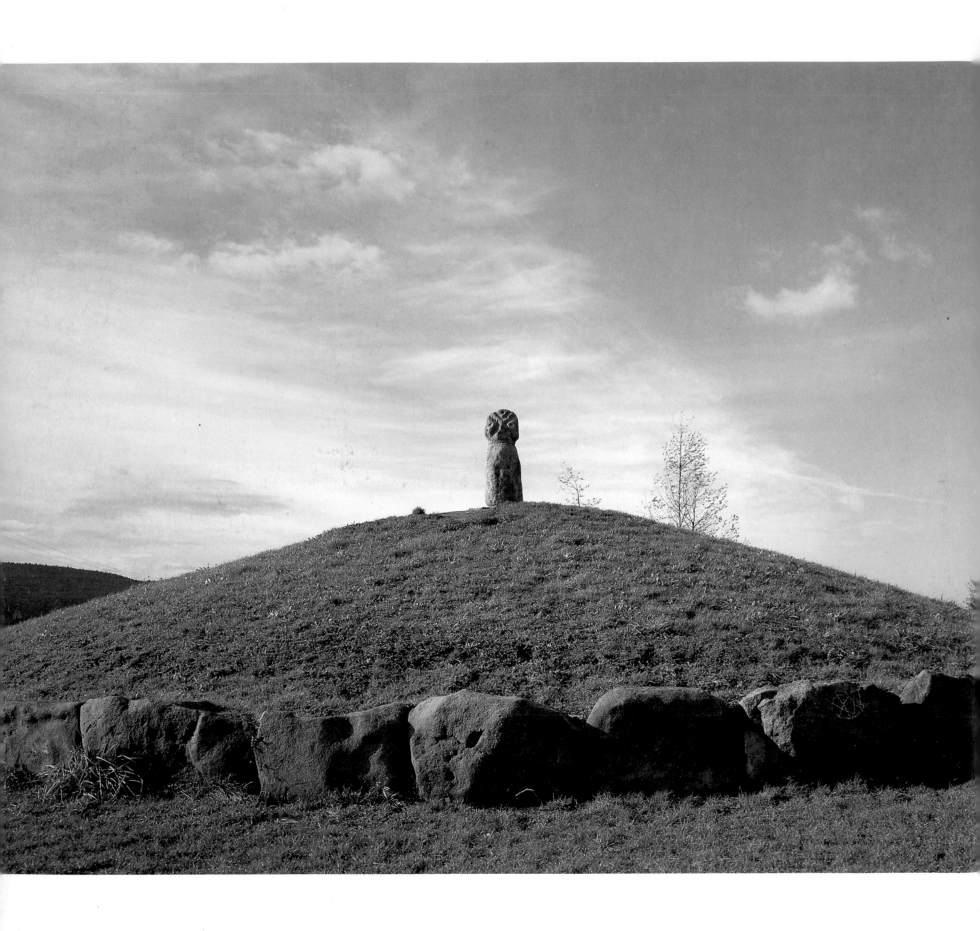

The rise of Celtic art

Funerary mound
Tübingen-Kilchberg
(Baden-Württemberg),
Federal Republic of Germany
This mound is reconstructed as it
would have appeared at the end
of the 6th century BC. Centrally
placed within a circle of large
stones was the burial chamber
which had been shallowly
excavated and then covered with
stones and earth. It contained
what appears to have been the
double burial of a warrior and a
woman. On the summit of the
tumulus stands a bifacial stela.
Monuments of this type were
reserved for persons of high rank.

A feature of the fifth century BC was the proof of contacts between the Mediterranean world, more especially northern Italy, and the Celtic peoples who lived in an area north of the Alps, which stretched from the Atlantic to the western edge of the Carpathian Basin. One of the consequences of these contacts was the emergence of a new form of artistic expression, very different from the geometrical art known until then in these regions and which distinguished itself not only by its repertory of ornamental motifs but also by the development of wholly original formal procedures.

Celtic art in the fifth century BC borrowed a number of elements from the Etruscan repertory—a plant world consisting of palmettes and lotus flowers, peopled by human figures with animal attributes (Silenus masks with pointed ears) and monsters such as griffins, sphinxes and chimeras. Celtic craftsmen plundered Etruscan art for its oriental elements, which in the fifth century BC were confined almost exclusively to a decorative function. Not only did the Celts adopt other motifs, likewise of remote oriental ancestry, from the art of the Italic peoples which was more strongly imbued with this mythological repertory, but also they perhaps borrowed directly from the East itself. For instance, very ancient themes such as the Tree of Life guarded by monsters or birds, or the Lord of the Beasts, appear in the art of the Celts. This imagery, probably appropriated by them because it could be adapted fairly easily to their own religious universe—of which, unfortunately, little is known—was to remain with them, either

15

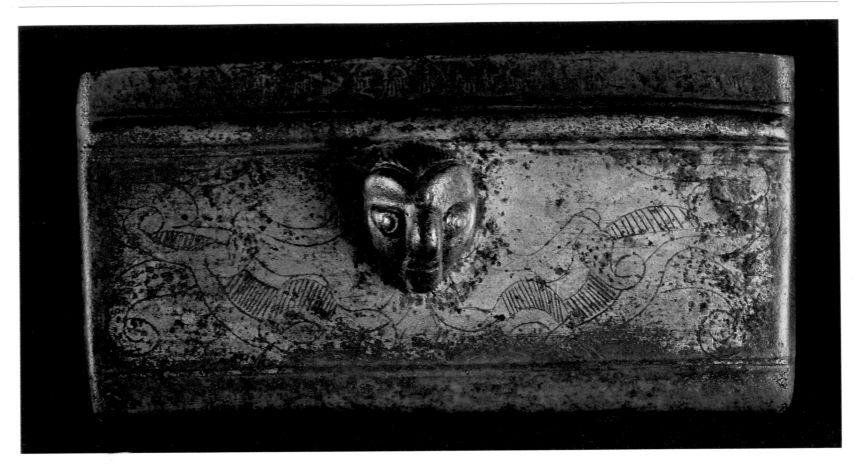

Bronze belt-clasp
Weiskirchen, Saarland
Federal Republic of Germany
5th century BC
This find-spot was located on the
eastern limit of the zone in which
Celtic art emerged. The
composition of the belt-clasp is
similar to that of the Weiskirchen
piece, where a face in the centre is
executed in relief and is flanked by
a pair of griffins engraved on the
plate.
Max. Length: 6.6 cm.
Slovenska Národne Muzeum,
Bratislava.

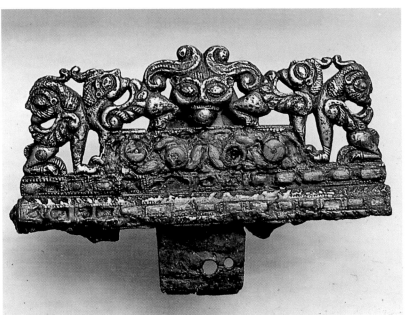

Bronze belt-clasp
Stupava, (Slovakia)
Czechoslovakia
5th century BC
This grave find clearly illustrates the ways in which the Celts transformed themes of remote oriental derivation. The central palmette, symbol of the Tree of Life, is replaced by a human face crowned by a pair of opposed S-motifs, a very frequent attribute enabling the observer to identify the deity. On each side of the central motif is a pair of winged sphinxes. The whole piece is enhanced by inset areas of coral, a substance valued for its magical properties.
Actual width: 6 cm.
Rheinisches Landesmuseum, Trier.

Twisted gold bracelet
Rodenbach, Federal Republic of Germany
Late 5th century BC
Grave find. Here we have another version of the Tree of Life theme: the face at the centre is crowned by what look like berries from the yew-tree, an evergreen with red berries, venerated by the Celts. It is flanked by recumbent ibexes.
Diameter: 6.1 cm.
Historisches Museum der Pfalz, Speyer.

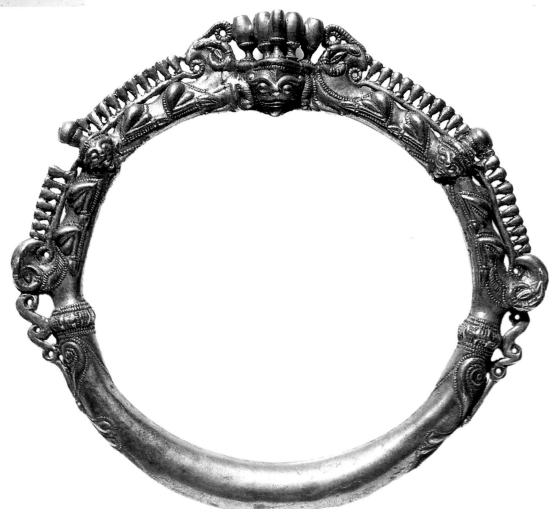

17

transformed beyond recognition or in a form scarcely differing from the models, for almost 500 years on the Continent, and for far longer in the British Isles.

Another novelty of Celtic art in the fifth century BC was the use of the compass, either to engrave a pattern directly or to prepare a working drawing for elaborate and refined compositions. The predilection, engendered by the compass, for the geometrical interplay of curvilinear forms and volumes, remained from then on one of the basic features of Celtic art. The works that have come down to us are chiefly small metal objects, since monumental sculpture was rare and architecture, in wood, is known only through the traces left in the ground. These surviving items consist almost exclusively of objects which accompanied important persons when they were buried, e.g. personal ornaments made of precious metals or bronze, decorated weapons, harness-trappings, metal decorations from chariots used in battle or for ceremonial purposes, and vessels from drinking-services. Among the latter, the richly decorated wine-flagons are particularly interesting as they show clearly the originality of the Celtic products when compared with the Etruscan models from which they derive. Although few in number, the stone sculptures are of great importance for they can only be interpreted as belonging to a religious context. The association of human faces in stone sculpture with similar elements found on metal objects confirms the probability that they were deities, unfortunately unidentified, of the Celtic pantheon.

The objects which mark the beginning of Celtic art appear in the second quarter of the fifth century BC at the earliest, and over a period of fifty years or so the new form of visual expression attained remarkable maturity. By the last quarter of the century some of the processes on which the specific character is based are already discernible in the more original works of Celtic art and it is those processes which enabled it at all times to assimilate its various borrowings and confer on them the stamp of unity.

Among the most significant of these processes is the transformation of natural shapes into abstract elements of definitive character and the juxtaposition—and in some cases the fusion in the same composition—of human, animal, plant and abstract forms. Two other features are remarkable, first the determination to avoid all narrative and dramatic representation, using only indirect and partial allusion and second, the affinity for ambiguity, which led Celtic artists to create works that could be "read" or interpreted in many ways.

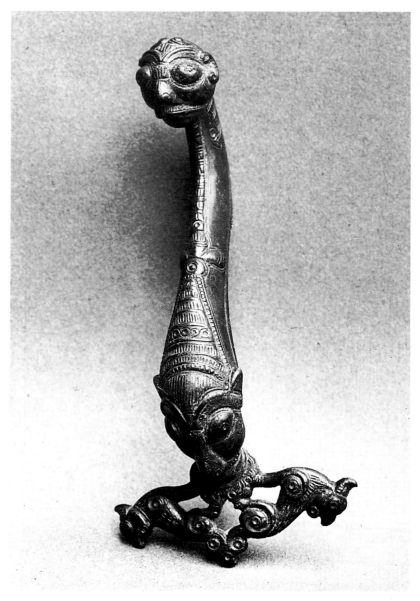

Bronze fibula Parsberg, Federal Republic of Germany 5th century BC
Found in a grave, the object shows how the type of composition illustrated by the preceding item was adapted to a particularly difficult base: a central face, with animal ears and a "tiara" surmounted by a palmette, forms the end of the fibula, the part above the spring is lost. A pair of griffins decorate the openwork plate which concealed the spring.

An expressive head without noticeable animal features constitutes the other end of the fibula.
This object illustrates remarkably well the tendency of Celtic artists to reduce natural forms into well-defined geometrical shapes, almost always with curvilinear contours.
Length: 9 cm.
Germanisches Nationalmuseum, Nürnberg.

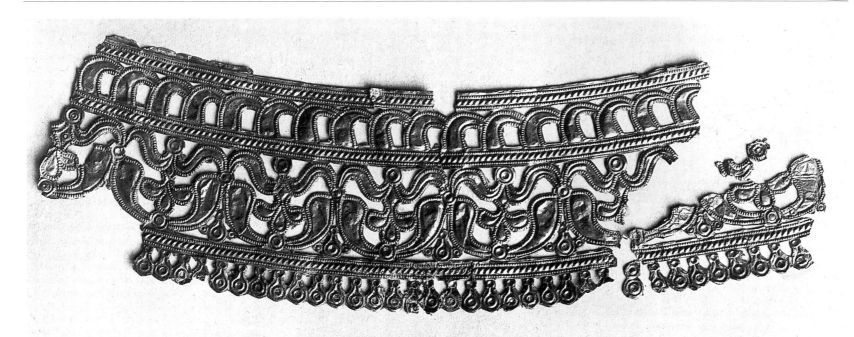

Gold mount

Eigenbilzen, Belgium
5th/4th century BC
Grave find. The object is in
embossed, openwork form and
probably was used for decorating
a drinking horn from the wine
service deposited in the burial.
The Mediterranean origin of the
motif on the central strip—a row
of palmettes alternating with lotus
flowers—is easily recognized.
However, the parts are arranged
in such a manner that the lotus
flowers may be interpreted in two
ways—either as such, or as pairs
of leaves framing the trifoliate
palmette.
Preserved Length: 22 cm.
Musées Royaux d'Art et
d'Histoire, Brussels.

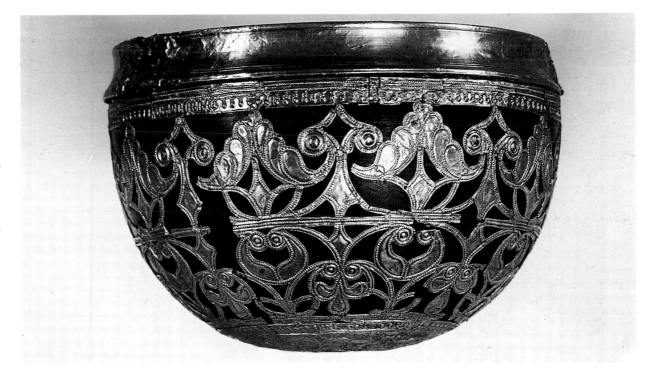

Openwork sheet-gold mounting

Schwarzenbach, Rheinpfalz,
Federal Republic of Germany
5th century BC
Found in a grave, this mount
probably decorated a wooden
bowl. More elaborate than the
combination of lotus flowers and
palmettes encountered in the
previous item, here the artist has
recomposed the motifs, making
as much use of the field as of the
pattern. In the lower part of the
principal strip, full trifoliate
palmettes alternate with
openwork lotus flowers. The
motif has been divided up and
transformed in such a way as to
reduce it to a limited number of
elements, the main one being a
kind of dissymmetrical leaf (or in
some cases a half-palmette)
terminating in a spiral scroll.
Diameter: 12.6 cm.
Antikenabteilung, Stiftung
Preussischer Kulturbesitz,
Staatliches Museum, Berlin.

19

Openwork bronze disc
Somme-Bionne, Marne, France
5th century BC
Found in a chariot burial, the
object, a *phalera,* was probably
a harness decoration. One of the
innovations of Celtic art in the fifth
century BC was the use of the
compass, often very skilfully
employed, and this bronze disc is
one of the finest specimens of
compass work in Celtic art of the
period. The patterns are based on
a working drawing prepared with
a compass. The result is not,
however, an abstract construction
of curves and counter-curves, for
the compass is used in such a
way as to bring out specific
forms—in this case, the lotus
flowers—to which symbolic value
was attached.
Diameter: 7 cm.
British Museum, London.

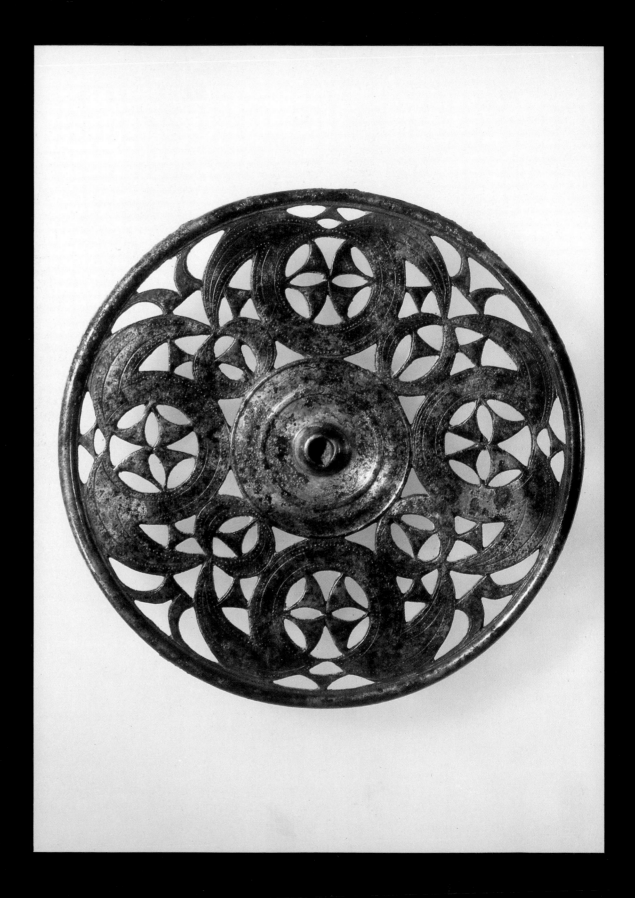

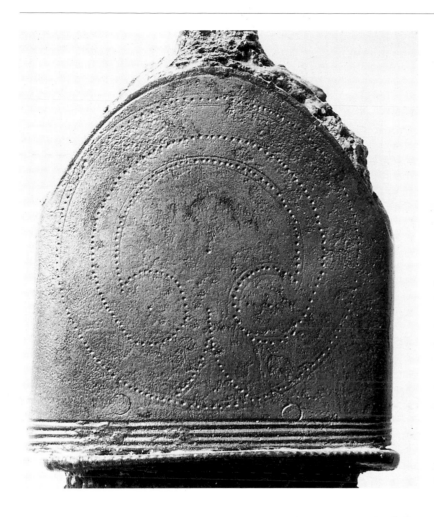

Engraved bronze scabbard plate (detail)
Bouy, Marne, France
Mid-5th century BC
The motif of the encircled palmette, symbol of the Tree of Life, here is transformed into a form evocative of a fan, which was to be used throughout the whole of Celtic art. This simple decoration was constructed with the help of a compass and the marks left by its point are still visible. The motif was then engraved by hand, which is why it is irregular and conceals the working drawing on which it was based.
Musée des Antiquités Nationales, Saint-Germain-en-Laye.

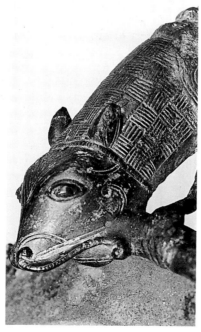

Bronze wine flagon
Borsch, Thüringia, German Democratic Republic
5th/4th century BC
A grave find, this wine flagon with a handle in feline form of Celtic manufacture but derived from Etruscan models is distinctly original. Only Celtic artists associated animals with foliage motifs and with abstract motifs in this way, probably for symbolic reasons. Here the palmette is displayed on the animal's hindquarters and spiral scrolls occur on the haunches and hindleg joints while S-motifs decorate the shoulders and frame the open jaws. Even the animal's coat is stylized with an unusual chequered pattern.
Height of handle: 17 cm.
Vorgeschichtliches Museum, Friedrich-Schiller-Universität, Jena.

21

Four-sided stone pillar
Pfalzfeld, Rheinland-Pfalz,
Federal Republic of Germany
5th century BC
This is the most important of the
Celtic works in stone which can
be assigned to the fifth century BC.
Surrounded by S-motifs, a stylized
human head in the centre of each
side is decorated with two foliage
motifs—the trifoliate palmette
under the chin and on the
forehead, and a large pair of
mistletoe leaves which form a
type of headdress. The latter was
a peculiarly Celtic motif, which
undoubtedly possessed
considerable symbolic
significance and was probably
the attribute of a much
venerated deity.
Height: 148 cm.
Rheinisches Landesmuseum,
Bonn.

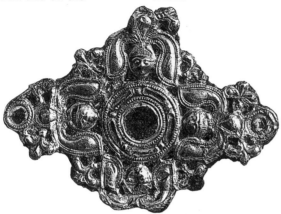

**Bronze plaque with
openwork gold foil in
repoussé relief**
Weiskirchen, Saarland,
Federal Republic of Germany
5th century BC
Originally, this grave find was
inset with amber or coral studs.
Once again the human face motif
is encountered, in association
with the trifoliate palmette. The
human face appears four times
and the trifoliate palmette is
arranged as a sort of headgear
framing the face, while a pair of
mistletoe leaves frame the top of
the head. That the foliage motifs
play the role of attributes in fifth
century BC Celtic art is very
apparent here.
Width: 8 cm.
Rheinisches Landesmuseum,
Trier.

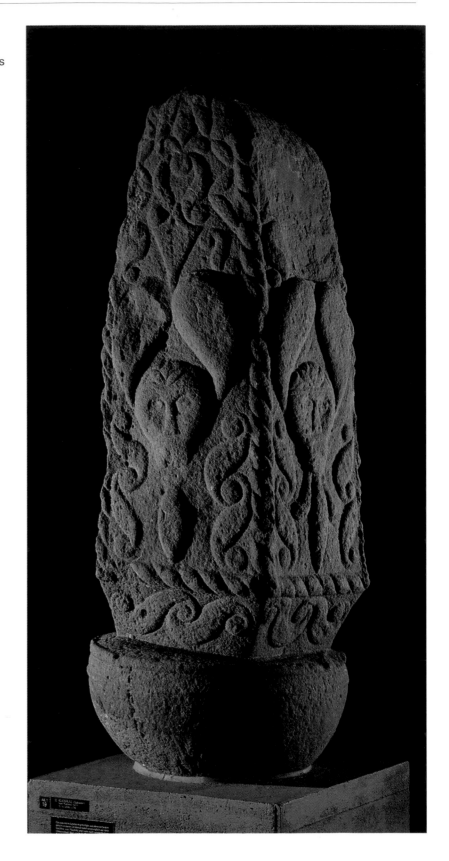

22

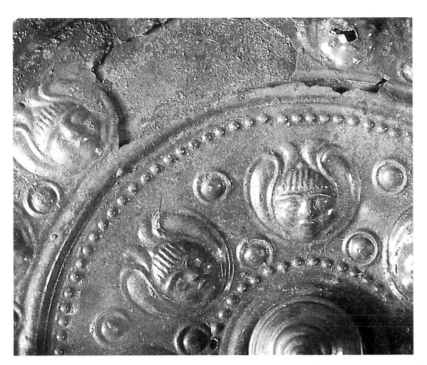

Iron and bronze *phalerae* (detail)
Hořovičky, Western Bohemia, Czechoslovakia
5th century BC
The *repoussé* decoration on these *phalerae* consists of a repetitive series of human faces, each of which is framed by a headdress formed of a pair of mistletoe leaves organized in two concentric zones. The faces were probably divine and therefore endowed with magical virtues.
Diameter: 12 cm.
Národne Muzeum, Prague.

Bronze wine flagon (detail)
Reinheim, Saarland, Federal Republic of Germany
5th/4th century BC
This bronze wine flagon, found in the grave of a woman of high rank, is undoubtedly one of the earliest examples of this type of utensil entirely designed and executed by the Celts. The series of motifs was either borrowed from the Etruscan repertory and adapted, or newly created. The most striking of these motifs invented by the Celts is unquestionably the human-headed horse which appears on the lid of the vessel and is represented again on Gaulish coins in the first century BC. The horse's head is crowned with a pair of mistletoe leaves.
Total Height: 50.4 cm.
Museum für Vor-und Frühgeschichte, Saarbrücken.

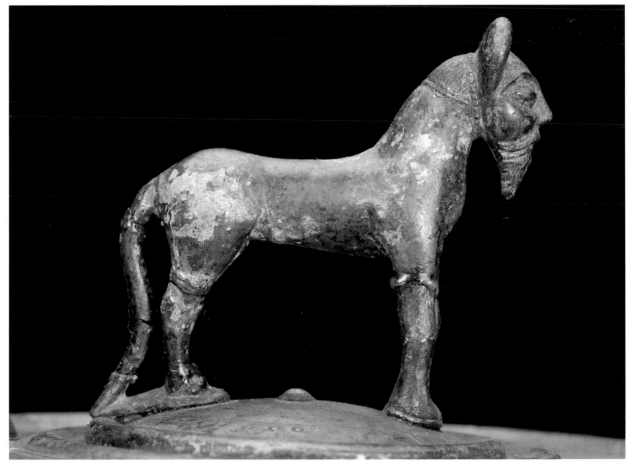

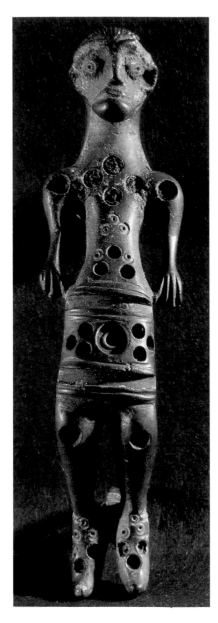

**Amber-studded, bronze
anthropomorphic fibula**
Manětín, Western Bohemia,
Czechoslovakia
5th century BC
The figure on this object probably
represents some deity or
legendary hero rather than any
ordinary individual. The clothes
are similar to those seen on the
Hallstatt scabbard.
Length: c. 8 cm.
Národní Muzeum, Prague.

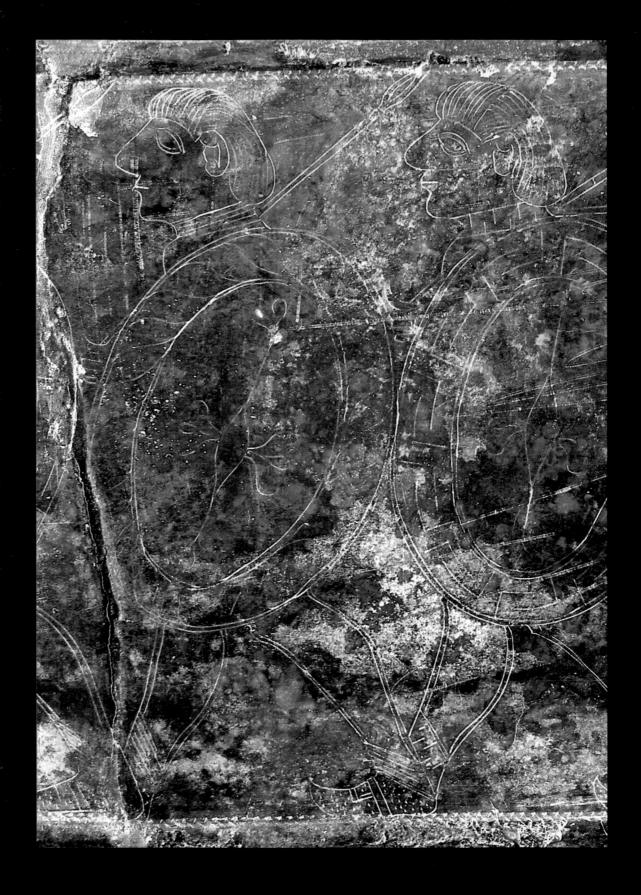

Engraved bronze scabbard (detail)
Hallstatt, Austria
5th century BC
This is an exceptional work, not only because of its high quality, but also because of the importance assumed by the human element. The artist who designed and executed it undoubtedly was strongly influenced by the orientalizing art of the *"situla"* art of northern Italy and the eastern Alpine territories and probably, the only novelty in the decoration of the scabbard is that the human figures represent scenes from the (unfortunately unknown) mythology of the early Celts.
Width: c. 5 cm.
Naturhistorisches Museum, Vienna.

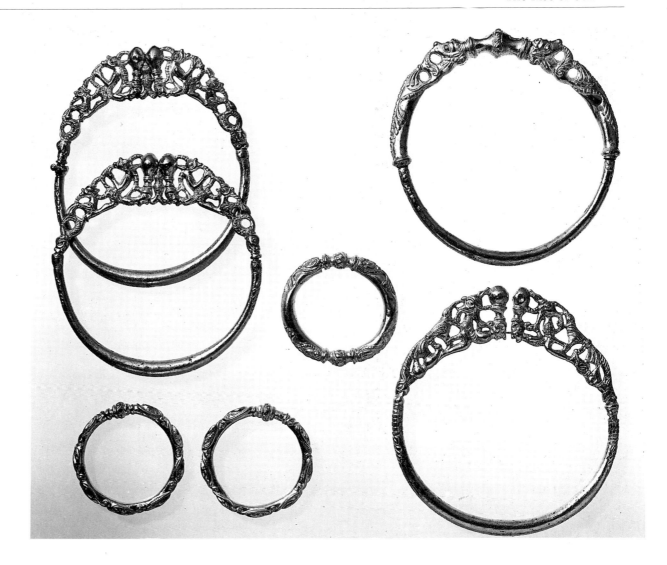

Four torcs and three bracelets
Erstfeld, Uri, Switzerland
5th/4th century BC
Discovered accidentally in 1962, these objects constitute an exceptional hoard illustrating the high quality of Celtic workmanship in gold. Although the rich decoration may be paralleled by that found on many contemporary objects discovered in the Rhineland or in central Europe, none equals it in exuberance.
Diameter of torc: 15.5 cm.
Schweizerisches Landesmuseum, Zürich.

25

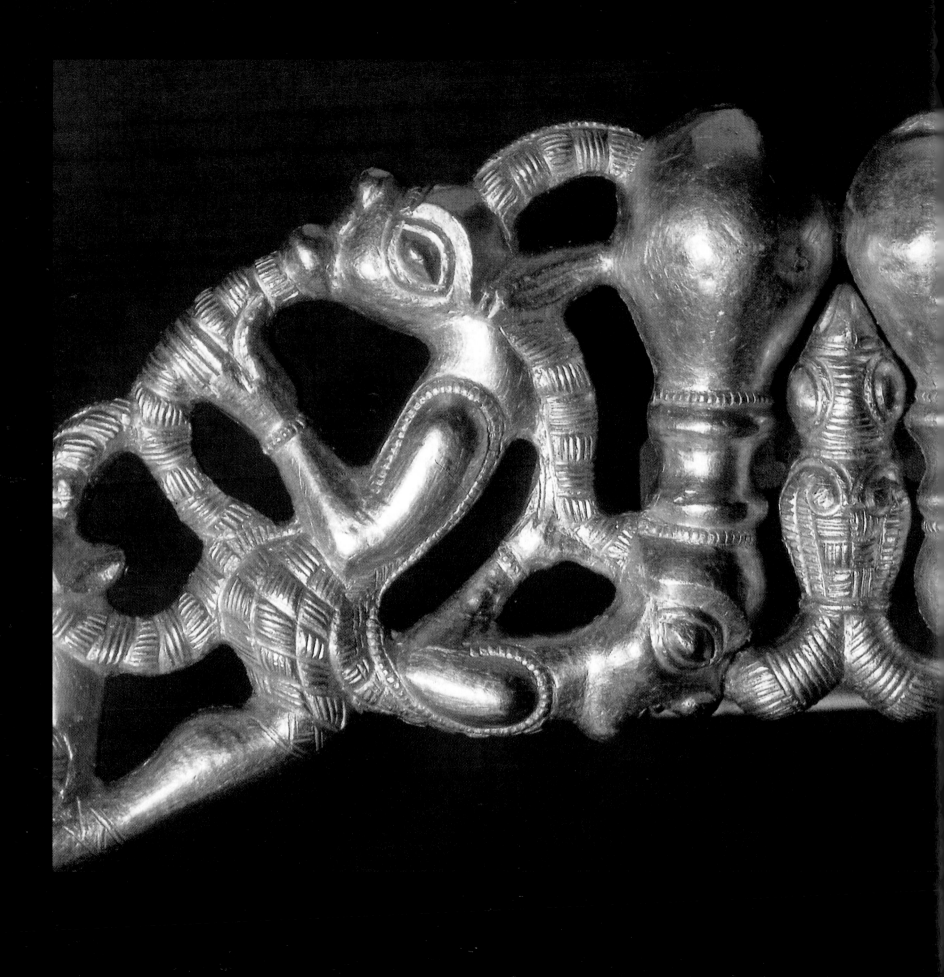

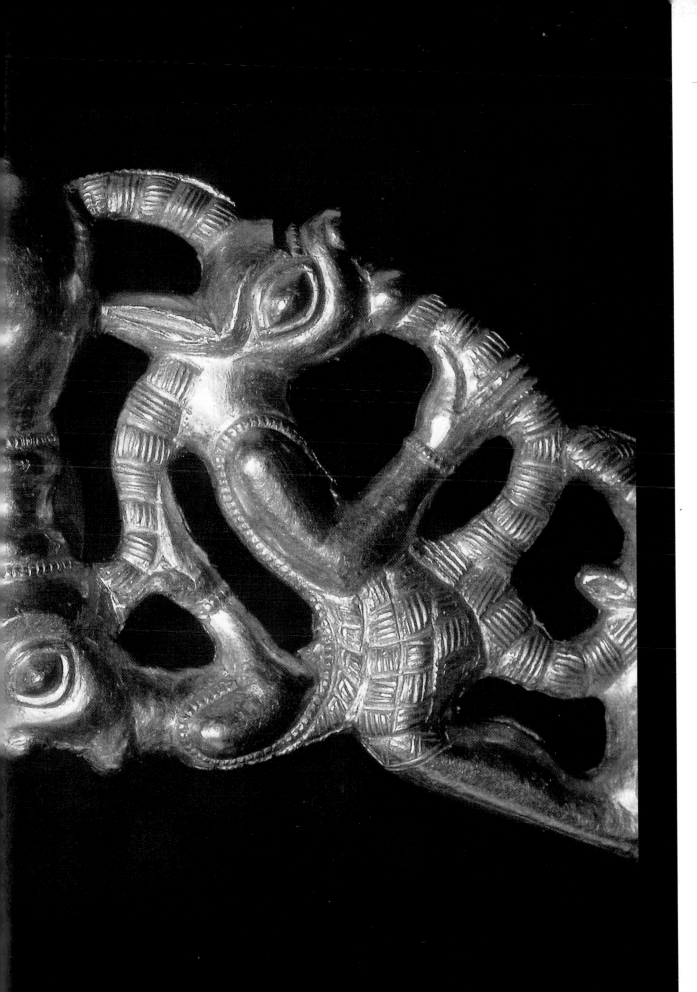

Detail of the Erstfeld gold
torc ornamented with
openwork.

Bronze fibula
Ostheim, Rhön-Grabfeld
Federal Republic of Germany
5th century BC
This fibula is entirely decorated with a type of dissymmetrical leaf with a narrow tip forming a scroll. The symbolic significance of the motif is emphasized by its repetition at either end of the fibula in three different abstract compositions, which may also represent griffins' heads. The object illustrates with remarkable virtuosity one of the fundamental principles underlying the Celts' transformation of Mediterranean prototypes—the reconstitution of the image in terms of signs which were filled with meaning.
Length: 8.8 cm.
Vorgeschichtliches Museum, Friedrich-Schiller-Universität, Jena.

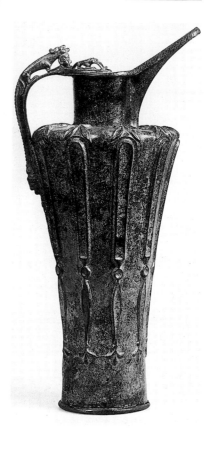

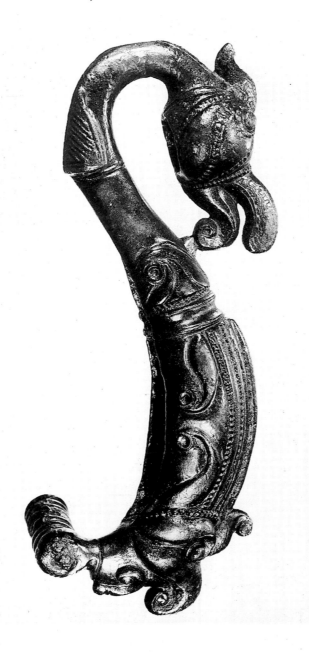

Bronze wine-flagon
Dürrnberg, Hallein, Austria
5th/4th century BC
Found in a chariot grave, this flagon is a good example of the perfect assimilation of elements chosen from the Mediterranean repertory and used in the expression of Celtic mythological concepts. On the handle attachment, a human head surrounded by a trifoliate palmette and S-motifs is crowned with "leaves" (similar to the decoration of the Ostheim fibula). Additional elements include strange monsters with long muzzles ending in scrolls (on the rim) and a grotesque animal leaning its chin on a human head with open eyes (on top of the handle).
Total Height: 46.7 cm.
Museum Carolino-Augusteum, Salzburg.

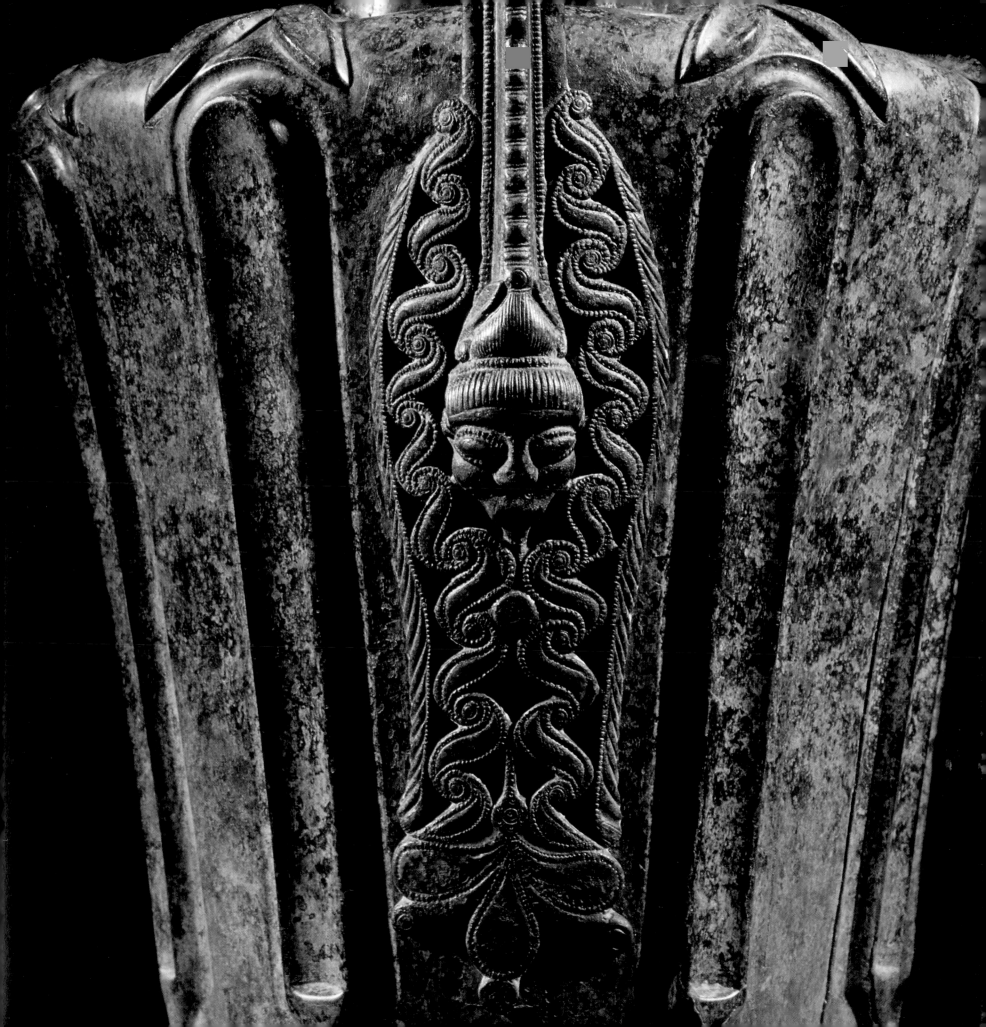

Two bronze flagons
Basse-Yutz (Moselle), France
Early 4th century BC
These bronze flagons are decorated with red *champlevé* enamel and coral insets. Practically all the iconography developed by the Celts before the fifth century BC is represented here. For example, the palmette either is engraved and studded with coral (under the spout) or is emphasized by enamel insets and is associated with animals (on the handle) or is combined with the human face (on the handle base). Other motifs include a duck in high relief (on the spout), interlaced S-motifs (at the bottom of the vessel) and chequer-work (under the beak).
Maximum Height: 40.4 cm.
British Museum, London.

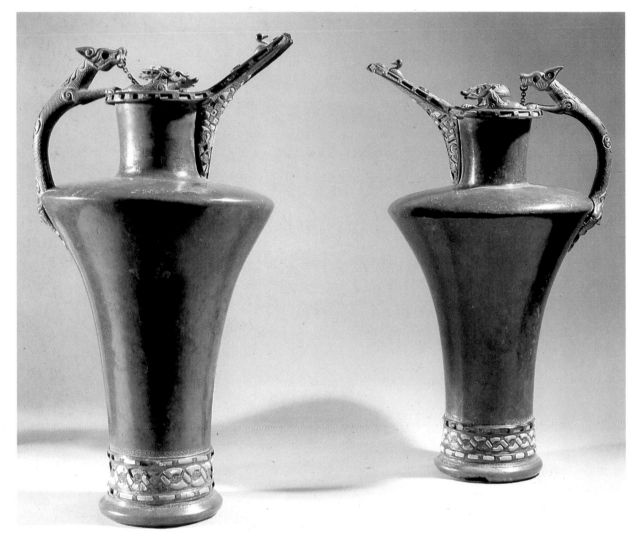

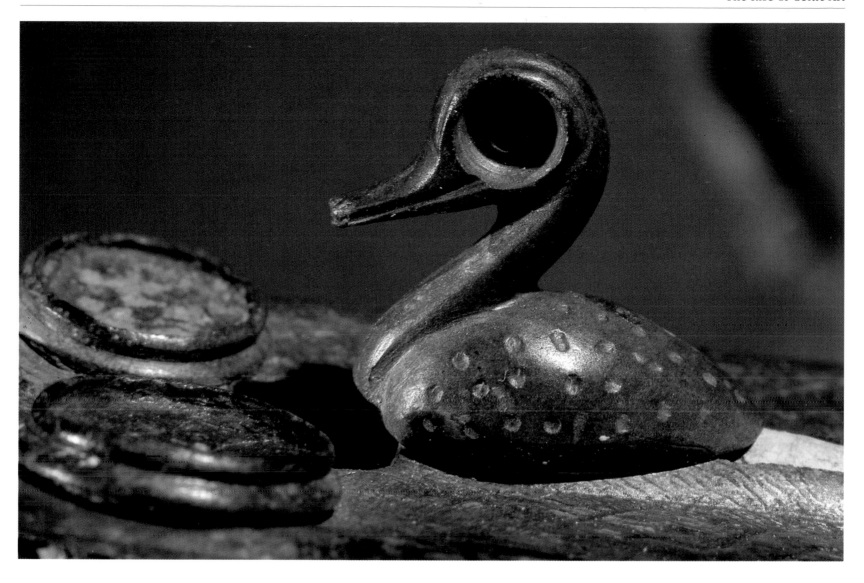

The climax of Celtic art

The great historic invasion which brought the Celts to Rome early in the fourth century BC culminated in the occupation of the greater part of northern Italy. As a result, a new style of decoration developed and spread. The weapons and jewellery discovered in Celtic burials in Italy are good illustrations of this new style, the main elements of which were foliage motifs, especially tendril scrolls. Hence one of its names: continuous foliage pattern. It is also known as the Waldalgesheim Style, after an important find-spot in the Federal Republic of Germany.

A feature of this prevailing trend in the fourth century BC was the adoption and transformation of motifs of Greco-Etruscan origin. The most striking examples are the two ceremonial helmets discovered in France—at Agris and Amfreville-sous-les-Monts—both found outside the area of expansion of Celtic art in the fifth century BC.

The strong Italic influence on the transalpine Celts is clearly apparent, too, in a series of painted vases found in Champagne (France), dating from the fourth century BC and probably produced in the same workshop. Their curvilinear decoration was executed, as on Greek and Etruscan vases, by blacking out the field and leaving the pattern in the colour of the clay (the "red-figure" style). This early attempt was followed a little later by a second series, found in Champagne, comprising ceramics in the "black-figure" style.

The stela of Sainte-Anne en Trégastel
(Côtes d'Armor), France
This monument is characteristic of the Armorican Iron Age. It is almost 2 metres high and bears a decoration of S-motifs, hardly visible today, which suggests a dating to the 5th or 4th century B.C. Such stelai, which are sometimes associated with cemeteries, would have had a religious significance.

33

The emergence of this new foliage pattern in the fourth century BC is evidence of the assimilation and interpretation by the Celts of the ornamental repertoire of Classical art, one of the foremost elements of which was the Greek or Etruscan palmette and its composite forms, with tendril scrolls. Fibulae discovered in Switzerland are closely akin to the Mediterranean prototypes, but the famous gold torc found at Waldalgesheim differs considerably.

The most important innovation of Celtic art in the fourth century BC, which became one of its main features, was undoubtedly the process known as plastic metamorphosis. This type of representation is ambiguous since the foliage pattern conceals, and at the same time evokes, a human face (often caricatured), a mask, or animal heads. It therefore represents a fleeting vision, in other words, it may be interpreted in two ways.

As a result of the movement of the Celts between the different regions of non-Mediterranean Europe and northern Italy, and their successive migrations eastwards to the Carpathian Basin, the fourth century BC decorative style spread rapidly. The engraved decoration of a fine piece of pottery from Armorica in France, showing an elegant interpretation of the frieze of palmettes, reflects the influence of Greco-Etruscan motifs at the western confines of the Continent. The decoration of an iron spearhead found in Hungary is very similar to that of the Waldalgesheim torc. The spread of this style seems to have followed Celtic expansion not only eastwards, but south-eastwards too and the fine gold torc with continuous tendril scrolls, found at Cibar Varos (Bulgaria), is the earliest evidence of the presence of Celts in Thrace.

This style was not, however, adopted immediately. Besides important finds scattered between Brittany and Bulgaria, evidence of its influence on local production also may be observed. The geometrical repertoire of the stamped pottery found widely in Bavaria, Bohemia, Austria and the Carpathian Basin was enriched by elements of the new foliage pattern. The motif stamped on a vase discovered in Hungary is a simplified version of the tendril scroll to be seen, for example, on a bronze handle-attachment found in Comacchio (Italy), while the pattern incised on another vase found in Hungary was copied from a metal object.

A small number of stone sculptures found in the Rhineland area of The Federal Republic of Germany also illustrates the rise of Celtic art in the fourth century BC. The motifs decorating these examples of monumental art derive from the ornamentation of metal objects and they may be interpreted as stone enlargements of metal engravings.

From the last decade of the fourth century BC onwards, the Celtic advance weighed more and more heavily on the whole of the north-eastern Balkans and threatened Greece as well. This change in direction was reflected in Celtic art, despite the

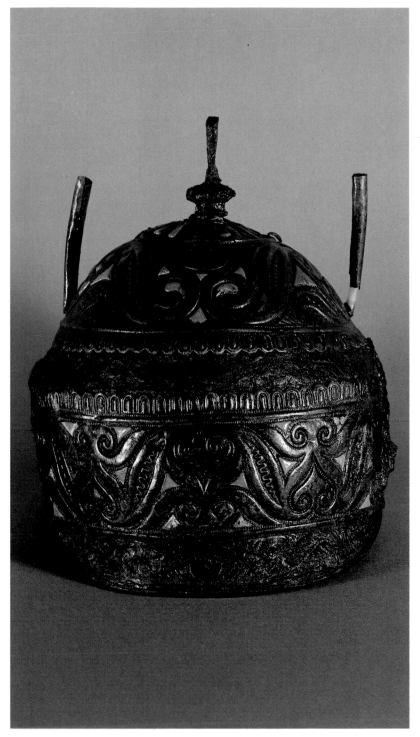

Helmet
Canosa (Apulia)
Mid-4th century BC
Iron helmet discovered in a hypogeum (rock tomb); decorated with two bands of repoussé. Iron, bronze and coral.
Height: 25 cm.
Preussischer Staatliche Museen Antikabteilung, Kulturbesitz, Berlin.

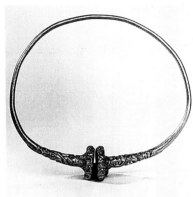

Gold torc
Filottrano (Marche)
350-300 BC
A continuous foliage pattern in
low relief garnishes this open torc
with buffer-terminals, which was
discovered in a tomb.
Diameter: 14.9 cm.
Museo Archeologico Nazionale
delle Marche, Ancona.

Bronze drinking service
Waldalgesheim burial,
Rheinland-Pfalz,
Federal Republic of Germany
350-300 BC
Forming part of a drinking service,
the flagon was produced locally
while the bucket was made at
Tarentum.
Height (flagon): 35 cm; (bucket)
23 cm.
Rheinisches Landesmuseum,
Bonn.

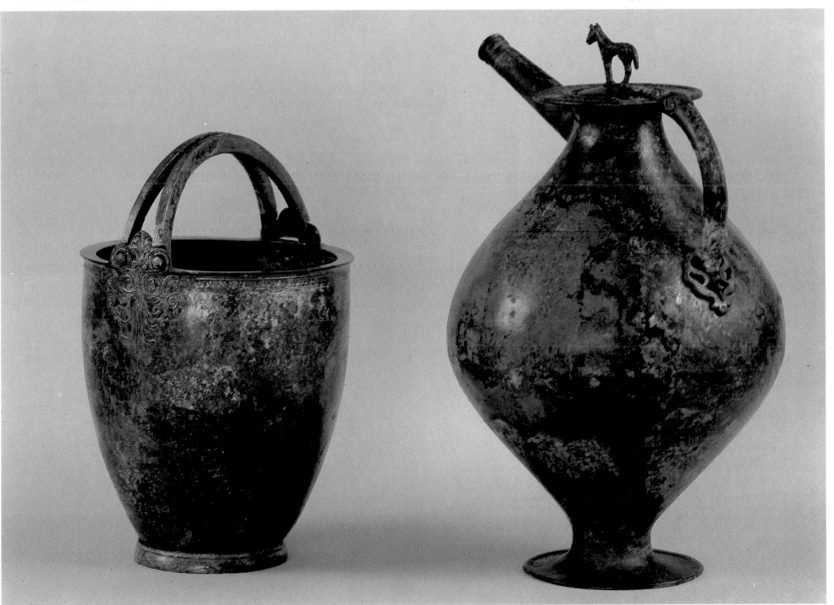

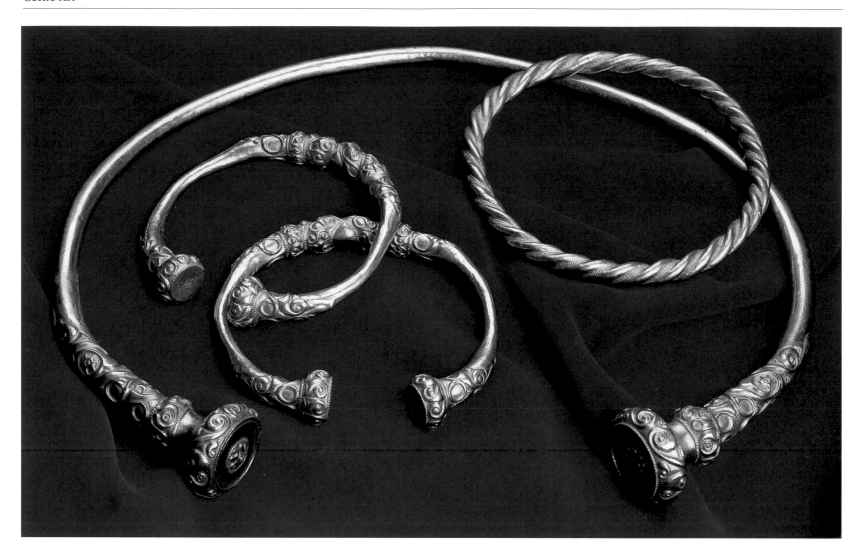

Gold personal ornaments
Waldalgesheim burial,
Rheinland-Pfalz,
Federal Republic of Germany
350-300 BC
These personal ornaments
comprise a torc, a pair of
bracelets which are decorated
with the continuous foliage
pattern and an armlet in the
form of a torc.
Diameter (torc): 19.9 cm;
(bracelets): 6.5 cm;
(armlet): 8.2 cm.
Rheinisches Landesmuseum,
Bonn.

Openwork plaque
Waldalgesheim burial,
Rheinland-Pfalz,
Federal Republic of Germany
350-300 BC
This bronze openwork plaque
with coral and enamel insets has
opposing birds in the centre and
originally the plaque would have
been placed at the centre of a
wooden yoke, probably as a
chariot fitting.
Width: 8 cm.
Rheinisches Landesmuseum,
Bonn.

failure of the great Celtic expedition against the Greek world in 279 BC. The grave of a military chieftain in the Ciumeşti cemetery (Romania) on the border of the Hungarian plain affords very clear evidence of this orientation towards the Balkans, since the grave goods include Greek bronze shin-guards. The roundels of the mail attest to the change in taste, for the embossed motifs owe more to the survival of elements of the Early Celtic style than to the continuous foliage pattern. The third century BC heralded the growing role of the plastic arts, for example, the extraordinary Ciumeşti helmet which is topped by a bird—a crow rather than an eagle—with mobile wings and enamel eyes.

By the first half of the third century BC the Danubian Celts had become a dynamic force through the absorption of heterogeneous elements from territories extending from the Atlantic to the Carpathian mountains. All these movements to and fro are reflected, *inter alia,* in the diffusion of scabbards decorated with heraldic pairs of fabulous animals—dragons, griffins and birds of oriental inspiration, which probably originated in Italy. These works are to be found throughout the whole of the Continental region covered by the Celts, from Normandy in the west as far as Transylvania in the east, from around Warsaw in the north to Belgrade in the south, not to mention northern Italy. To complete the picture, similarly decorated scabbards have been discovered in the River Thames (England).

This new trend in the Celtic world explains the remarkable development of the middle Danube region during the third century BC—one of the finest periods in Celtic art. The Danubian scabbards decorated with spirals of delicately intertwined foliage and other elements of plant or animal life, forming a continuous pattern of curves and counter-curves, represent a new style known as the "Hungarian Sword Style". It was brought to perfection in the scabbard found at Cernon-sur-Coole (France), the closest parallel to which was discovered at Drňa (Czechoslovakia). The motif most charac-teristic of these scabbards—the crested head of a fantastical bird—also appears on a fibula found at Conflans (France), which bears witness to the virtuosity of the Celts in the working of iron.

The "Hungarian" and "Yugoslav" sword scabbards display new and unexpected variations on foliage motifs. The compli-cated interlacings are sometimes associated with animal elements, here only distantly related to the prototypes which can be observed on items decorated in the continuous foliage pattern of the fourth century BC. In some cases, the pair of fabulous animals fuses with the decoration typical of the "Hungarian" swords. It will be noted that towards the end of the third century BC, foliage and floral patterns become geometric to a certain degree.

The "Swiss Sword Style" represents a contemporary trend comparable to the "Hungarian Sword Style", but with marked

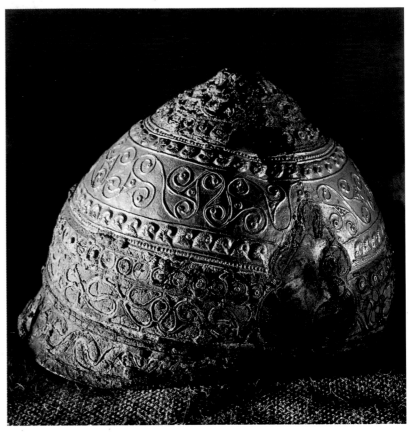

Helmet
River Seine at
Amfreville-sous-les-Monts,
France
4th century BC
Found in a former channel of the River Seine, this bronze helmet is similar in conception to the Agris helmet. Here, however, the openwork areas are inset with enamel and gold leaf survives only on the central band. The decorative motifs employed also are more varied, involving S-motifs and triskeles.
Height: 16 cm.
Musée des Antiquités Nationales, Saint-Germain-en-Laye.

Helmet
Agris, Charente, France
4th century BC
This magnificent object was discovered recently in a cave outside the area covered by Celtic art in the fifth century BC. The helmet, covered with gold leaf, is decorated with four main bands either composed of vegetal openwork, inset with coral, or of palmettes in relief.
Height (without cheek-piece):
21.4 cm.
Musée Municipal, Angoulême.

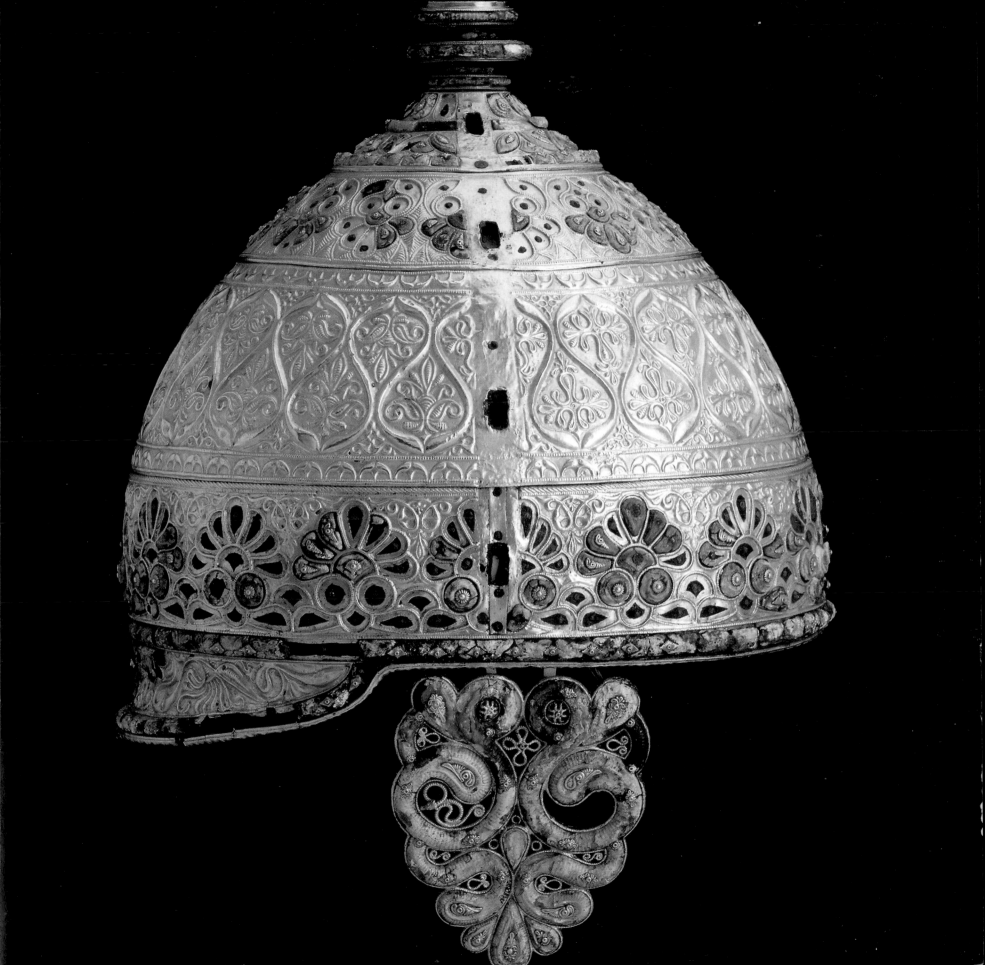

differences. The decoration is less abstract, as may be seen from the La Tène scabbard on which three animals in slight relief are depicted in a fanciful way with incised tendril scrolls planing a secondary role in the composition. Even the running scrolls of tendrils on the "Swiss" swords are closer to the Italian prototypes than to the Hungarian variety. The importance of a symmetrical composition is another noteworthy feature of the "Swiss" swords.

The emergence in Central Europe of the Plastic Style, one of the most original manifestations of early Celtic art, was also due to the eastward shift in the centre of gravity of the Celtic world. A few rare objects scattered between the middle Danube region and south-west France give some idea of the refinement of the products of the Celtic workshops. The gold torc and bracelets are sumptuous works, especially the bracelet found in Aurillac (France) with its striking profusion of flowers, buds and leaves. The Lasgraisses torc is made up of flowers interlaced in a double torsade and this ornament was probably inspired by Hellenistic jewellery.

The precursory signs of the Plastic Style appear on the bronze bracelets and fibulae found in Bohemia (Czechoslovakia) and on the bronze torc found in the Rhineland area of the Federal Republic of Germany. Although this first series obviously derives from the fourth century BC, objects with foliage decoration, direct allusions to the continuous foliage pattern, are rare. The transformed elements, like the scrollwork, are in marked relief and although the basic element—the lyre—does not change, S-motifs and triskeles are increasingly important in these plastic compositions.

The Plastic Style was brought to perfection in bronze ornaments, chiefly pairs of anklets, but also bracelets, some hundreds of which originated in Bohemia and Moravia. Their decoration, based principally on S-motifs, triskeles and combinations of these forms, along with the *yin-yang* as an innovation, is often in very high relief—in some cases almost fully in the round. The composition of the most baroque specimens gives the effect of an exercise in solid geometry. The purpose of this plastic form elaborated during the third century BC was not merely decorative. Certain motifs constantly recur throughout the Celtic world. The human face, expressive and sometimes caricatured, appears among S-motifs and knobbed spirals on parts of chariots unearthed in areas extending from France to Bulgaria. The openwork decoration of the Brno-Malomerice specimen, with its plastic virtuosity, lends an eerie character to the human masks.

The ornamental repertoire used in Celtic art of the third century BC is not lacking in incredible monsters or in real animals. The birds of prey that adorn the rim of a cauldron found at Brå are stylized and at the same time highly expressive. They undoubtedly served the same purpose as the griffin handle-ring on the cover of the vase found at Brno-

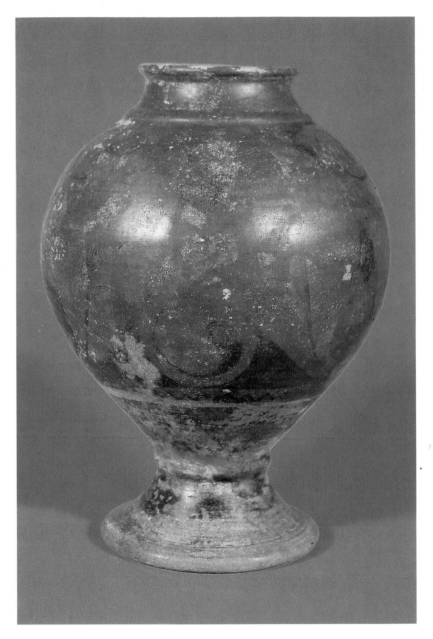

Pottery vase
Prunay, France
4th century BC
Vase with pedestal base, painted
in the "red-figure" style.
Height: 31.1 cm.
British Museum, London.

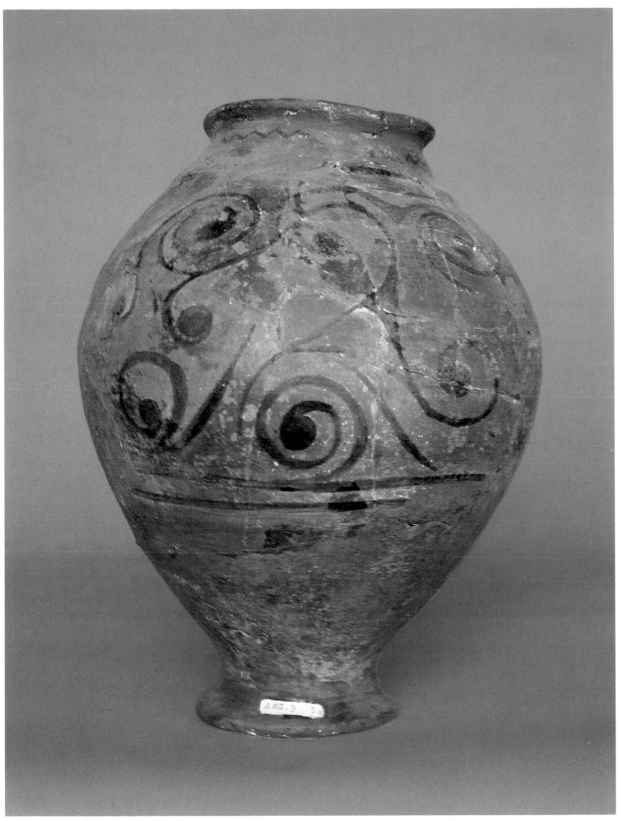

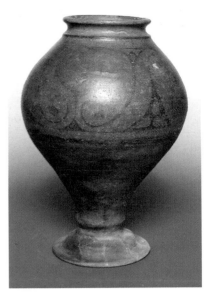

Pottery vessel (detail)
Prunay, France
4th century BC
The decoration on the upper part of the vase was produced by blacking out the field and leaving the design in the colour of the clay.
Height: 35 cm.
Musée Saint-Rémi, Reims.

Decorated vase
Beine-L'Argentelle, France
c. 300 BC
Discovered in a tomb, the decoration of this vase was executed in the "black-figure-style".
Height: 37 cm.
Musée Saint-Rémi, Reims.

Malomerice (Czechoslovakia). The drinking-horn in the form of a dragon, found in Hungary, is particularly interesting as the animal motif which harks back to the Hellenistic *Kétos* or sea monster.

The art of the Carpathian Basin during the third century BC was open to Balkan influences and it owes its filigree and granulation techniques, little known in the western La Tène regions, to the Thracian-Illyrian cultural sphere. The most striking example is the hoard unearthed in Szárazd-Regöly (Hungary), which illustrates the Celto-Illyrian cultural amalgam. The fashion for bronze jewellery decorated with imitation filigree flourished shortly before the middle of the third century BC, inspired by objects found commonly throughout the Carpathian Basin and in Moravia. The bracelet discovered in Chotín (Czechoslovakia), a masterpiece in this style, gives the illusion of true filigree-work.

The influence of metal vases of Hellenistic origin introduced new forms into the ornamental repertoire of eastern Celtic pottery. One type of Danubian kanthar (third century BC), imitates Greek prototypes and it was during the same period that kantharoi with theriomorphic and anthropomorphic handles first appeared. Vessels on which a human figure serves as handle evoke Etrusco-Italic models. The kantharoi represent one of the most original aspects of the art of the Celts of the Carpathian Basin.

In the second century BC Celtic art was distinguished both by continuity, as shown by the late specimens of the "Hungarian Sword Style" and the Plastic Style, and by an important innovation, the increasing role of glass as a vehicle for art. The bead found in Vác (Hungary) derives from the large family of Punic amulets, but it is an imitation made in the Pontic region, and was a type highly prized by the eastern Celts. The appearance of rather conservative stylistic tendencies, however, is to be noted— the reintroduction of symmetry in the composition and the predilection for summary forms. Nonetheless, the Celtic masters' feeling for both angular and curved forms remained astounding, as can be seen simply by looking at the anklet found in Batina (Yugoslavia) or the pendant ornament found in Jászbereny (Hungary).

Continental Celtic art at its height extended its influence over insular art and it is possible to speak of its impact on the British Isles. The ornament from a chariot found in Brentford (England) is a significant example of the adoption of the running tendril scroll and of motifs that can be interpreted in differing ways. The central boss of the Witham shield demonstrates the importance both of high relief and of a composition based on the principle of the symmetry of rotation. Irish sword-scabbards are usually more finished than Continental ones, but their decoration reflects the innovations of the "Hungarian" and "Swiss" masters of the third century BC.

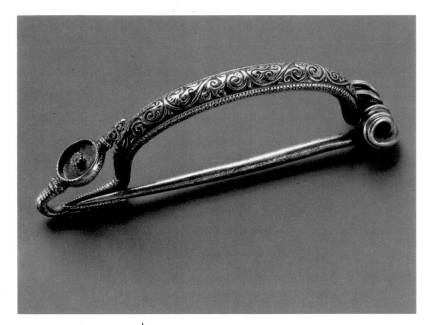

Silver fibula
Bern-Schosshalde, Switzerland
c. 300 BC
A running scroll of palmettes closely resembling the Greek prototype is displayed on the bow of the fibula.
Length: 6.3 cm.
Bernisches Historisches Museum, Berne.

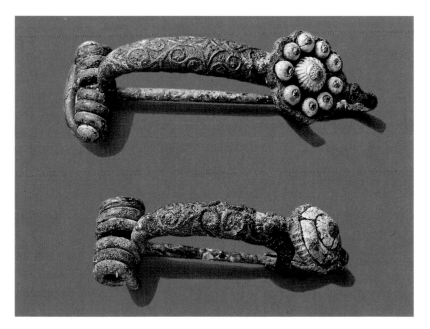

Fibulae found in a cemetery
Münsingen, Switzerland
Mid-4th century BC
Decorated with palmettes and half-palmettes. Bronze and coral.
Length: 8.4 and 6.8 cm.
Bernisches Historisches Museum, Berne.

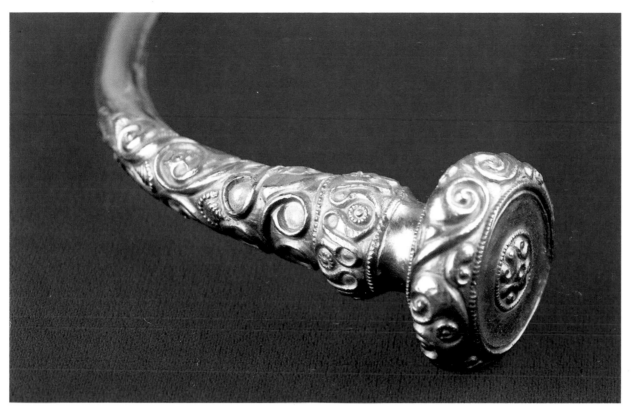

Gold torc (detail)
Waldalgesheim, Federal Republic
of Germany
350-300 BC
Detail of decoration.
Diameter: 19.9 cm.
Rheinisches Landesmuseum,
Bonn.

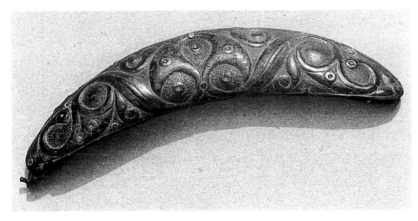

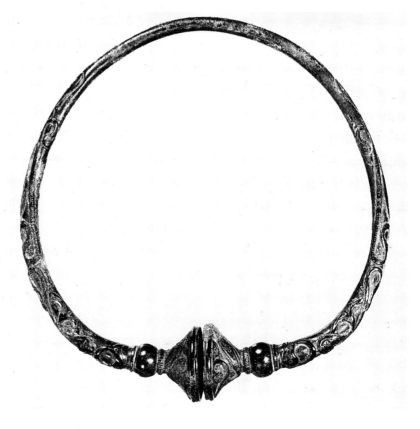

Bronze object
Brunn am Steinfeld, Austria
350-300 BC
This crescent-shaped object,
made of two strips, illustrates the
metamorphosis of a foliage motif
into a mask.
Length: 10 cm.
Museum für Urgeschichte des
Landes Niederösterreich, Asparn
an der Zaya, Austria.

Bronze torc
Beine-Argentelle (Marne), France
4th/3rd century BC
Birds' heads are discernible on the
decoration of this bronze torc.
Diameter: 12.7 cm.
Musée Saint-Rémi, Reims.

Pottery vase
Saint-Pol-de-Léon (Finistère),
France
4th century BC
The palmette pattern, incised on
this vase, is inspired by a style
used in metal engraving.
Height: 26 cm.
Musée Municipal, Morlaix.

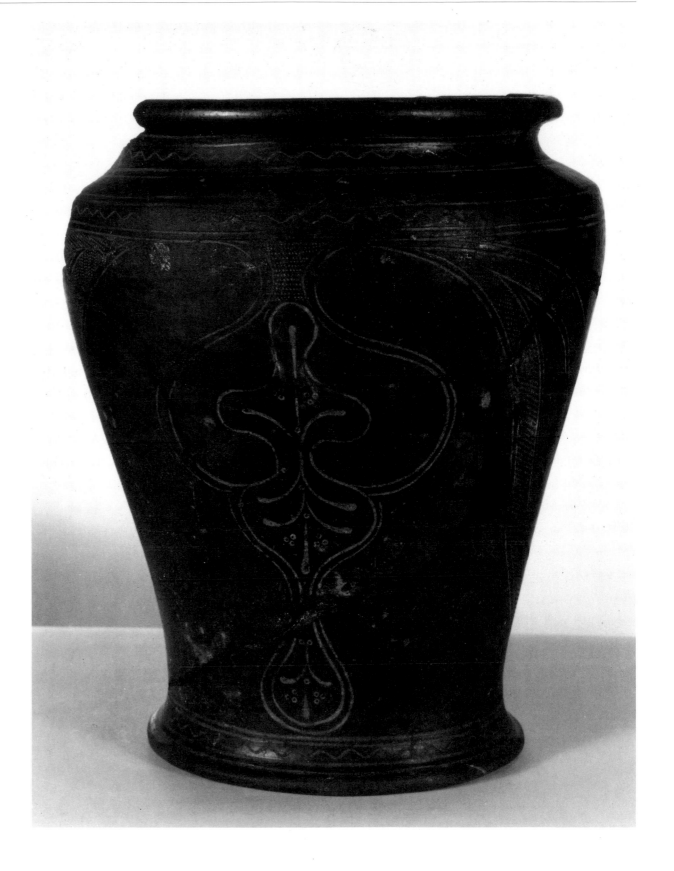

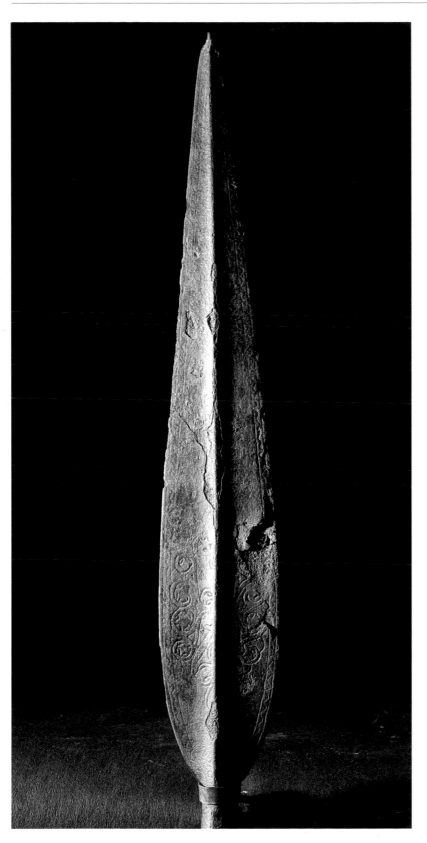

Iron spearhead
Hungary
Late 4th century BC
Decorated with an engraved
pattern very similar to that of
the Waldalgesheim torc.
Height: 30 cm.
Magyar Nemzeti Muzeum,
Budapest.

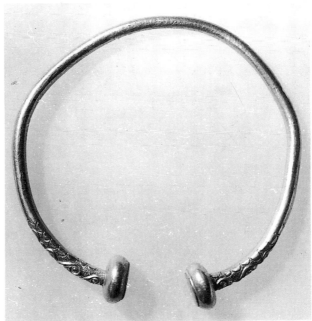

Gold torc
Cibar Varos, Bulgaria
Late 4th century BC
Decorated with a running scroll
and framed by dotted or cusped
festoons.
Diameter: 15.2 cm.
Narodnija Archeologičeski Muzej,
Sofia.

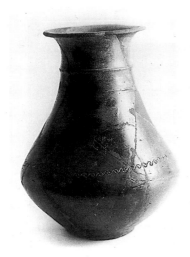

Pottery vase Sopron-
Bécsidomb, Hungary
Late 4th century BC
The stamped patterns on this
vase found in a tomb in a Celtic
cemetery are drawn from the new
ornamental repertory.
Height: 31 cm.
Liszt Ferenc Múzeum, Sopron.

Bronze handle attachment
Comacchio (Emilia), Italy
Late 4th century BC
This bronze handle attachment
decorated with continuous
scroll-work is set against a
punched or dotted background.
Length: 12.5 cm.
Formerly Museum für Vor-und
Frühgeschichte, Berlin: now lost.

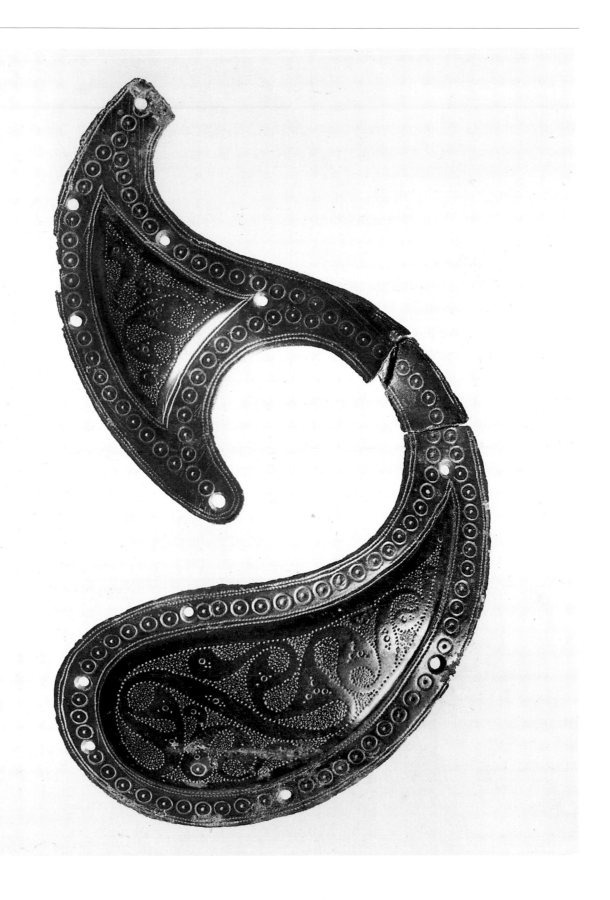

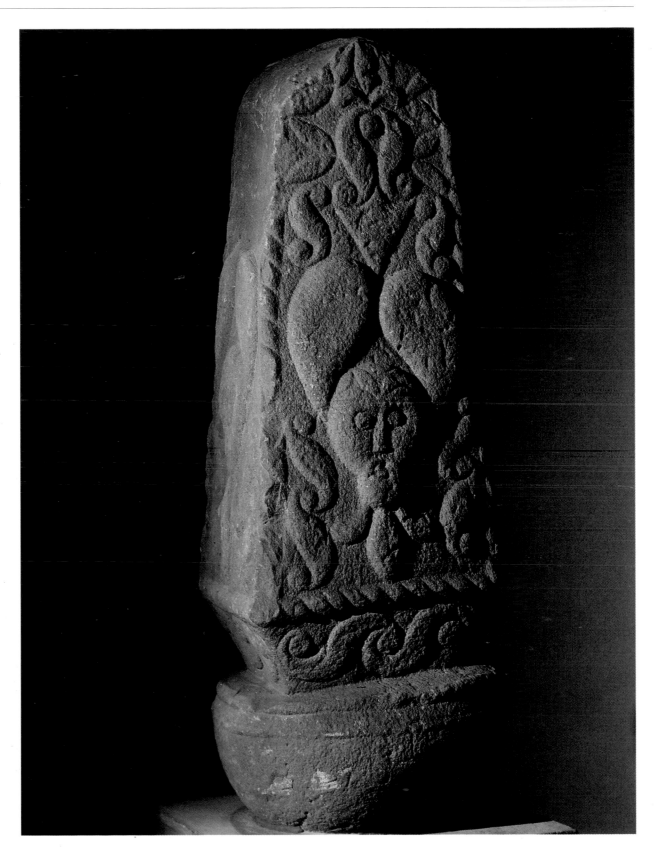

Obelisk
Pfalzfeld, Federal Republic of
Germany
4th century BC
A small sandstone obelisk
decorated in bas-relief with a
mask surmounted by two huge
leaves, an inverted palmette and
interlaced S-motifs.
Height: 148 cm.
Rheinisches Landesmuseum,
Bonn.

Pillar statue
Steinenbronn, Federal Republic
of Germany
Late 4th century BC
A sandstone pillar statue depicts
the left forearm of a human figure.
Below, on the four sides, are
curvilinear compositions.
Height: 125 cm.
Württembergisches
Landesmuseum, Stuttgart.

Iron helmet
"Chieftain's grave" at Ciumeşti
(Romania)
First half of the 3rd century BC
The iron helmet is surmounted by
a bird of prey made of bronze and
enamel.
Height: 41.7 cm.
Muzeul de Istorie a R.S. Romania,
Bucharest.

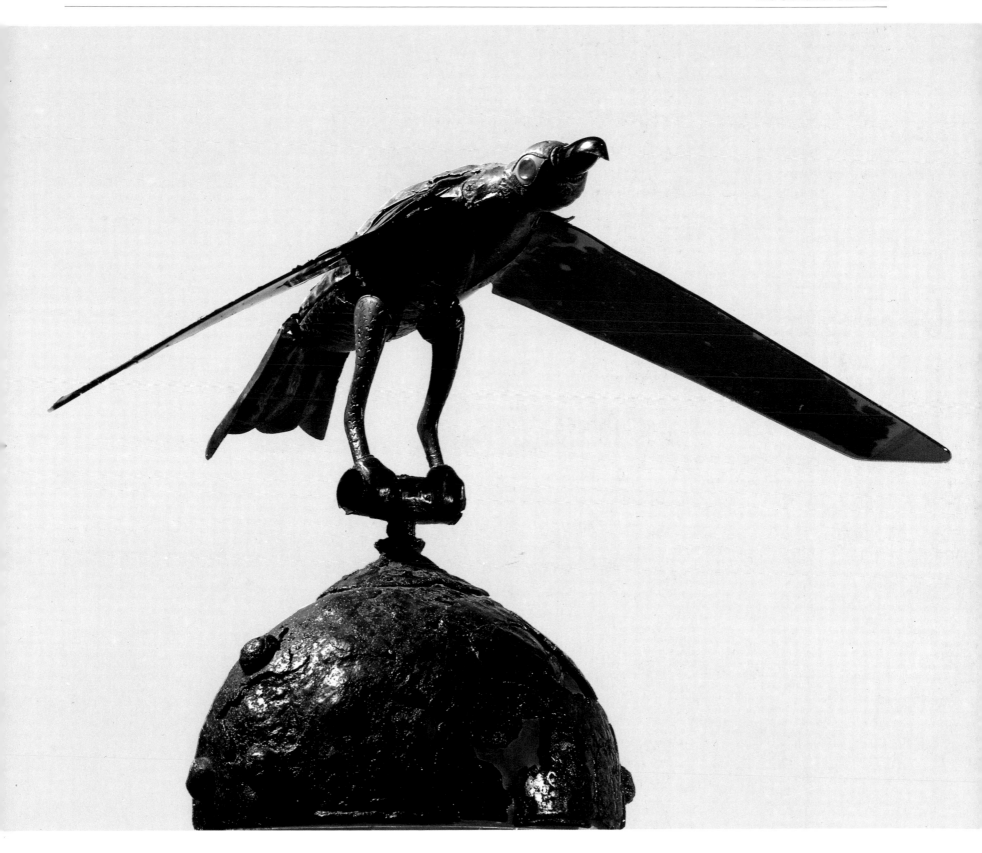

Iron scabbard
Thames River at
Hammersmith, England,
United Kingdom
3rd century BC
The scabbard is ornamented with
the so-called "dragon pair"
decoration, which consists of two
opposing S-motifs, or lyre, with a
schematic representation of
dragon heads.
Length of sword: 70.1 cm.
British Museum, London.

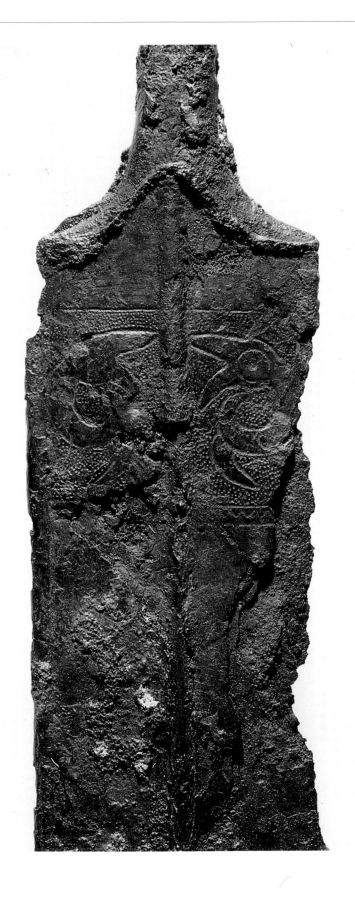

Iron sword
Kosd, Hungary
Mid-3rd century BC
This sword from a Celtic cemetery
is bent following Celtic practices.
The "dragon pair" which decorate
it have been fleshed out and have
been given a tail.
Length: 72 cm.
Magyar Nemzeti Múzeum,
Budapest.

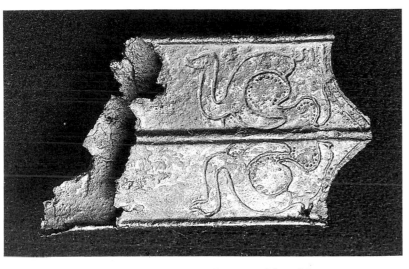

Iron scabbard fragment
River Saône
at Marnay, France
3rd century BC
This fragmentary scabbard (with
sword) displays two affronted
dragons either side of the centre
line. The beasts are further
defined by the use of punched or
dotted background.
Length of sword: 73.4 cm.
Musée Denon, Châlon-sur-Saône.

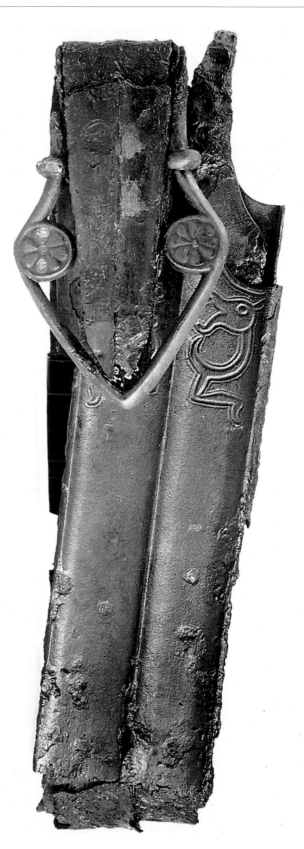

Iron scabbard (detail)
Cernon-sur-Coole, France
Mid-3rd century BC
Found in a cremation-burial,
foliage and animal motifs interlace
in curves and counter-curves on
this iron scabbard.
Total length: 74 cm.
Musée Municipal, Châlons-sur-
Marne.

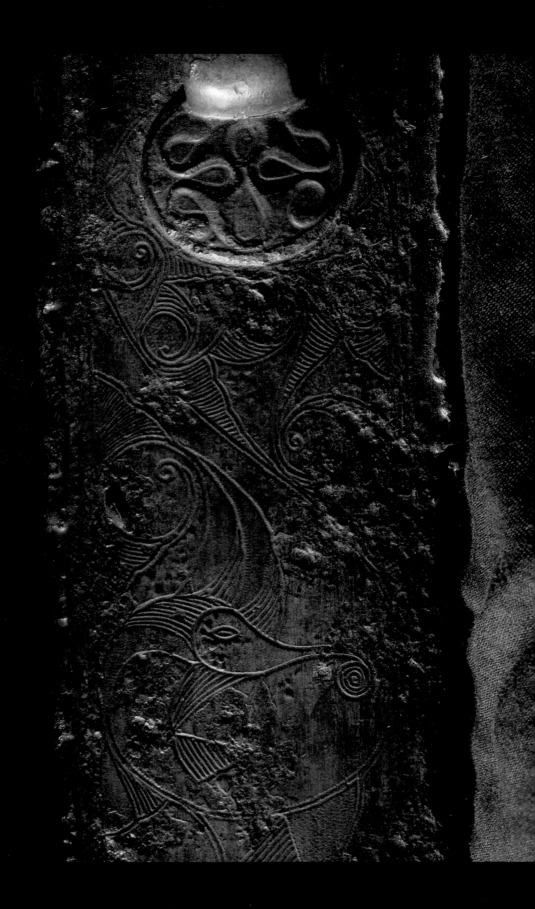

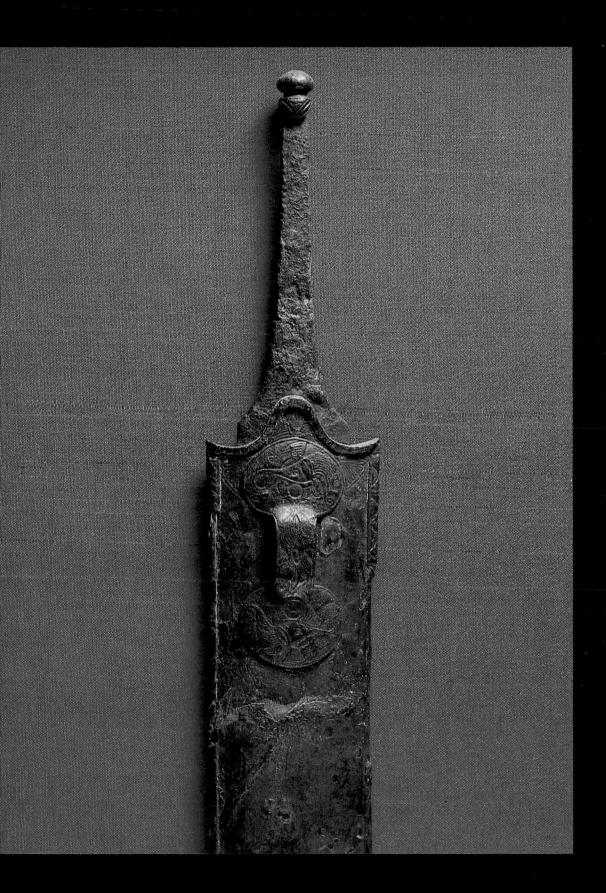

Iron fibula
Conflans (Marne), France
Mid-3rd century BC
A bird frieze decorates the display
side of the fibula.
Length: 12 cm.
Musée des Beaux-Arts, Troyes.

Iron sword (detail)
Drňa, Czechoslovakia
3rd century BC
This iron sword, the counterpart
of the Cernon scabbard, was
found in a disturbed cemetery.
Length: 83.3 cm.
Gemerské Múseum, Rimavskà
Sobota.

53

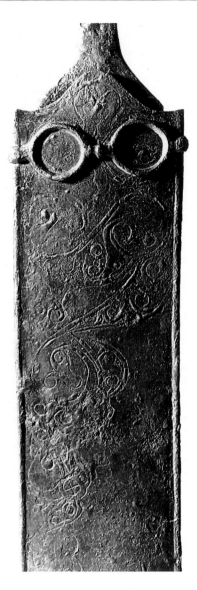

Iron scabbard
Bölcske-Madocsahegy, Hungary
c. 200 BC
The floral motifs on this fragmentary iron scabbard are transformed into geometric forms.
Length: 33 cm.
Magyar Nemzeti Múzeum, Budapest.

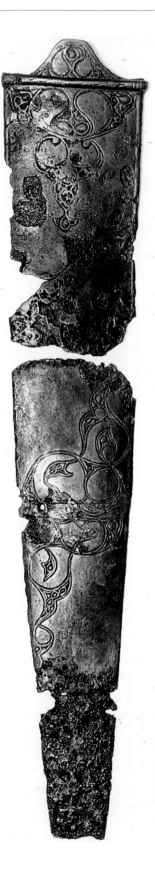

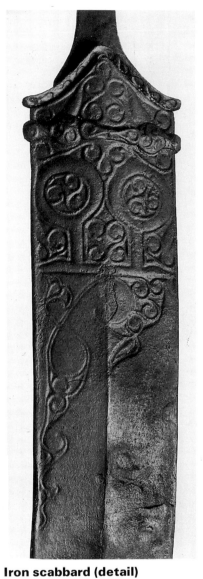

Iron scabbard (detail)
Batina, Yugoslavia
3rd century BC
The pattern incised on the scabbard shows the fusion of foliage elements in an unrestrained manner.
Length: 77 cm.
Naturhistorisches Museum, Vienna.

Iron scabbard (detail)
Brežice, Yugoslavia
c. 200 BC
This scabbard discovered in a Celtic cemetery displays a stylized "dragon-pair" and arabesques.
Width: 5 cm.
Posavski muzej, Brežice.

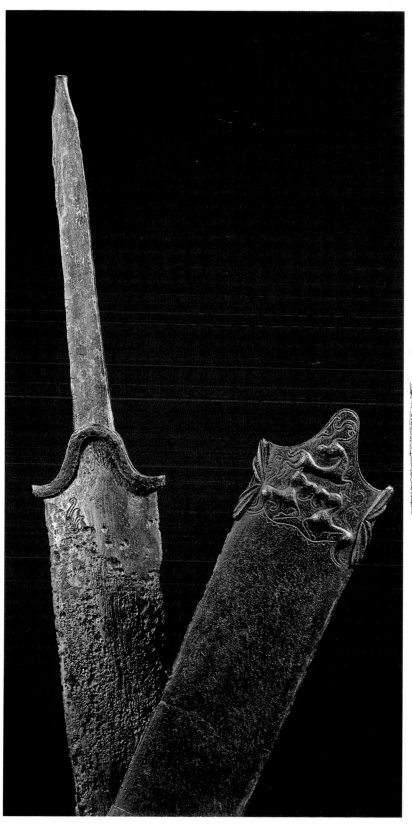

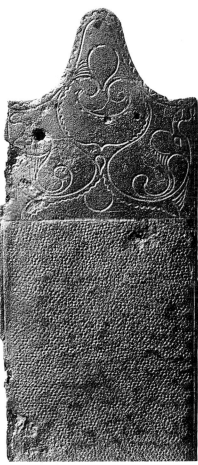

Iron chape
La Tène (Neuchâtel Canton),
Switzerland
c. 200 BC
A decorated chape of a scabbard
displaying three animals in a
triangular arrangement.
Total length: 82 cm.
Musée Cantonal d'Archéologie,
Neuchâtel.

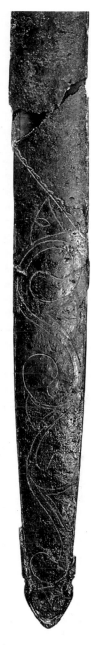

Iron chape
Basadingen, Switzerland
c. 200 BC
Incised with an inverted pelta at
the top and a curvilinear imaginary
animal on either side. Below is an
area which has been punched or
stamped.
Width: 5.3 cm.
Schweizerisches Landesmuseum,
Zürich.

Iron scabbard
La Tène (Neuchâtel Canton),
Switzerland
c. 200 BC
This decorated scabbard displays
scroll-work derived from Etruscan
prototypes.
Length: 75 cm.
Musée Cantonal d'Archéologie,
Neuchâtel.

Gold bracelet
Lasgraïsses (Tarn), France
3rd century BC
This torc consists of a single ring
of flowers, while the bracelet has
two rings of flowers.
Diameters: 17 cm and 16.2 cm.
Musée Saint Raymond, Toulouse.

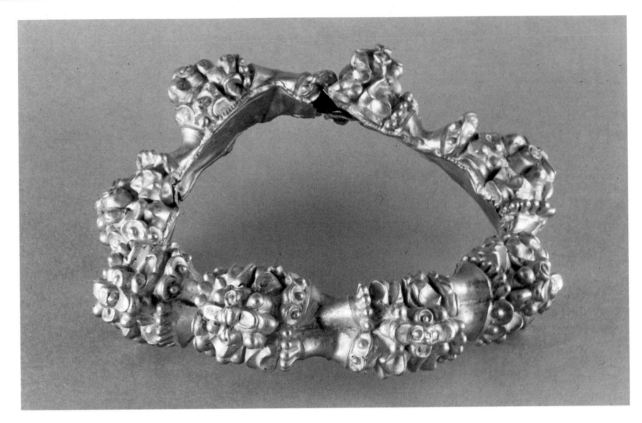

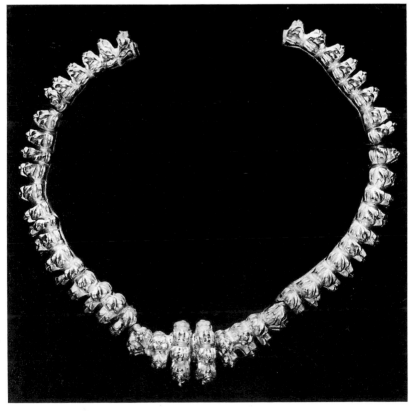

Gold torc
Gajić-Hercegmárok, Yugoslavia
3rd century BC
A torc, with buffer terminals, is
decorated with rosettes in very
pronounced relief.
Diameter: 13.8 cm.
Magyar Nemzeti Múzeum,
Budapest.

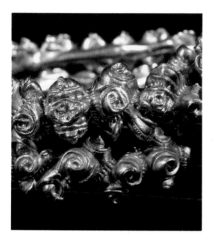

Gold Bracelet
Aurillac (Cantal), France
3rd century BC
A spiral patterned bracelet
garnished with a floral motif.
(Modern assembly.)
Diameter: 7.1 cm.
Cabinet des Médailles,
Bibliothèque Nationale, Paris.

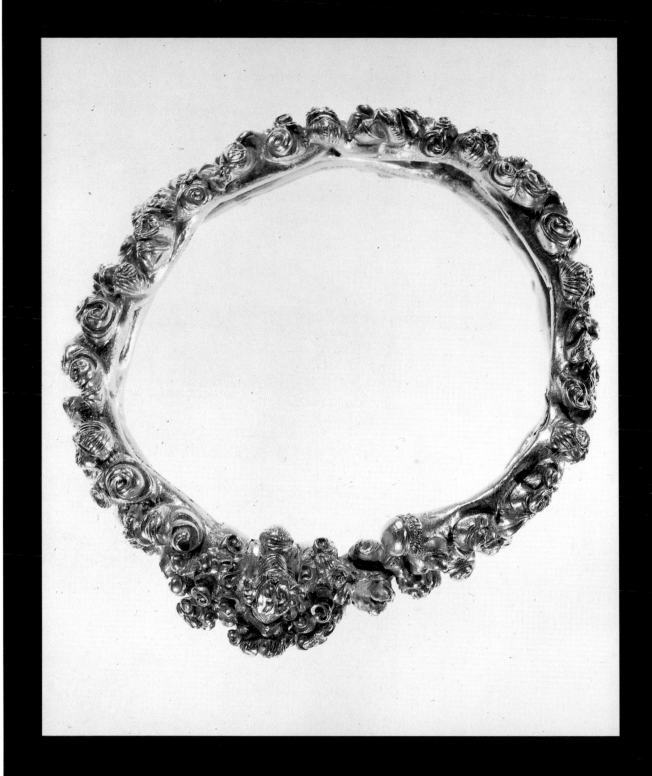

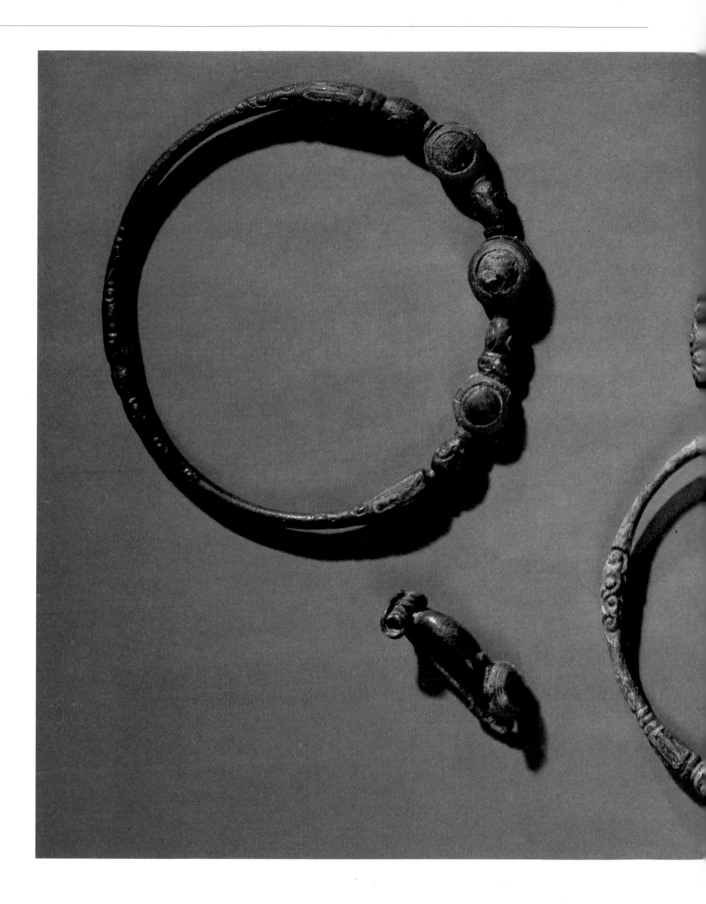

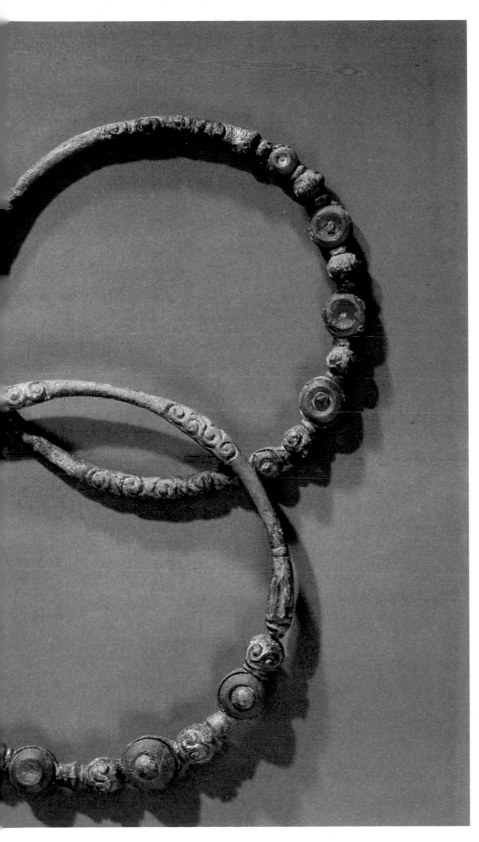

Bronze torc
Nebringen Federal Republic
of Germany
c. 300 BC
A torc with large enamel insets
and knops decorated with
S-motifs.
Diameter: 15.2 cm.
Württembergisches
Landesmuseum, Stuttgart.

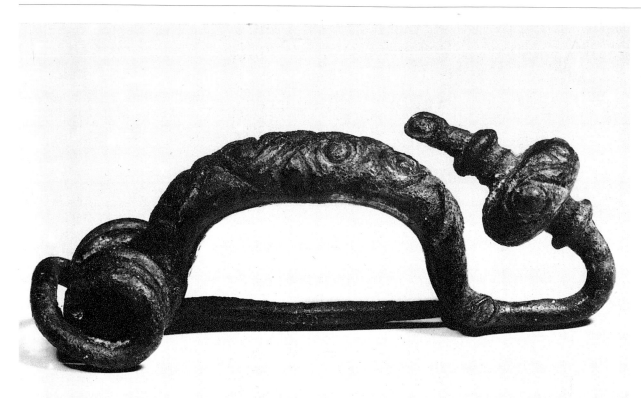

Bronze fibula
Lenešice, Czechoslovakia
c. 300 BC
Decorated with foliage motifs.
Length: 6.3 cm.
Okresní Múzeum, Louny.

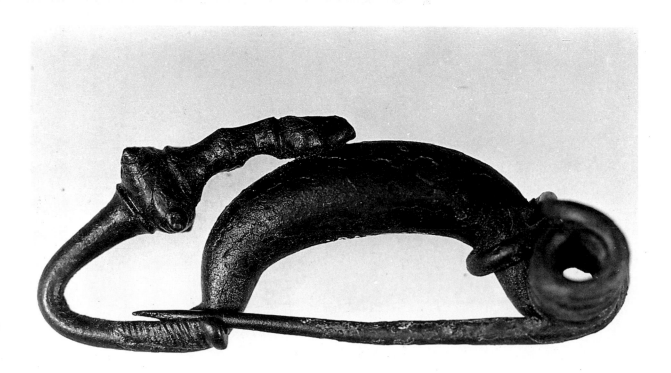

Bronze fibula
Střekov, Czechoslovakia
c. 300 BC
A pair of diverging tendril scrolls
on the knobbed catchplate of a
fibula.
Length: 7.8 cm.
Okresní Múzeum, Litoměřice.

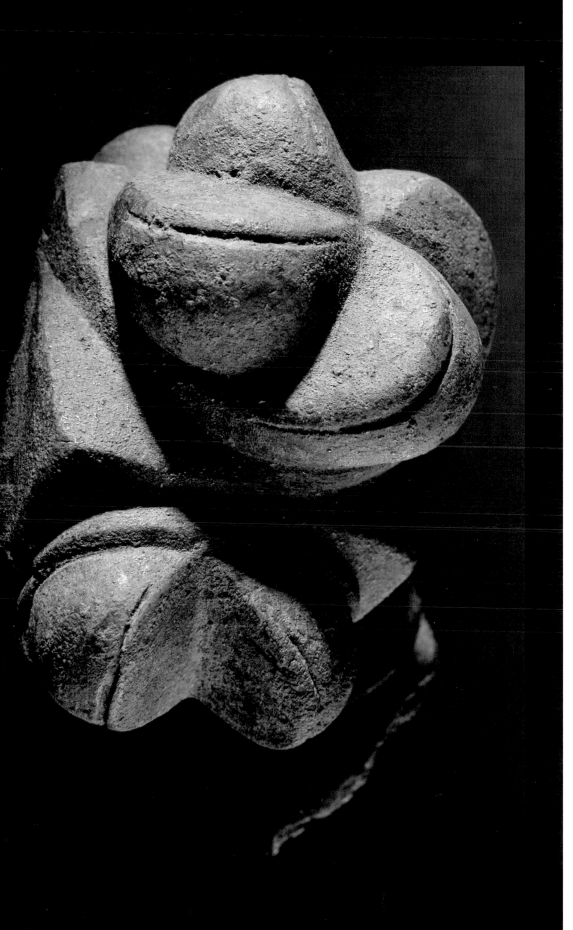

Fragment of a bronze anklet
Uhřice, Czechoslovakia
3rd century BC
Fragment of anklet with "baroque"
decoration in high relief.
Height: c. 6 cm.
Moravské Muzeum, Brno.

Bronze anklets
Staňkovice, Czechoslovakia
3rd century BC
These bronze anklets, discovered in a rich burial, display two alternating patterns, each consisting of a counter clockwise triskele.
Diameter: 8 cm.
Polánkovo Muzeum, Žatec.

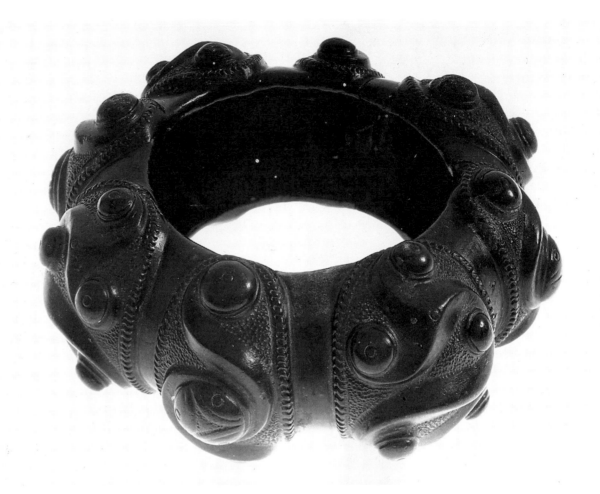

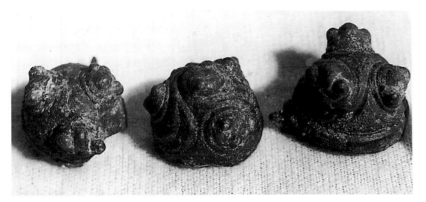

Bronze bracelet
Tarn River, France
3rd century BC
The bronze bracelet consists of eight hollow *ova,* of which four are decorated with linked triskeles and four with S-motifs.
Diameter: 5 cm.
Musée des Antiquités Nationales, Saint-Germain-en-Laye.

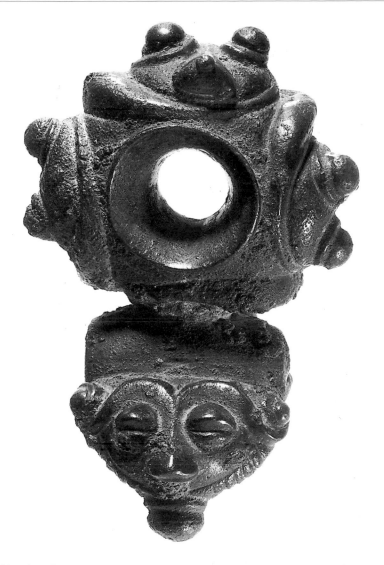

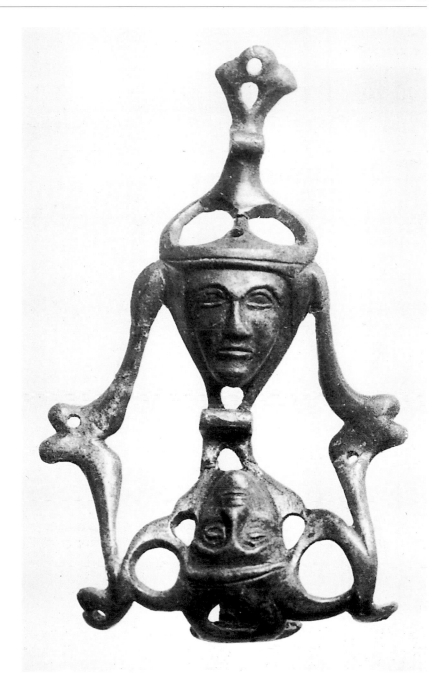

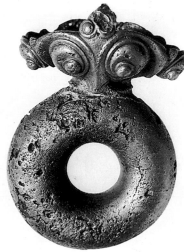

Chariot fitting

France (Paris or Champagne?)
3rd century BC
The width of the large ring is
augmented by a three-faced mask
with bulbous features. The eyes
protrude and the eyebrows curl
around them. Bronze.
Diameter: 5 cm.
Musée des Antiquités Nationales,
Saint-Germain-en-Laye.

Chariot fitting

Mezek, Bulgaria
3rd century BC
Another chariot fitting. This ring is
surmounted by four comic masks
or faces. Bronze.
Height: 9.3 cm.
Narodnija Archeologičeski Muzej,
Sofia.

Bronze vase mount

Brno-Maloměřice, Czechoslovakia
3rd century BC
This fragment of bronze
open-work decoration featuring
two schematized human masks in
relief probably garnished a vase.
Height: 18 cm.
Moravské Muzeum, Brno.

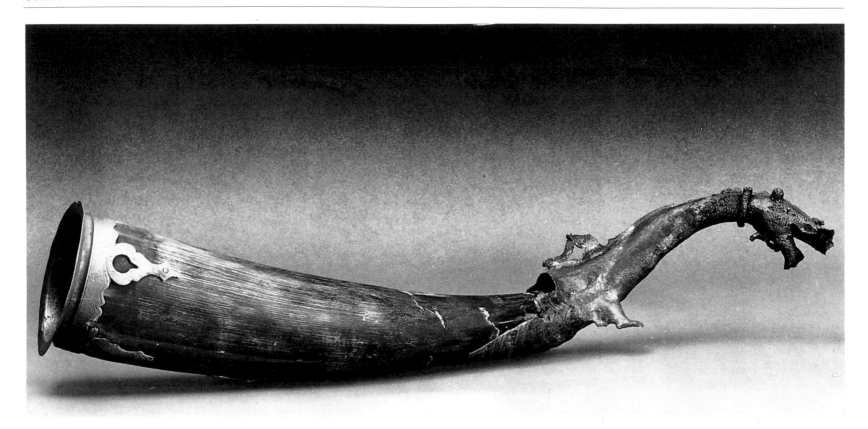

Bronze drinking-horn
Jászbereny-Cseröhalom, Hungary
3rd century BC
Found in a cemetery grave, this drinking-horn takes the form of an open-mouthed dragon. This type of subject matter harks back to a Hellenistic type of *Ketos,* or sea monster.
Height: 20.3 cm.
Damjanich János Múzeum, Szolnok.

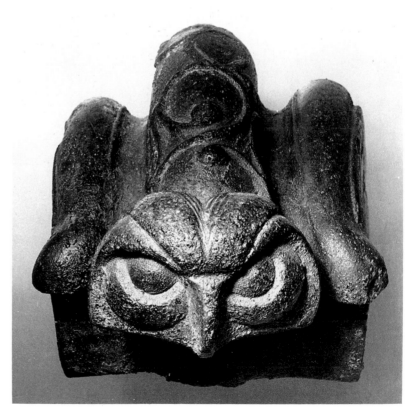

Bronze handle attachment
Brå, Denmark
3rd century BC
This handle attachment belongs to a cauldron and consists of a stylized but expressive owl's head.
Width: 4.2 cm.
Forhistorisk Museum, Moesgård, Højbjerg.

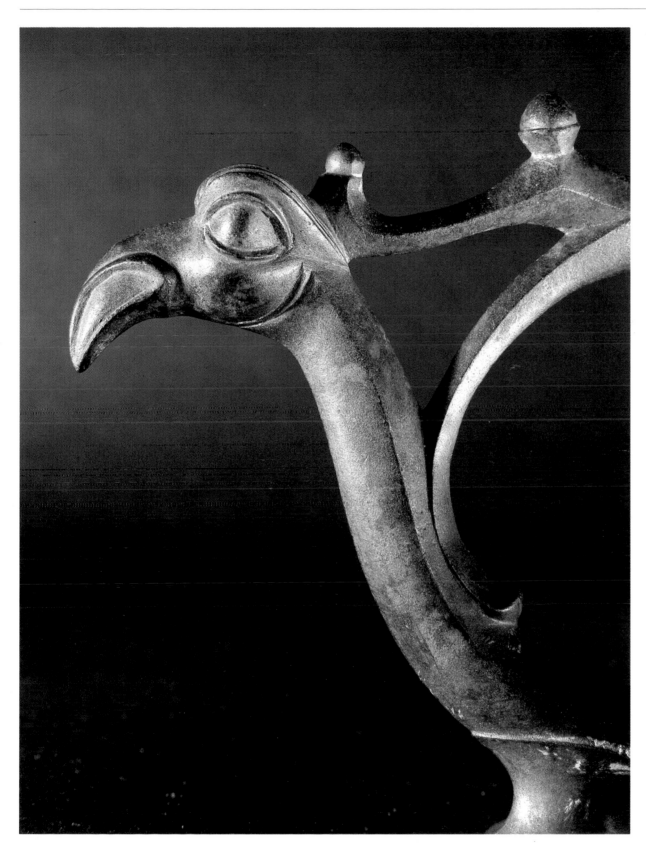

Bronze vase handle (detail)
Brno-Maloměřice, Czechoslovakia
3rd century BC
This ring, forming the handle of
the lid of a vase, represents a
griffin.
Height: 9.7 cm.
Moravské Muzeum, Brno.

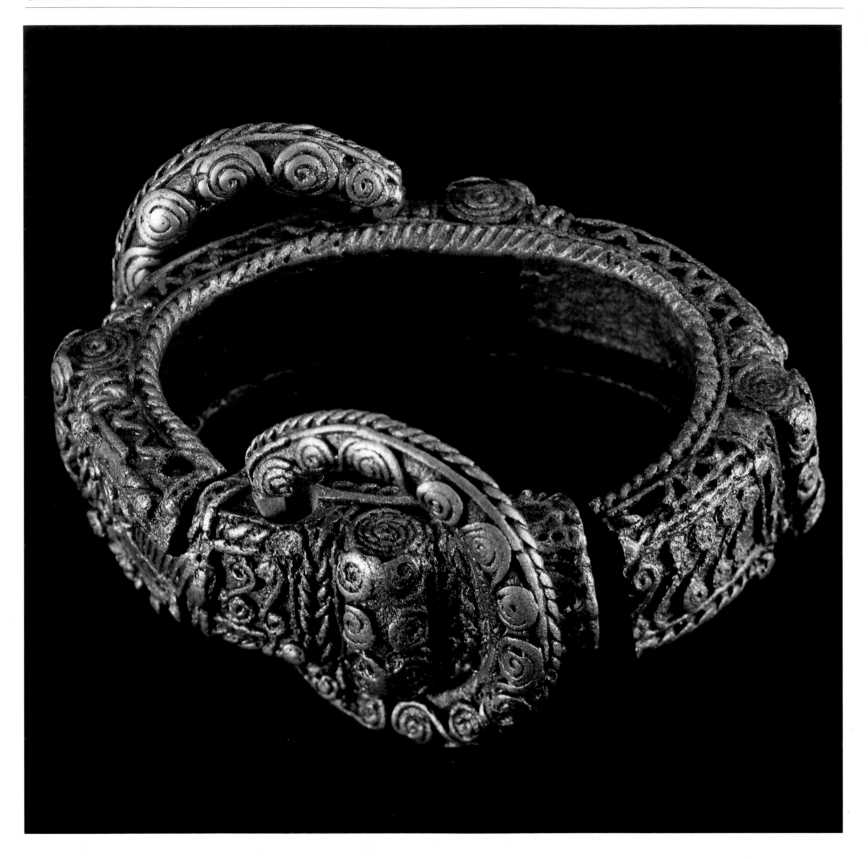

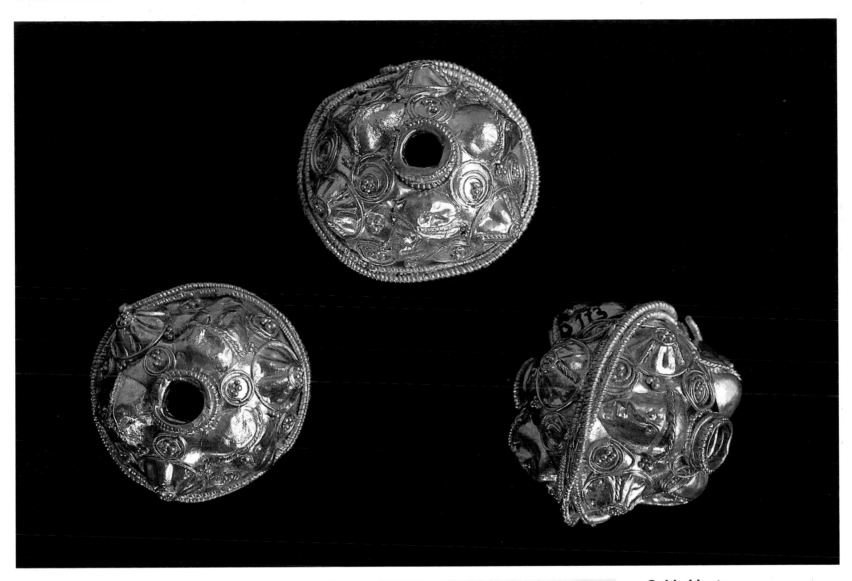

Bronze bracelet
Chotín (Slovakia), Czechoslovakia
3rd century BC
The decoration consists chiefly of
parallel S-motifs and imitates
filigree work.
Diameter: 7.6 cm.
Podunajské Muzeum, Komárno.

Bronze fibula
Mistřín, Czechoslovakia
3rd century BC
This bronze fibula displays
imitation filigree.
Length: c. 6 cm.
Moravské Muzeum, Brno.

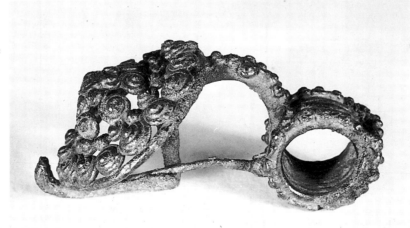

Gold objects
Szárazd-Regöly, Hungary
2nd century BC?
These gold objects or ornaments
from a hoard are decorated with
true filigree-work on the beads
and tubes and with granulation on
the wheels.
Diameter (beads): 2.5-3.5 cm;
(wheels): 2.6-3.2 cm; (tubes):
3.2-3.8 cm.
Magyar Nemzeti Múzeum,
Budapest.

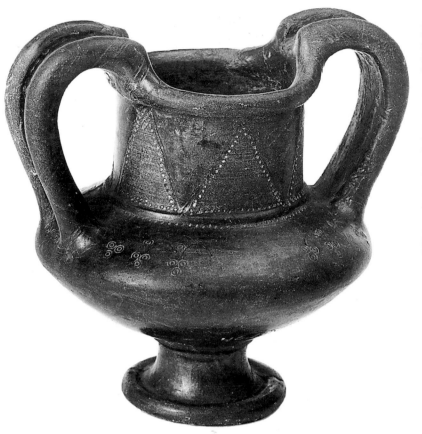

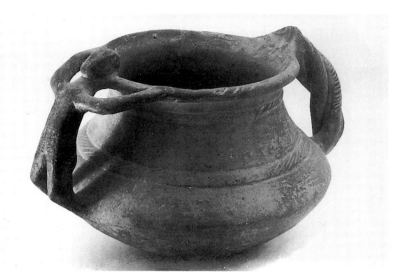

Pottery kanthar
Kakasd, Hungary
3rd century BC
One of the handles is formed of a
plaited motif; the other is replaced
by a human figure holding the
body of the vessel.
Height: 14.3 cm.
Balogh Ádám Múzeum,
Szekszárd.

Pottery kanthara
Kosd, Hungary
400-350 BC
This grave find portrays a
somewhat simplified version of a
Hellenistic kanthar.
Height: 9.5 cm.
Magyar Nemzeti Múzeum,
Budapest.

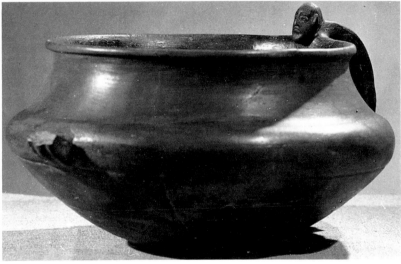

Pottery kanthar
Balatonederics, Hungary
3rd century BC
The unusual handle is surmounted
a human mask with a
moustache.
Height: 18.5 cm.
Balatoni Múzeum, Keszthely.

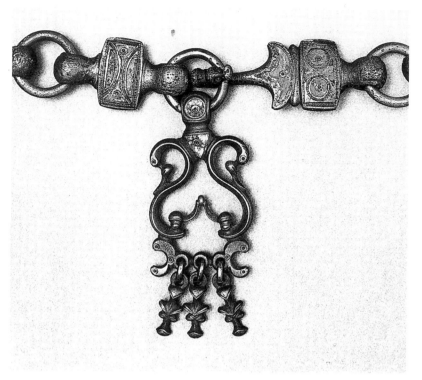

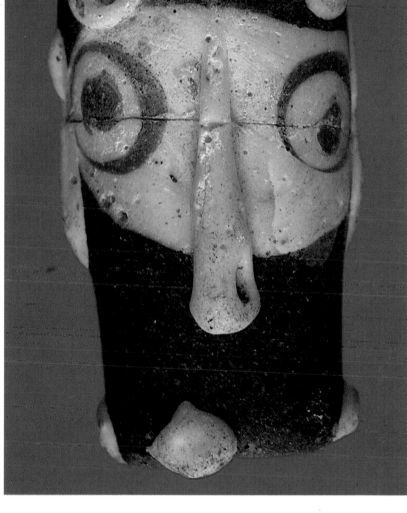

Bronze and enamel pendant
Jaśzberény-Öregerdö, Hungary
c. 200 BC
This pendant for a belt-clasp
consists of highly stylized bird and
animal-heads.
Height: 9.2 cm.
Damjanich Jānos Múzeum,
Szolnok.

Bronze anklet
Batina, Yugoslavia
c. 200 BC
Anklet with three hollow *ova*.
Height: *(ova)* c. 8 cm.
Naturhistorisches Museum,
Vienna.

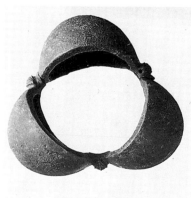

Glass bead, Vác,
Hungary
c. 200 BC
A grave find. This glass bead
takes the form of a human mask
from a Celtic burial.
Height: 4.2 cm.
Vak Bottyán Múzeum, Vác,
Hungary.

Bronze scabbard decoration (detail)
Bann River, Northern Ireland, United Kingdom
c.200 BC
The decoration on this and related scabbards displays elements similar to those found on "Hungarian" swords, including the use of bird heads. But distinctive to the scabbards found in the British Isles is their emphasis on compass-aided design, all-over patterning and sometimes cross-hatching.
Width: 3.4 cm.
British Museum, London.

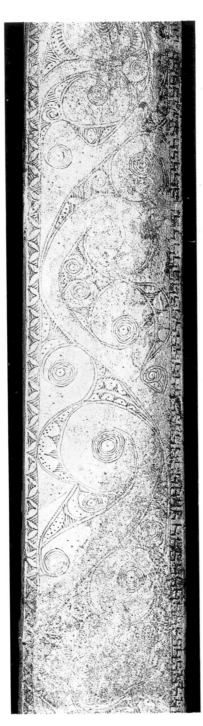

Antler handle (detail)
Fiskerton, Lincolnshire, England, United Kingdom
3rd century BC
A tendril motif, executed in pointillé, decorates the antler handle of an iron rasp.
British Museum, London.

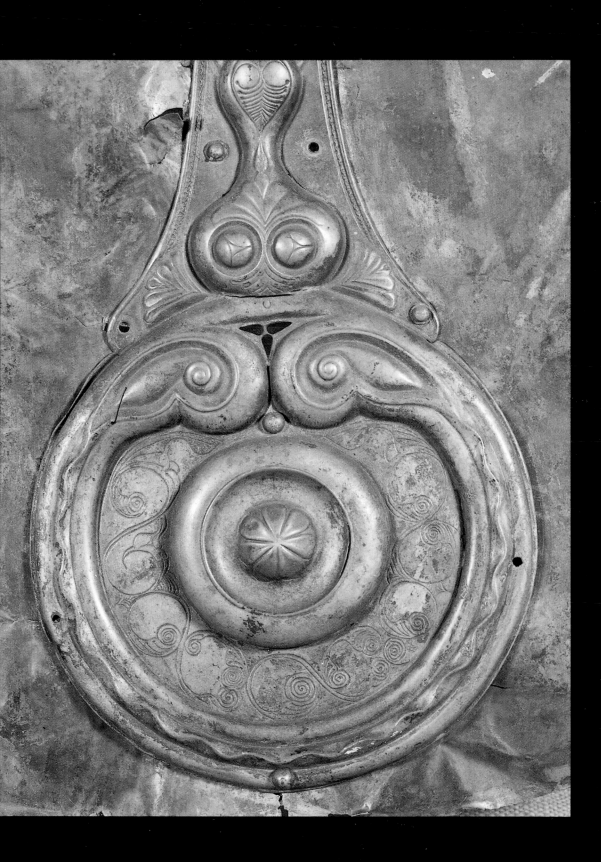

Shield boss
Witham River, England,
United Kingdom
c. 200 BC
One of the terminal roundels
of the shield, this boss bears
engraved ornament, which is
dominated by typically insular
hairspring spirals and "sprung
palmettes", comparable to that
found on Irish scabbards.
Total length: 113 cm.
British Museum, London.

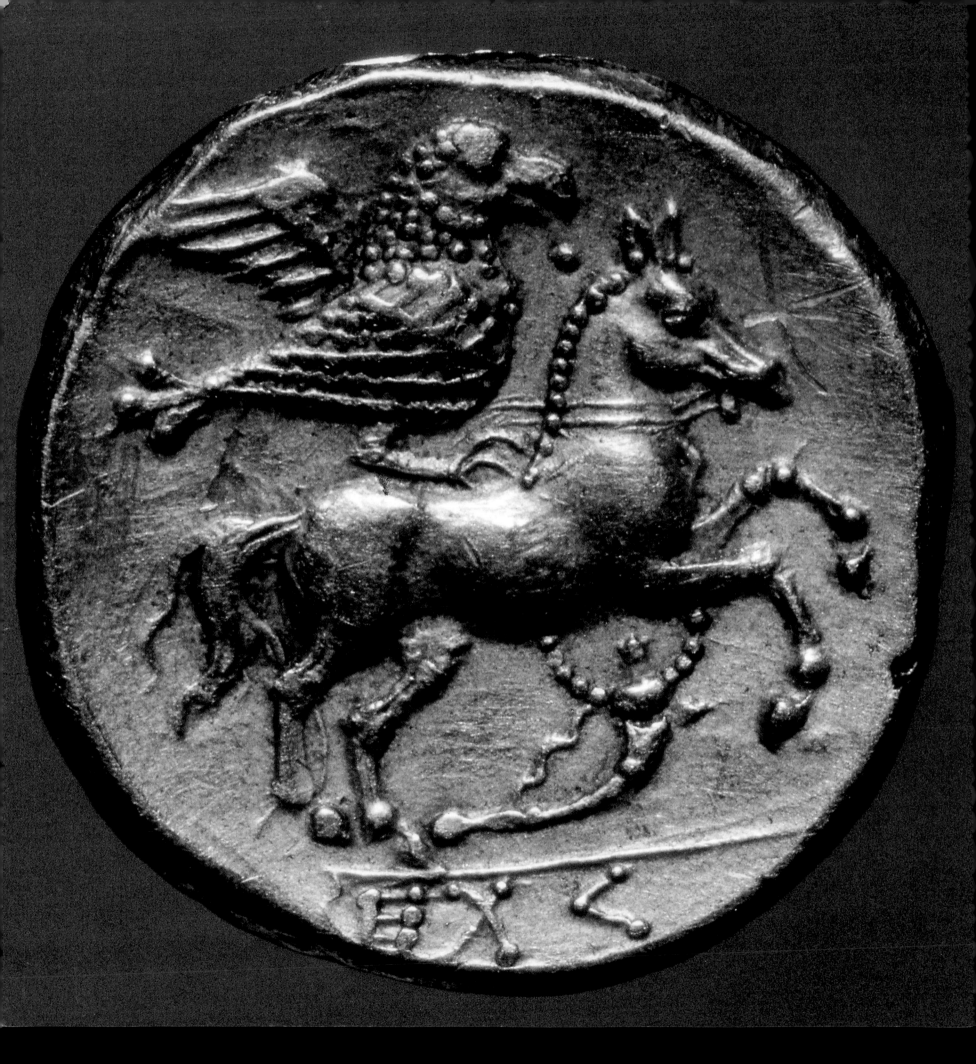

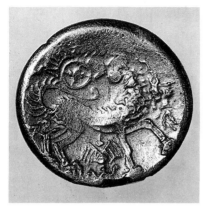

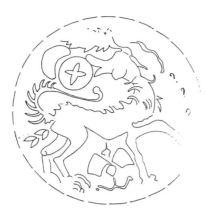

CHAPTER 3

Celtic coins

Gold coin

Armorica, France
Reverse
Only one copy is known and the image is incomplete at the top. A huge wolf turns its face towards the sun and the moon, which it is either about to devour or has just spat out. From its rear end a leafy branch emerges while beneath it an eagle with unfolded wings is depicted poised on a snake. Above the wolf is the trace of a sloping palm and on the right, unexplained emboss occur which may refer to a Gaulish legend, expressing the end and the rebirth of a happy period, perhaps of a reign.
Diameter: 1.7 cm.
Monnaies gauloises, No. 6925.

Gold coin

Armorica
Drawing
The drawing was made both from the coin examined under a binocular miscroscope, and from a photograph enlarged five times. This schematic replica, where the shadow cast by the raised relief is removed, reveals the entire image in all its detail, including those parts not fully reproduced owing to an imperfect hammer blow, as, for instance, the palm near the edge.

Gold coin, reverse

Armorica
2nd/1st century BC
This coin struck with a complete image is one of the masterpieces of Gallic coinage from Brittany. On a galloping horse sits a bird of prey, which lets a ball fall from its beak. Beneath the horse, a fearsome imaginary sea monster can be seen along with a snake, which perhaps has a protective role. Below these animals are three meaningless letters which

are reminiscent of the inscription *Philippou* on the coins of the father of Alexander the Great. The coinage of the latter served as models for the Gauls of the central Celtic territory as is attested to by the fact that the reverse side of their coins usually depicted a horse, based on the two-horse chariot of the "Philippi".
Diameter: 1.9 cm.
Monnaies gauloises, No. 6421 (A5), Cabinet des Médailles, Bibliothèque Nationale, Paris.

Celtic coinage is of interest for the degree of social development it reveals and for the economic and historical evidence it provides. Displaying outstanding artistic skill, often of remarkable aesthetic quality, possessing obvious sociological and religious significance and also a mythological character which is beginning to be recognized, Celtic coins, and particularly those of the Gauls, amply illustrate the degree of cultural development over a period of more than three centuries. Their varied technical and artistic characteristics are due to the fact that they were produced by many tribes, numbering around a hundred in Gaul, with the addition of many others in the rest of Celtic Europe (although not all of them minted coins), which possessed neither national nor political unity.

However, their artistic value is enhanced by this diversity and also by the use of different metals and by the adoption of varying techniques. The exceptional importance of these Celtic coins lies in their having been produced by a vast ethnic group in which it was not common practice to use writing, (which was the preserve of the druids), except for dedications, epitaphs and commercial purposes (e.g. potters' accounts). In the final period of coin manufacture, however, inscriptions occur comprising a name, generally that of the issuing authority. Thus, these coins, through their images, resemble an extremely varied set of miniatures which speak to us employing the language of works of art.

The minting of coins, invented and developed by the Lydians of Asia Minor, by the cities and islands of Greece and by Asia in the seventh century BC, was adopted by the Celts around the end of fourth century BC. It spread from Gaul throughout the whole of middle Europe (except Ireland) from the third century until the end of the first century BC on the mainland and until the second and third century AD in Britain. Most of the coins, melted down for the purpose of reusing the metals, have vanished. However, a large number buried in the ground at the time of various invasions have been discovered in the course of agricultural activities, building work and archaeological excavations. Some of these hidden treasures have yielded as many as 10,000 coins. Other coins have been found in rivers where they had been thrown as tribute to some god. Many coins are in private collections and in the hands of dealers, while the richest coin collection in Europe, containing approximately 15,000 Celtic coins, the majority of which are Gaulish, is housed in the Bibliothèque Nationale, Paris. We may well wonder how many millions of such coins were minted originally.

The coinage of Greece, Etruria and Italy, brought back by conquerors, mercenaries and merchants, served as prototypes for the coins of the Celts. First they were made of gold, then of silver (particularly in the Danubian region) and finally, in the first century BC, of bronze which varied in quality. The subjects, taken from the Classical models which initially were very few in number, were gradually transformed, and through a process of amalgamation and metamorphosis not only new interpretations but also new motifs and subjects appeared. These generally consisted of representations of plant life but also of a few select animals: horse, bull, bird and reptile. The obverse of the coin, the noble side, was dominated by the idealized face of Apollo which probably became that of the chief, no less idealized, but increasingly simplified and almost merging into the decorative elements. On the reverse side, the original two-horse chariot became a horse led and not ridden, and it was soon provided with a human head and sometimes with large, open wings. Mythologically-based Celtic themes appeared on the coins, for example, the wolf devouring the moon and the sun and then regurgitating the vegetation, which may be interpreted as restoring life to the universe. As the size varied according to weight and value, so the subjects were adapted, without being over-simplified, by the skilful engraver. The tendency towards abstraction gradually came into its own.

With the exception of the latest coins minted, which were cast in double moulds, the strip of metal or "planchet" was placed between two deeply incised bronze dies which, on being struck by a hammer, left their imprint simultaneously on the two faces of the coin. The outline of the coin nearly always remained irregular. It is estimated that some 700 coins could

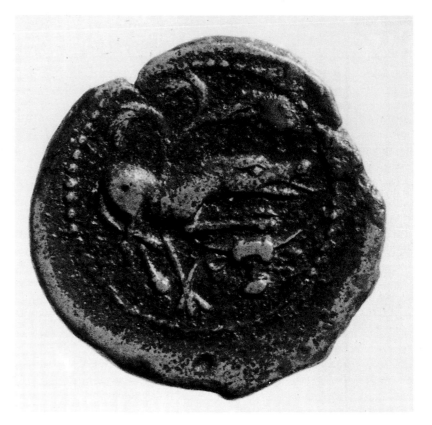

Gold coin

Périgord, France. Reverse
Early 1st century BC
The image with a beaded border is complete but lacks a few details, such as the tip of the back right paw. A wolf, mouth open and tongue protruding, is portrayed outside the forest, symbolized by a tree. Under its raised front paws the presence of the entire head of a bull symbolizes the wolf's usual prey. The wolf had considerable importance in Celtic art for it was the most common enemy, along with the snake, in these heavily wooded regions.
Diameter: 1.3 cm.
Monnaies gauloises, No. 322, Cabinet des Médailles, Bibliothèque Nationale, Paris.

The striking of coins

The coin starts as a strip of metal and the main image is engraved on a bronze *cupel* which is affixed to an iron "die" and is set on a wooden block. The secondary image engraved on the other side is fixed in a mobile iron die held in the hand. The strip of metal is inserted with tongs between the two dies, one immobile, the other mobile. The two sides are thus imprinted at the same time by a single hammer blow. If the blow is inaccurate the image may well be incomplete; then the dies crack and must be changed. Whenever the images are engraved anew the result is always slightly different. There are coins which have been struck in a double mould from poor bronze in batches of ten and although the image is complete it is far less precise.

Gold coin

Armorica. Reverse
2nd/1st century BC
The image is almost complete except for a small part at the top and to the left. The scene portrayed is complex: a horse, apparently in harness, is racing full tilt, driven by a charioteer whose chariot is not represented. In his right hand the man holds a Celtic type of weapon, either a large dagger or a small sword. A strap is loose in front of the man but he does not grasp it. At the other end of the strap is a T-shaped object, a mallet or an uncommon form of the standard, which the rider hurls at his opponent to excite his own horse and frighten those of his enemy. Beneath the horse a large Celtic cauldron, the symbol of abundance and hence of power can be seen. At the bottom, below ground level, are the letters of the Greek inscription *Philippous* which are no longer recognizable. Thus, the symbols alluded to on this coin include the cutting blade of military power, the mallet of the fighting horsemen, the cauldron of prosperity and the ground, which perhaps represents the earth.
Diameter: 1.6 cm.
Monnaies gauloises, No. 6931,
Cabinet des Médailles,
Bibliothèque Nationale, Paris.

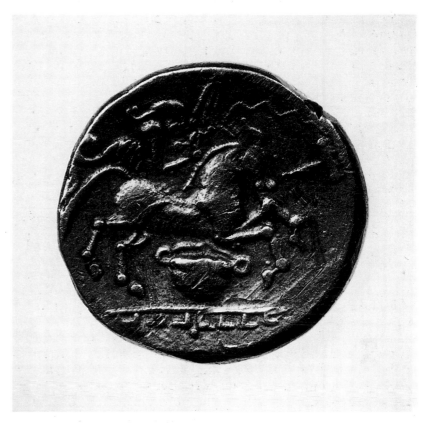

Gold coin

Le Mans region, France
Reverse
3rd/1st century BC
Only one copy of this coin is known. A mare has foaled a colt which is already big and suckling its lean-flanked mother. A monster, semi-terrestrial and semi-aquatic, is about to land on the back of the mare. A palm branch with an ornate cord, symbolizing victory, stands before the male, while inexplicable twigs (bones?) occupy part of the surrounding area. The coin depicts a supernatural, legendary scene, perhaps the early life of a horse destined for an epic future.
Diameter: 2 cm.
Monnaies gauloises, No. 6901,
Cabinet des Médailles,
Bibliothèque Nationale, Paris.

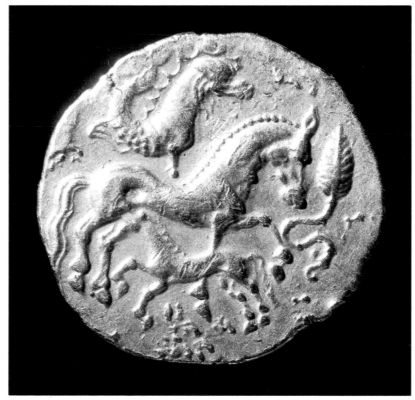

Gold coin

Le Mans region, France
A drawing of the previous item No. 7, enlarged by photography and a binocular microscope. This facsimile highlights the coexistence of realism (the lean-flanked mare, the foal already standing but still thin, being suckled by its mother), expressionism (the decorative treatment of the two horses' manes), magical invention (the monster) and symbolism (the palm).

be struck without changing the dies. The subject depicted on the new dies was the same as that shown on those which had been worn down but, since it was cut by hand, it revealed small differences. Gradually the image became deformed, and misdirected hammer blows could cause part of the image to be omitted from the finished coin. Those who used these coins, which initially were made not only for the treasuries of chiefs and druids but also for the payment of prestigious acquisitions, ransoms, mercenaries and reserves, gradually grew accustomed to these changing forms. These coins did not display the technical perfection of Greek coins nor the almost mechanical regularity of those produced by the large Roman workshops, but on the other hand they were characterized by an inadvertantly acquired changeability which enabled the artist to indulge in a kind of imaginative freedom.

In many cases the image was encircled by a slightly raised smooth or dotted line the diameter of which varied between 1 and 2.5 or 3 cm. The cutting, which required great skill, must have been done with the help of a magnifying glass, although we possess no evidence of its form nor indeed of its existence. The study of the subjects represented on the coins as works of art had been considered to be impossible due to the excessively large number of incomplete or unreadable images, and due to the frequency of irregular hammer blows, which meant that parts of the narrative were altered. However the collaboration of the numismatist and the draughtsman made it possible some years ago to develop a reliable method which reveals an image often intact. The numismatist analyses the struck images in order to identify several coins produced from the same die using the Colbert de Beaulieu method, while the draughtsman then traces an exact copy in the form of an outline drawing of the enlarged incomplete image. Finally, the different exact copies are superimposed and automatically an image which closely reproduces the complete imprint is revealed. This is how the two unblemished images of the coin of Vercingetorix with its inscription were obtained. Thus, henceforth, by tracing an enlarged photograph while checking it under a binocular microscope against the coin itself, a perfect image may be acquired which may well never have been seen by anyone since it was cut on the die and impressed on the coinage blank. Finally, it is possible to publish enlarged photographs of exact copies which often reveal details, undetectable when the small coin is set before the naked eye or even photographed. Drawings, the method preferred by Paul-Marie Duval, are the key to a fuller understanding of Celtic coinage.

The art of Celtic coins, when studied methodically, reveals the success obtained from the amalgamation of subjects, metamorphosis and abstraction. It is the only ancient art imbued with an expressionistic spirit which, at a remove of two thousand years, recalls the painting of the modern era.

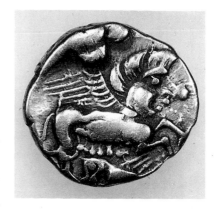

Small gold coin
Possibly Armorican Reverse
Early 1st century BC
Only one copy is known of this coin. A winged supernatural mare is portrayed with a large human head and an excessive number of udders, which are placed all the way along the belly, like those of a sow, a bitch or a female cat. Beneath the mare is a winged colt, only the head, neck and parts of the back and the breast of which are visible. Above the wing and behind the tail appears what may be a shadowy being, very incomplete. Everything here is unreal, legendary, marked by an inventiveness that leaves no scope for naturalism.
Diameter: 1.1 cm.
Monnaies gauloises, No. 6911,
Cabinet des Médailles,
Bibliothèque Nationale, Paris.

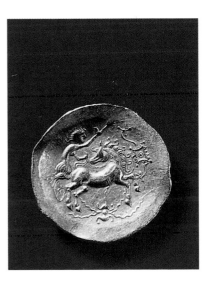

Gold coin
Middle Loire, France
Reverse
2nd century BC
The image is complete and only one copy is known. A female charioteer stands on a chariot only the wheel of which is shown. In her left hand she holds the reins of a moving horse and in her right hand a kind of wand (?). Beneath the horse is a monstrous mollusc, which appears to be seeking to grasp the steed in its tentacles. In front, attached by a strap to the horse's breast, a decorated standard floats in the air along with two ornate cords. This is the standard which is meant to frighten the enemy horses. The woman, bare-breasted, wears a short, puffed-out skirt.
Diameter: 2.5 cm.
Monnaies gauloises, No. 6422,
Cabinet des Médailles,
Bibliothèque Nationale, Paris.

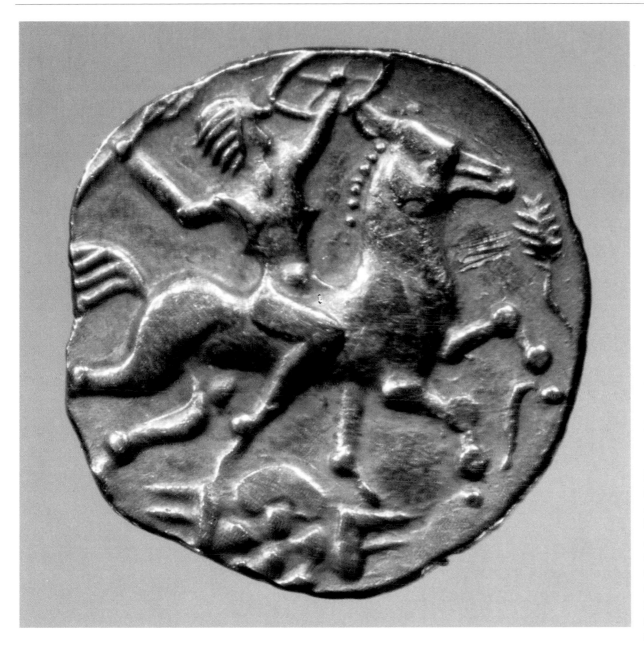

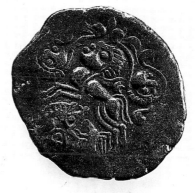

Electrum coin, reverse
(Gold and silver alloy)
Armorica
Early 1st century BC
Above a human-headed, winged
and galloping horse, two small
severed heads attached to leafy
cords form a large symmetrical
motif. Beneath the horse, a
standard displaying a boar in
caricatured style and a heraldic
eagle is represented. Everything
expresses power and the
human-headed horse, a creature
of Armorican mythology, along
with the standard, symbolize the
supernatural strength of the
chief's horsemen, who had the
coin made.
Diameter: 2.2 cm.
BN Monnaies gauloises,
No. 6571, Cabinet des Médailles,
Bibliothèque Nationale, Paris.

Gold coin
Armorica. Reverse
Early 1st century BC
This gold coin belongs to a series
of different dies where the
secondary elements of the subject
vary. A naked woman, wearing a
short cape, is depicted astride a
galloping horse. In her right hand
she holds a lance and in her left an
oval Gallic shield. In front of the
horse is a palm branch with a cord
while below is Jupiter's
six-pronged thunder-bolt. This
is perhaps a superhuman
representation of the Gallic female
warrior, naked like certain Celtic
warriors for reasons of heroic
provocation, and protected by the
Celtic god of lightning (Taranis). A
desire to glorify the Gaulish
cavalry and its victories (note the
palm) explains the portrayal of
such a subject.
Diameter: 2 cm.
Monnaies gauloises, No. 6756,
Cabinet des Médailles,
Bibliothèque Nationale, Paris.

Electrum coin, reverse
Armorica
Early 1st century BC
A human-headed horse racing along is surmounted by an enormous bird of prey, open-clawed and with wings outspread. An object in the shape of a cross attached to a sort of chain floats in the air before and around the human head. This object is a substitute for the standard which would be out of place here since there is no rider to hold it. Beneath the horse is a banner decorated with the image of a bull. The human-headed horse or mare is an Armorican creation and symbolizes the supernatural power of the horsemen, specified here by the standard.
Diameter: 2 cm.
BN Monnaies gauloises,
No. 6578, Cabinet des Médailles,
Bibliothèque Nationale, Paris.

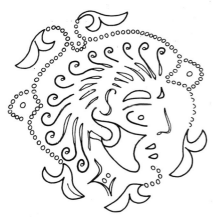

Coinage of the Parisii, obverse
Lutetia, Paris
Early 1st century BC
This is a graphic synthesis of a coin. This technique, accomplished by superimposing exact copies of two incomplete gold coins, which were made from the same die, but which were struck differently, allows the reconstitution of the original image. The head, perhaps that of a woman (although this is fairly rare in Celtic coinage), is crowned with a mass of curly hair, arranged in two symmetrical groups. Two

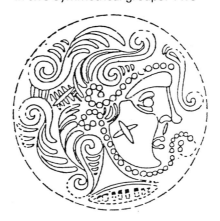

Drawing by graphic synthesis of an Armorican coin
2nd/1st century BC
The complete image (except for two details shown by the dotted lines) is reconstituted from several coins of the same die. A head with curly locks is encircled by beaded cords ending in a pair of leaves. The image is remarkable for its vaguely symmetrical decorative composition in which the axis is not that of the head. Two leaves are isolated beneath the chin. The whole composition is of an elegant lightness.
Diameter: 2 cm.
Musée de Bretagne, Rennes.

lines of beads encircle the face. The series constitutes the last high-quality production of Gallic coinage before the Roman conquest of the country.
Diameter: 2 cm.
Graphic synthesis of two coins from the same die: BN, Monnaies gauloises, No. 7789, Cabinet des Médailles, Bibliothèque Nationale, Paris and Moravské Muzeum Brno.

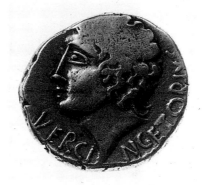 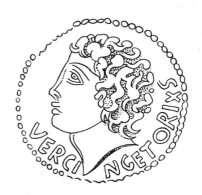

Electrum coin, obverse

Armorica
2nd/1st century BC
The coin is incomplete at the bottom and to the bottom right. A woman's head is portrayed with abundant hair arranged in artistic, symmetrical curls. At the back of the woman's head a small inverted severed head is attached to a beaded twine which covers the head. Below, the same twine indicates that there was also a severed head facing in the other direction. Between these two small heads an unexplained, vertical geometric motif is inserted.
Diameter: 2 cm.
BN Monnaies gauloises,
No. 6578, Cabinet des Médailles, Bibliothèque Nationale, Paris.

Gold coin bearing the name of Vercingetorix, obverse

Auvergne, France
52 BC
The coin is slightly incomplete in the upper part and the hair is poorly rendered. The reverse side shows a rearing horse. This coin is an idealized portrait of a young chief, intended to represent Vercingetorix, the great chief of the Gauls, whose name is inscribed in its Celtic form: VERCINGETORIXS. Twenty-seven coins exist in this series, two of which display the helmeted head broken and eleven of which are from the same die. The style is not Gallic but modelled on the coinage of Greek princes. These twenty-seven coins, which can be dated to 52 BC, constitute the last gold coinage of the Gauls.
Diameter: 1.9 cm.
BN Monnaies gauloises,
No. 3774, Cabinet des Médailles, Bibliothèque Nationale, Paris.

Coin of Vercingetorix

The graphic synthesis of six coins unequally struck from the same die gives the best representation of the original design. (See, for example, the previous item.) This facsimile reveals the totality of a coin representing the Gallic chief as it existed at the time of the hero, slightly more than nineteen hundred years ago.

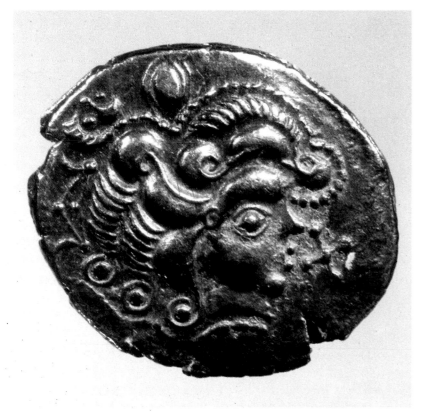

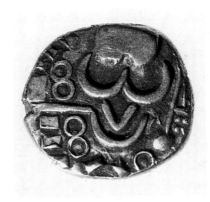

Gold coin, obverse
Northern Gaul
(Metz region) France
Early 1st century BC
The only known copy, this coin
was clearly too small for the die,
for the image is incomplete
around the edge. The
incomprehensible geometric
image represented is an artistic
transformation of a head, perhaps
a woman's head, inspired by the
coinage of Tarentum and of Belgic
Gaul. Various successive
distortions make it possible to
recognize the stylized curls of the
crown at the top and, in the
middle, the modified shape of the
ear. The engraver, following his
own inspiration, produced an
abstract composition with
separate elements of the human
head. Frequent in the north and
south-west of Gaul, this creative
work attests to the Celtic
attraction to abstract art.
Diameter: 1.5 cm.
BN Monnaies gauloises,
No. 8749, Cabinet des Médailles,
Bibliothèque Nationale, Paris.

Coin, reverse
Ribnjačka, Yugoslavia
1st century BC
Imitating a coin of Alexander the
Great, this coin, completely intact,
is known only from this one copy.
A man, apparently naked, is
seated either on a stool decorated
with a curved pattern, or possibly
on a broad-backed chair. A type
of long, curled plume decorates
his headdress and his left arm is
raised, while his hand although
closed, probably holds an unseen
object. His right arm is bent and
he holds a long rod, perhaps a
weapon (despite the seated
position), which passes behind his
body. Seven elements emerge
from the background. At the top
of the coin is a thick ring. To the
top left, a vaguely triangular motif
appears and located slightly
lower, to the right, is an object
shaped like a yoke with spherical
terminals. Below, in front of the
man's knees, a small sitting dog
looks at him while in front of the
dog's face is a plant-like motif
composed of three balls. To the
right, behind the man's head, a
semi-circular motif with a
spherical shape at the top is
represented and at the bottom,
behind the seat, is a semi-circle,
the ends of which may have
extended beyond the edge of the
blank.
Here and there are spherical
shapes with no apparent role.
Diameter: 1.7 cm.
Archeoloski Musej, Zagreb.

Coin, obverse
Ribnjačka, Yugoslavia
Unlike the image on the reverse,
this side reveals the fluidity of the
finest western Celtic style. The
head, with an abundance of curls,
is probably female. The supple
branch with several spheres,
which appears to emerge from the
back of her neck, merges towards
the front with the neckline.
Beneath this branch is another
leafy branch and above the
forehead a curl continues through
the flowing line of the nose. This
mixture of plant life and human
features is typical of Celtic art.

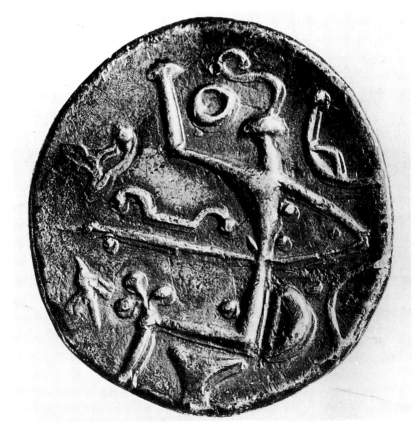

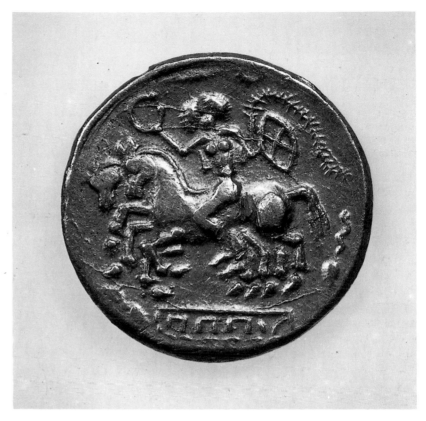

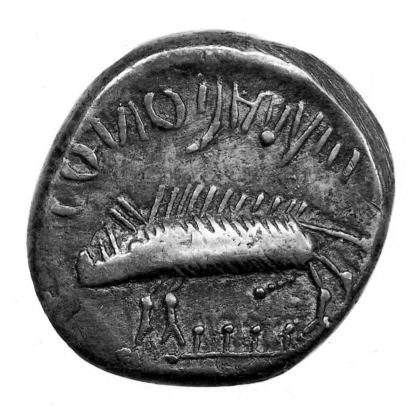

Silver coin, reverse

Pannonia, Hungary and Yugoslavia
Early 1st century BC
Almost intact, this coin displays a boar, more angular in appearance than those on Gaulish coins. The bristles stand on end, the belly and tail are rectilinear, and probably also the ears(?) and tusks(?). The genitalia are represented by a succession of balls. Beneath the boar, on the ground, are four vertical sticks with spherical shapes at the end. Above is an inscription, not completely legible: COVIO. A.V.III, sometimes interpreted as *Coviomarus*. The style, although not realistic, is hardly caricatural and it lacks totally the flowing lines of Celtic art.
Diameter: 1.8 cm.
Monnaies gauloises, No. 10138, Cabinet des Médailles, Bibliothèque Nationale, Paris.

Gold coin, reverse

Amiens region, France
2nd century BC
This coin, completely intact, is known from two copies made from the same die, one in Paris and the other in London. Above a rectilinear ground line formed by an inset containing the deformed letters of the name *Philippou*, two walking horses are represented one carrying a horsewoman, naked but for a belt and a short cape, riding astride. Depicted as a triumphant warrior, she brandishes in her left hand a shield and a kind of long palm-leaf(?), clumsily rendered, and in her right hand a large torc. Behind the horse, a snake is to be seen with its head pointing downwards. To the left, at the edge of the coin (this slightly raised surface is almost entirely visible), is a stylized plant ornament not easily interpreted. The horsewoman has a schematised round face and a mass of curly hair with a parting down the middle.
Diameter: 1.5 cm.
Monnaies gauloises, 10379 = 10303 A, Cabinet des Médailles, Bibliothèque Nationale, Paris.

81

Gold coin, obverse
Le Mans region
2nd century BC
The composition of the subject on this coin, which is almost intact, is skilful and intricate. The human head portrayed is small, leaving room for a symmetrical arrangement located off-centre to the left. This symmetrical composition is formed of four small heads attached to a large one by gracefully curved and beaded lines. These small "severed heads" face outwards. Beneath the central head is a horizontal plane of curvilinear motifs, as symmetrical as the main subject is asymmetrical. The sense of movement, suggested by the configuration of the small heads, is perhaps related to the struggle which they symbolize.
Diameter: 2 cm.
Monnaies gauloises, 6880, Cabinet des Médailles, Bibliothèque Nationale, Paris.

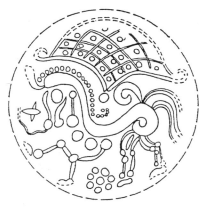

Gold coins of the Parisii, reverse
Lutetia (Paris)
Early 1st century BC
A graphic synthesis was created by superimposing facsimiles of two incomplete gold coins which were made from the same die but were struck differently. The traditional horse presents certain peculiarities. The front legs, for example, are represented as one for the sake of convenience. From the hindquarters rises a loop, probably all that remains of the outline of a second horse which is represented in the Greek model of the two-horse chariot. From the nostrils emerges an incomplete cord and above the steed is a sort of net, which contains balls. This series of coins, the last example of fine Celtic coinage, is unique of its kind.
Diameter: 2 cm.

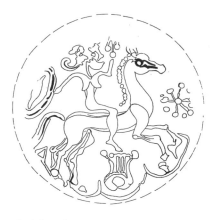

Gold coin, reverse
Armorica
Early 1st century BC
This coin, a facsimile, is incomplete at the top and to the left. A naked woman sits astride a galloping horse and bounces upwards. Her breasts suggest the corners of the short cape shown on other coins in the series. In her right hand she holds an incomplete oval shield and, in her left, a small sword, the blade of which has not been preserved as the coin was imperfectly struck. Beneath the horse is a long, thick fetter strap, which has become undone and a lyre, the customary instrument of Apollo. However in this case its significance is unknown, while in front of the steed is a rosette.
Diameter: 2 cm.

Gold coin, obverse
Vexin region (north of Paris)
Early 1st century BC
Except at the top and to the left this coin is incomplete. The image portrays the front part of a large head in profile with a huge eye, but without a forehead and apparently with its mouth wide open. It is either a sea animal, a man with a deliberately deformed head, or more likely a monster, perhaps from the sea, with gaping jaws. A Z-shaped figure in front of the mouth could be a small, decapitated man kneeling and stretching out an arm. The rest of the image comprises either a sun

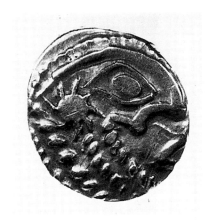

turning towards the right or a large imaginary shellfish and three parallel beaded lines, which perhaps belong to the main part of the head.
Diameter: 1.8 cm.
Monnaies gauloises, No. 7231, Cabinet des Médailles, Bibliothèque Nationale, Paris.

Gold coin, obverse

Wornesh (Surrey),
United Kingdom
Early 1st century BC
Although very incomplete this
coin presents two very different
styles. The reverse shows the
traditional Celtic horse, with
turning sun and wheel, imitated
from coins imported from the
region of Amiens (Belgic Gaul).
The obverse, shown here,
replaces the human head by a
cruciform geometric motif,
decorated with straight lines,
parallel pellet forms and two small
"moons" on either side of the
centre. This coin shows the
influence of classical Roman art,
which is altogether alien to Celtic
art proper, and this development
and this mixture are characteristic
of the coinage and, more
generally, of the art of Britain.
Diameter: 1.75 cm.
British Museum, London.

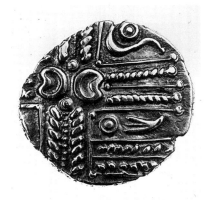

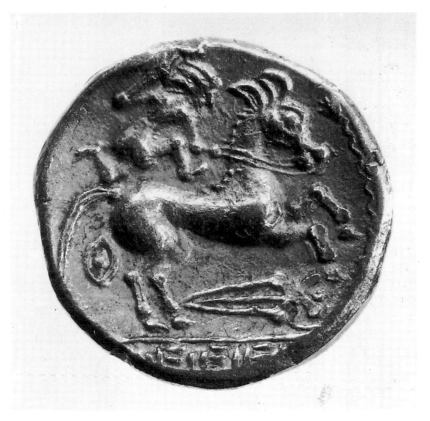

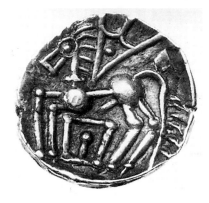

Silver coin, reverse

Aquitaine, France
2nd/1st century BC
Complete except at the very top
and bottom, this coin depicts a
winged horse, at rest and
standing on the ground. Between
its bent legs an imperfect square
is to be found, made up of stalks
with rounded ends. Another,
similar stalk is represented on the
ground line. The style is
remarkably angular, almost like a
caricature of the animal, and yet
true to life in its proportions.
Diameter: 1.5 cm.
Monnaies gauloises, No. 3589,
Cabinet des Médailles,
Bibliothèque Nationale, Paris.

Gold coin, reverse

Cotentin (Armorica)
2nd century BC
Almost complete except at the
top, this coin displays a rearing
horse, the reins of which are held
by a small, naked man leaping
above its hindquarters. Beneath
the horse is located a short sword
with a simplified anthropomorphic
handle attached to the end of a
long strap. This strap reappears in
front of the animal's head. Behind
the horse, a pointed diamond
shape in the middle of a convex
circle seems to represent a
miniature shield with four attached
rods. The man's raised right hand
seems to be brandishing
something. Beneath the
groundline are ill-formed letters,
which derive from *Philippou*
inscribed on the Greek coins of
Philip of Macedonia. The leaping
figure may represent a sporting
exercise connected with military
training rather than an acrobatic
activity.
Diameter: 1.7 cm.
Monnaies gauloises, No. 6932,
Cabinet des Médailles,
Bibliothèque Nationale, Paris.

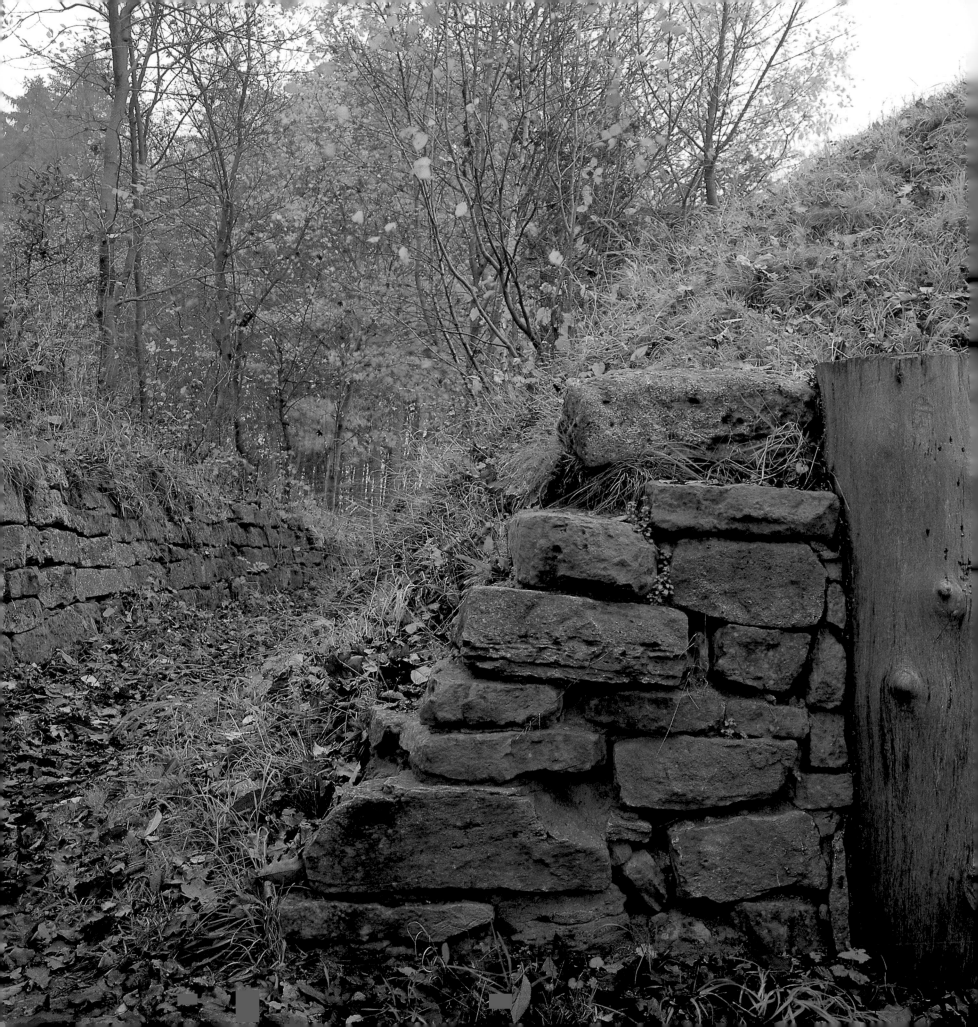

The end of Celtic art on the continent. Later Celtic art in the southern region

Entrance through the latest rampart of the oppidum of Finsterlohr
(Baden-Würtemberg),
Federal Republic of Germany
This was probably constructed around the beginning of the last century BC. The outer face which is partially preserved, was reinforced by vertical posts (reconstructed in this section exposed by the excavation) and supported a rampart of earth which covered the remains of two earlier phases.

T he art of the end of the Iron Age, when Celtic Europe, under pressure from the south, the east and the north, was on the defensive, has not yet aroused the same keen interest which is shown by specialists in early Celtic art. The absence of any overall study covering the last two centuries BC and the aftermath of the Celtic artistic tradition at the beginning of our era is regrettable. It should be mentioned, however, that exceptional finds, such as that at Fellbach-Schmiden, open up avenues of research which did not exist ten or twenty years ago.

The main explanation is undoubtedly to be found in the radical change in the material evidence available, i.e. in the archaeological sources. In the second and first centuries BC burials became rare and were to leave hardly any trace in a large part of the Celtic world—chiefly owing to the wide-spread practice of cremation. Domestic accoutrements, often of humble appearance, therefore take the place of the richly decorated ornaments and weapons of the preceding two or three centuries. In addition to this change in funeral customs, there was a gradual but fundamental change in Celtic society, due in part to the influence of the Roman or Romanized world. Before the end of the third century BC this transformation was to lead to the development of the oppida, the first fortified urban settlements north of the Alps, which flourished in the second and first centuries BC.

85

In contrast with the homogeneity of the artifacts earlier in use, a wide diversity took place in the artistic activity of the "oppidum" civilization. This variety is responsible undoubtedly for the apparent disintegration of a sophiscated art with a strictly regulated mode of expression, which is disconcerting for the researcher who is without comparable material, and for the impression this gives of a break with the past. Continuity in the way of thinking and in the ideology of the Celts was, however, to take other forms. Their coinage, in particular, enables us to follow the evolution of an imaginative and dynamic style, capable of adapting motifs and transforming them into themes consistent with the Celtic vision. The quality of this artistic expression never falls below the "level" attained by the earlier works.

The Celtic view of the world was to be expressed in the most varied materials and in objects serving a multitude of purposes. This seems to be a new factor, although this may be an illusion, given the sources at our disposal.

A new category which might be described as "industrial art"—painted pottery, for instance—emerged and served as a means of expression for the development of Celtic art. However, some of this work is known only through objects that were used for long periods or discarded in the rubbish-pits of the dwellings, and no longer through "luxury" or "prestige" products such as those found in the burials of earlier times. The skill of the craftsmen—blacksmiths, bronze-smiths, coppersmiths, sculptors in wood or stone, glass-makers—is unquestionable nonetheless and an ornamental tradition can be traced particularly in the metal remains, for example sword scabbards. Generally speaking, the style displayed on such objects tends towards a certain sobriety, where the decoration is flatter and the forms are defined by means of strict lines. Increasing use is made of techniques involving the use of gold or silver wire, bronze or iron wire is found in place of the lost wax process. Cloisonné work becomes increasingly common. The compositions are much simpler, but the vivacity, power and originality of Celtic expression are preserved.

This evolution, which followed a dynamic internal logic, underwent various influences—from the east that of the Eastern Celts and from the south that of Cisalpine Gaul. Initially, motifs were taken over and assimilated into the Celtic way but later the artists were submerged, by Rome in particular, and lost their creative force. With the new economic order and the gradual establishment of a new way of life—especially as a result of imports—art underwent a transformation.

The most striking and original feature of the art of the Celts was perhaps the return of the human figure. Artists, less reluctant to represent people realistically and following the example of Mediterranean cultures, revealed a secret and

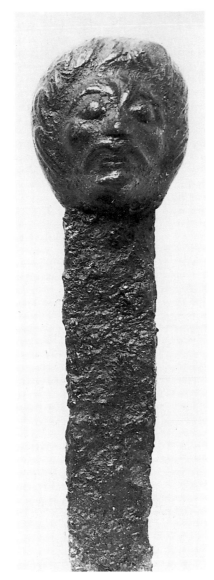

Iron linch-pin
Stradonice (Bohemia),
Czechoslovakia
1st century BC
This iron linch-pin comes from the axle of a chariot, which was discovered in an oppidum. The pin is surmounted by a head cast in bronze. The walrus moustache, curly hair and raised eyebrows convey the new form of realistic expression.
Height of the head: 3.5 cm.
Naturhistorisches Museum, Vienna.

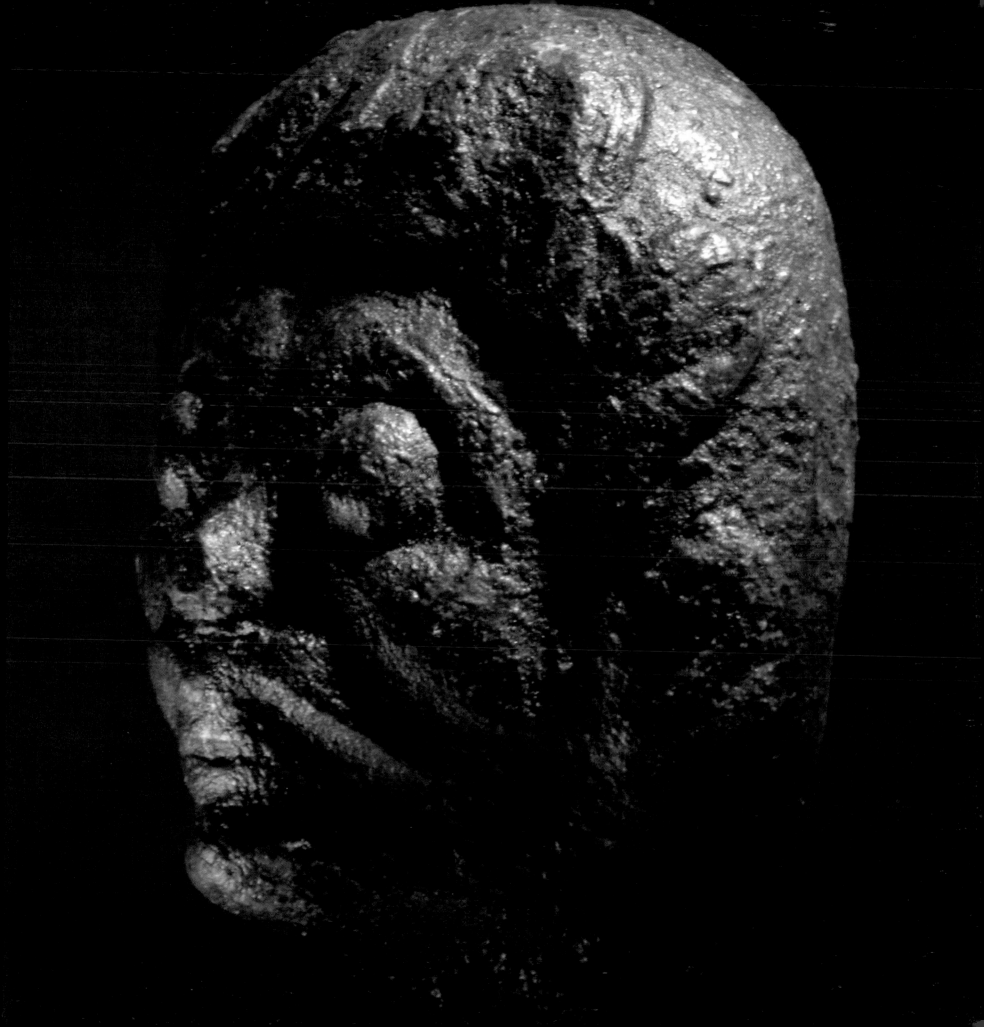

magical world, which formerly had been left to the imagination. Gradually, they adapted these figures, which in some cases display a high degree of syncretism. Works sculpted in stone or in wood become more numerous and apart from the Celtic peculiarities in the treatment of hairstyle, moustache or ornaments, such as the well known torcs, the stylistic composition of the figures is generally distinguished by a new, naturalistic touch. The representation of animals developed simultaneously in small-scale sculpted works and the members of the Celtic pantheon were portrayed always in a strictly realistic fashion, as for instance the god Cernunnos in the form of a deer.

From the early first century BC onwards, the creative powers of the Celtic artist waned and at the very beginning of our era they seem to disappear completely as a result of the massive action undertaken by Rome north and east of the Alps. A new ideology was installed and art took on a new, openly official significance. In spite of everything, the Celtic genius peers through in sculpted figures such as votive offerings in wood and the motifs painted on pottery, to say nothing of the actual forms. An artistic tradition survived and persisted, ghostlike, in the first century and the greater part of the second century of our era, and was to reappear sporadically in the second and third centuries AD, for instance, in the decoration of pottery, mainly in Gaul. Thereafter, the post-Roman invasions were to leave their mark. On the Continent, in contrast with the insular world, Celtic art died a lingering death, except in the most inaccessible parts of the Alps, where traces of it may still be discerned today in the folklore.

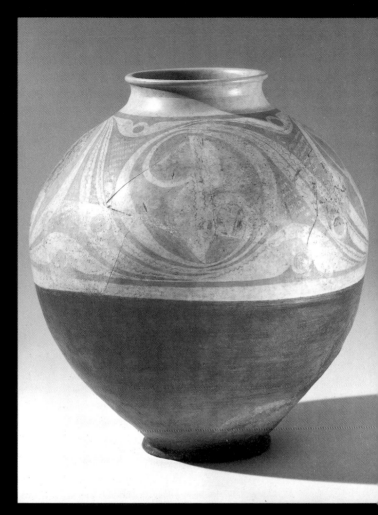

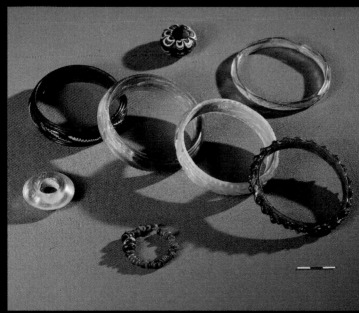

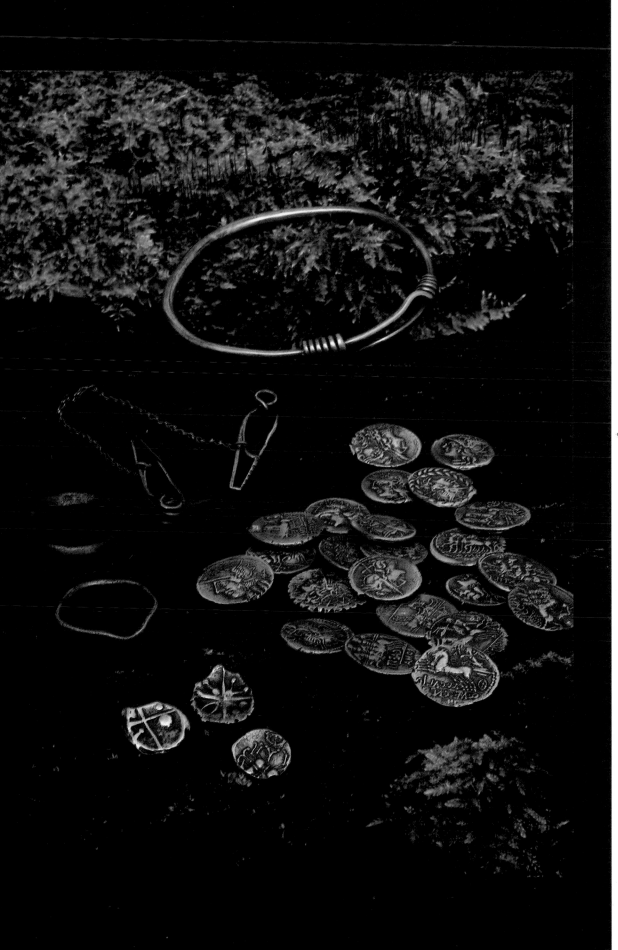

Pottery flask
Basle, Switzerland
c. 100 BC
Unearthed in a rubbish-pit of the Gasfabrik settlement, this pottery flask is decorated with a curvilinear pattern, consisting of circles and S-motifs in the upper part of the vessel. The flask is painted in dark colours on a white field.
Height: 37.5 cm.
Historisches Museum, Basle.

Glass bracelets and beads
Berne Canton, Switzerland
2nd century BC
The craftsman gave free rein to his penchant for coloured effects with these grave finds.
Diameter (average): 7 cm.
Bernisches Historiches Museum, Borne.

Personal ornaments
Lauterach, Austria
Late 2nd century BC
This collection of a silver bracelet, a silver ring, two silver fibulae joined by a small chain, and a bronze ring, are representative of the simplicity and austerity of the decorative arts of the end of the Celtic period. Three Celtic coins and twenty-three Roman silver denarii accompanied this offering.
Diameter (bracelet): 8.9 cm.
Vorarlberger Landesmuseum, Bregenz.

Cheek-piece of an enamelled bronze helmet
Šmarjeta, Yugoslavia
1st century BC
Decorated with a highly stylized representation of a crane or stork, this helmet was peculiar to the Slovenian Celts at the beginning of the Roman era.
Height: 11 cm.
Národní Muzej, Ljubljana.

Anthropomorphic bronze sword-hilt
Châtillon-sur-Indre (Indre), France
1st century BC
Although the face and the detail of the hair show a marked Mediterranean influence, the form of the hilt and consequently the posture of the figure, are Celtic.
Length of hilt: 14 cm.
Musée Thomas Dobrée, Nantes.

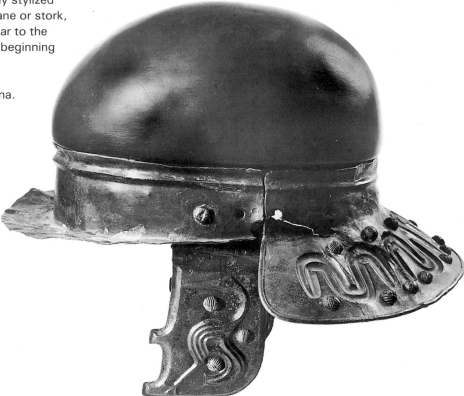

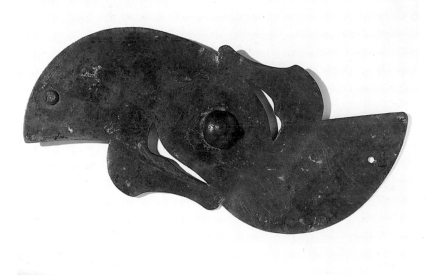

Bronze openwork plaque
La Tène (Neuchâtel Canton), Switzerland
2nd century BC
These two horses' heads, turned face-to-face, are presumably from a shield ornament. They were worked up from the sheet-metal by means of a refined technique.
Length: 22 cm.
Musée Schwab, Bienne.

Bronze boar
Báta, Hungary
1st century BC
Length: 10.9 cm
Magyar Nemzeti Múzeum,
Budapest.

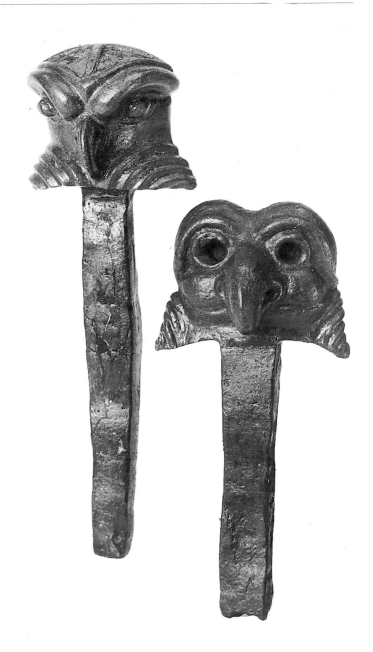

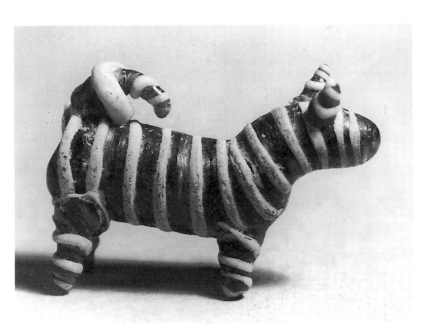

Glass dog
Wallertheim
Federal Republic of Germany
2nd century BC
Found in a warrior's grave, this
tiny dog is composed of bluish
glass paste.
Length: 2.1 cm.
Mittelrheinisches Landesmuseum,
Mainz.

Bronze linch-pin
Manching (Bavaria), Federal
Republic of Germany
c. 100 BC
From a chariot discovered in an
oppidum, the pin is capped by a
powerfully expressive owl.
Height: 3.3 cm.
Prähistorische Staatssammlung,
Munich.

91

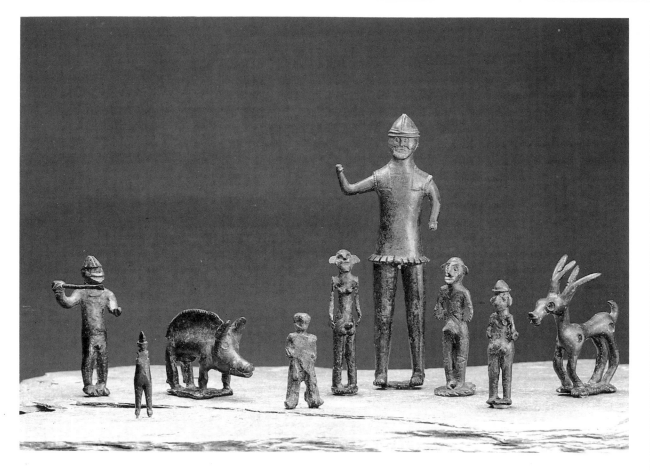

Bronze figurines
Balzers, Liechtenstein
c. 100 BC
These figurines, helmeted and armoured warriors, a deer and a boar, probably were cult objects, from the fringe of the Celtic world. Rhaetic.
Height: 12.7 cm.
Liechtensteinisches Landesmuseum, Vaduz.

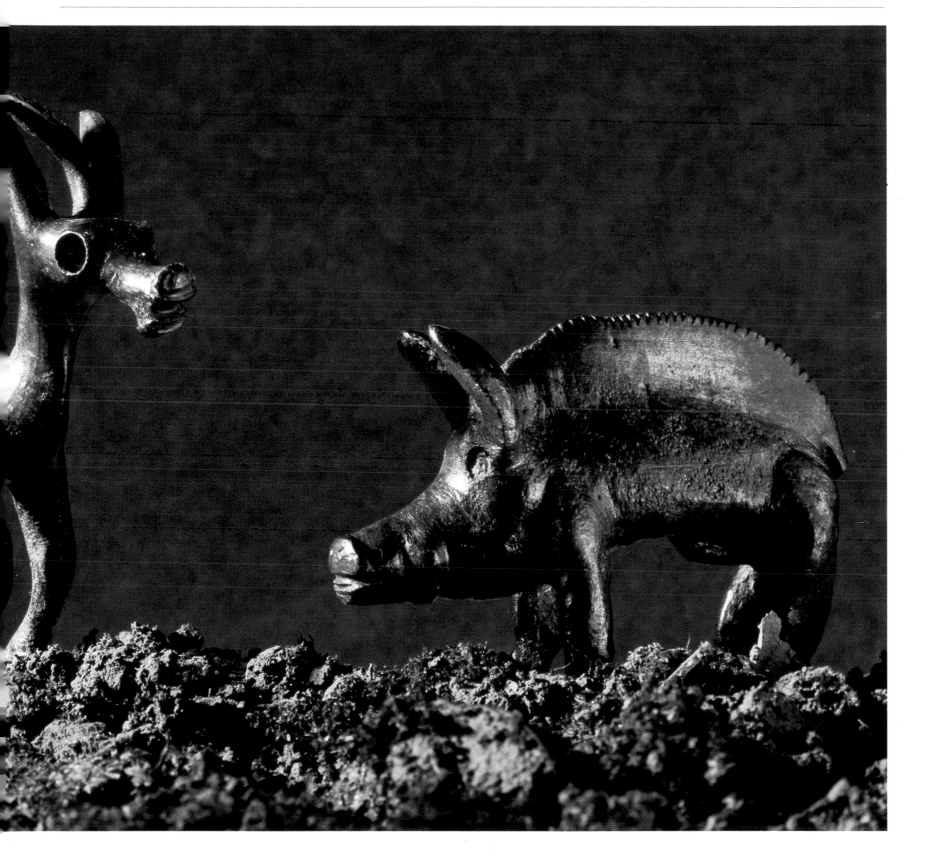

Wooden sculpture

Fellbach-Schmiden,
Federal Republic of Germany
2nd century BC
This sculpture, found in a well and
carved out of oak, was probably
associated with the god
Cernunnos, but only fragments of
the composition survive, including
the two opposing rams or goats.
This type of composition is found
both in the oriental motif of two
ibexes, and in the iconography of
the Tree of Life and the Lord of
the Beasts. Many Celtic works
such as the Korisios sword found
at Port, Switzerland, and the
scabbard found at Mihovo,
Yugoslavia depict this same
composition.
Height: 18.2 cm.
Württembergisches
Landesmuseum, Stuttgart.

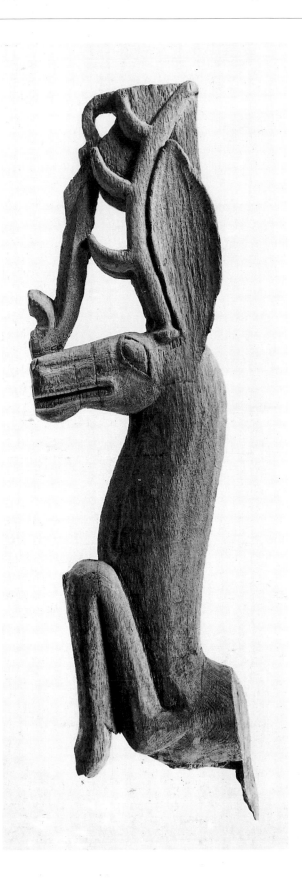

Stone sculpture of male head

Mšecké Žehrovice (Bohemia),
Czechoslovakia
c. 100 BC
Found in an enclosure presumed
to be sacred, both the
schematization of the facial
features and the presence of the
torc are typically Celtic.
Height: 25 cm.
Národní Muzeum, Prague.

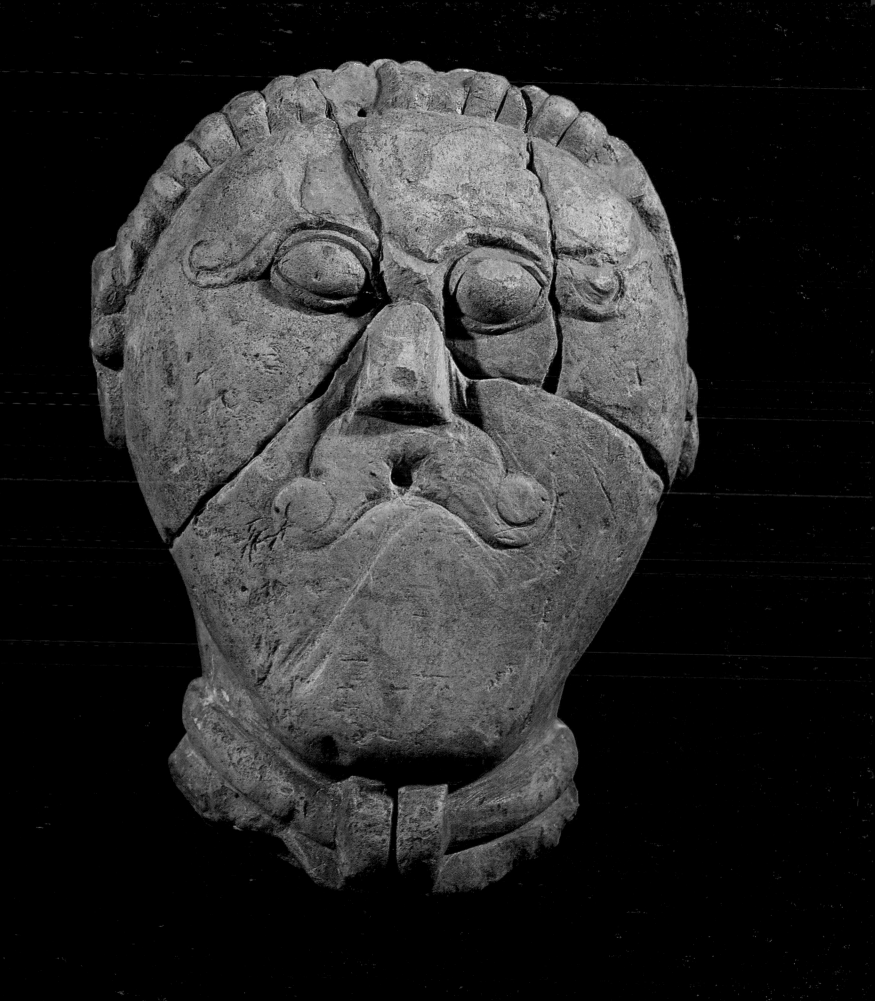

Silver cauldron
Gundestrup (Jutland), Denmark
c. 100 BC
Deposited in a dismantled form
in a peat-bog as a votive offering,
this cauldron probably originated
in the Balkans, on the eastern
edge of the Celtic world, and is
the most informative physical
representation of Celtic
mythology.
Overall diameter: 69 cm.
Nationalmuseet, Copenhagen.

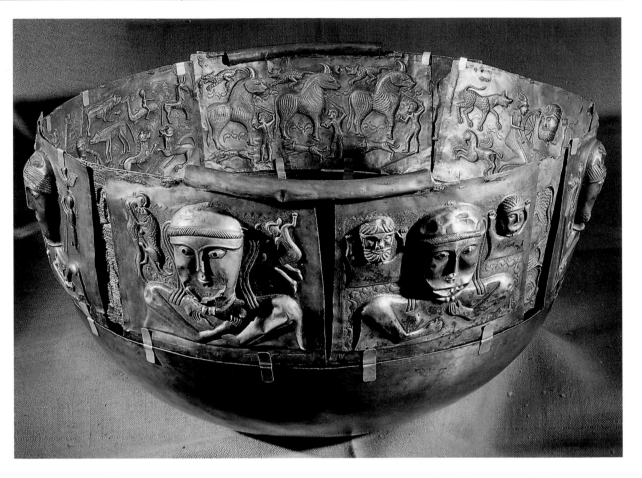

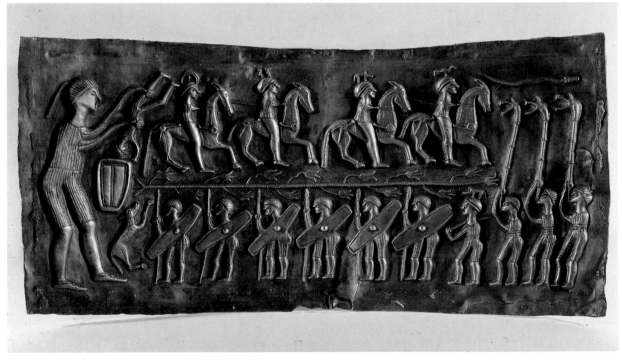

Gundestrup cauldron
Detail of one of the plates
c. 100 BC
A human sacrifice is represented
with helmeted armed warriors and
trumpeters, who blow the *carnyx*,
or the Celtic war-trumpet.
Height: 20 cm.

Stone sculpture
Entremont (Bouches-du-Rhône),
France
2nd century BC
From the southern edge of the
Celtic world, the severed human
head represented by this stone
sculpture combines Celtic and
Ligurian elements.
Height: 29 cm.
Musée Granet, Aix-en-Provence.

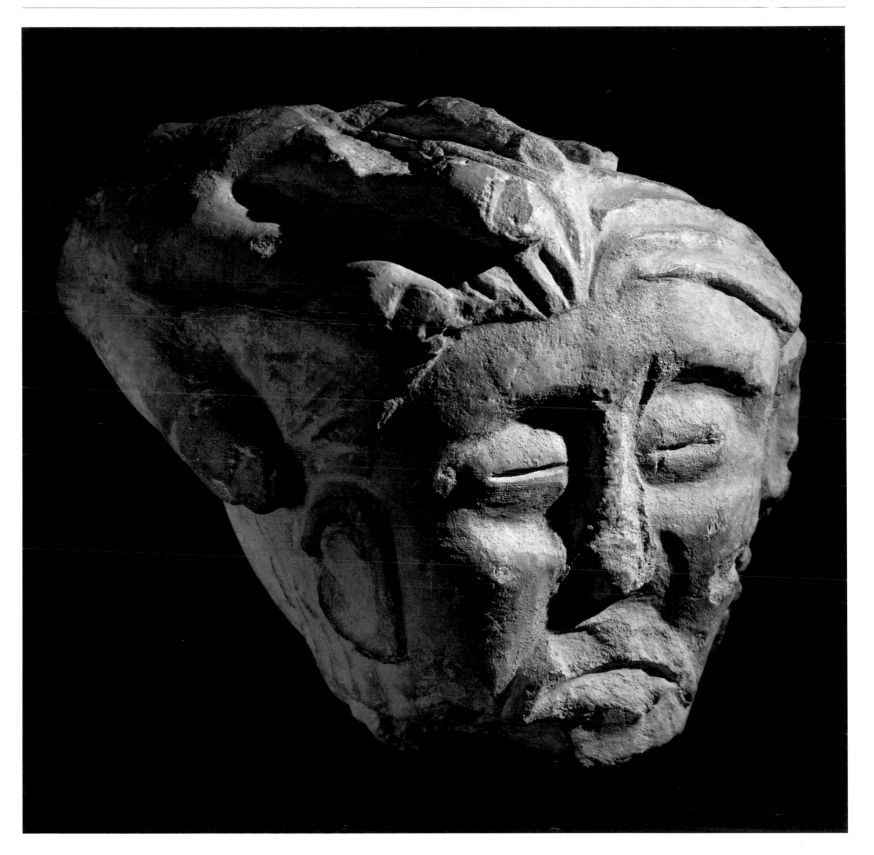

Wooden figure
Chamalières (Puy-de-Dôme),
France
1st century AD
This votive offering represents the
bust of a veiled woman wearing a
Celtic torc.
Height: 41 cm.
Musée Bargoin, Clermont-Ferrand.

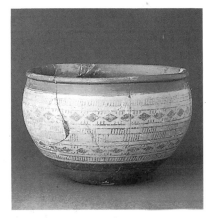

Painted ceramic bowl
Roanne (Loire), France
End 1st century BC
Decorated with diamonds and
"laddering" in brown and black
against a white ground, the
"Roanne bowl", named after the
site where it was found, illustrates
the Celtic geometrical tradition,
which flourished at the beginning
of the Roman period.
Height: 13 cm.
Musée Joseph Déchelette,
Roanne.

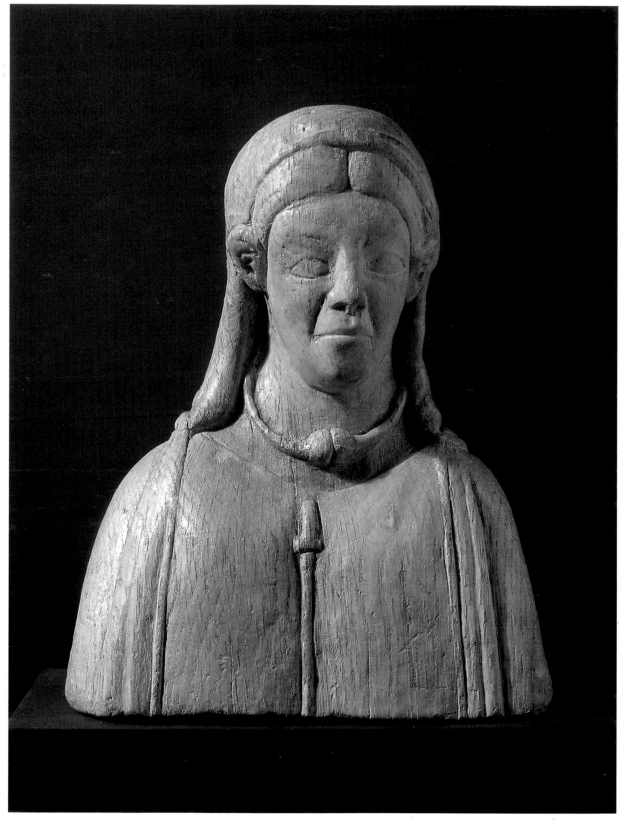

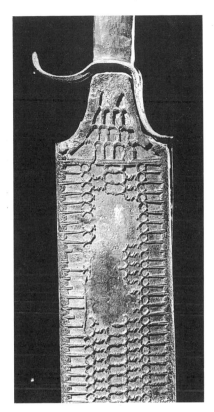

Bronze scabbard (detail)
Goeblingen-Nospelt, Luxembourg
End 1st century BC
Cloisonné work was common at
the very end of the Celtic period
and at the beginning of the Roman
period. The foliage pattern is not
unlike the tendril scrolls found on
Roman weapons.
Width: 3.5 cm.
Musées d'Histoire et d'Art de
l'État, Luxembourg.

Sheet bronze statue
Bouray-sur-Juine (Essonne),
France
Early 1st century BC
Found in a river, this statue
depicts realistically the upper
torso of a figure, a divinity, with a
torc. Appended to it is a smaller
lower torso with crossed legs and
hoofed feet.
Height: 45 cm.
Musée des Antiquités Nationales,
Saint-Germain-en-Laye.

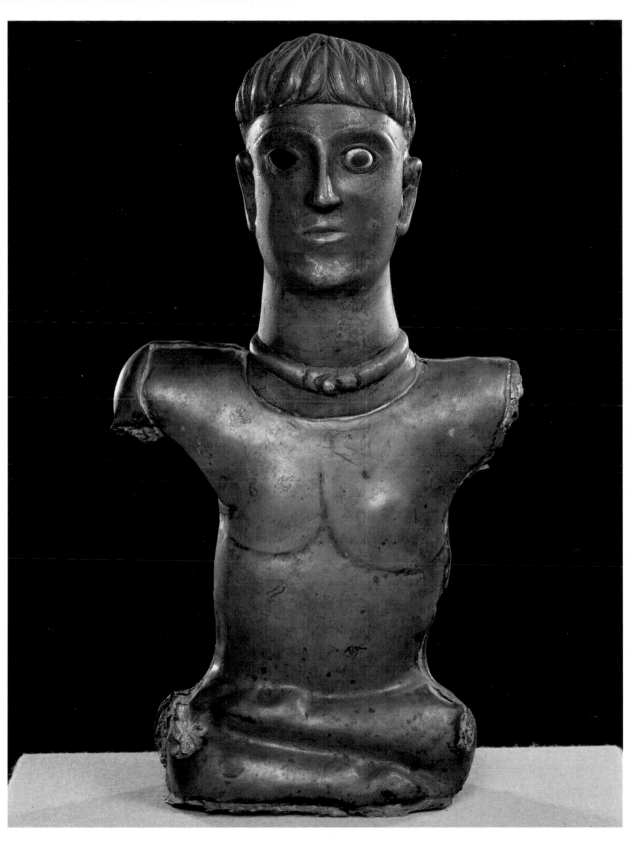

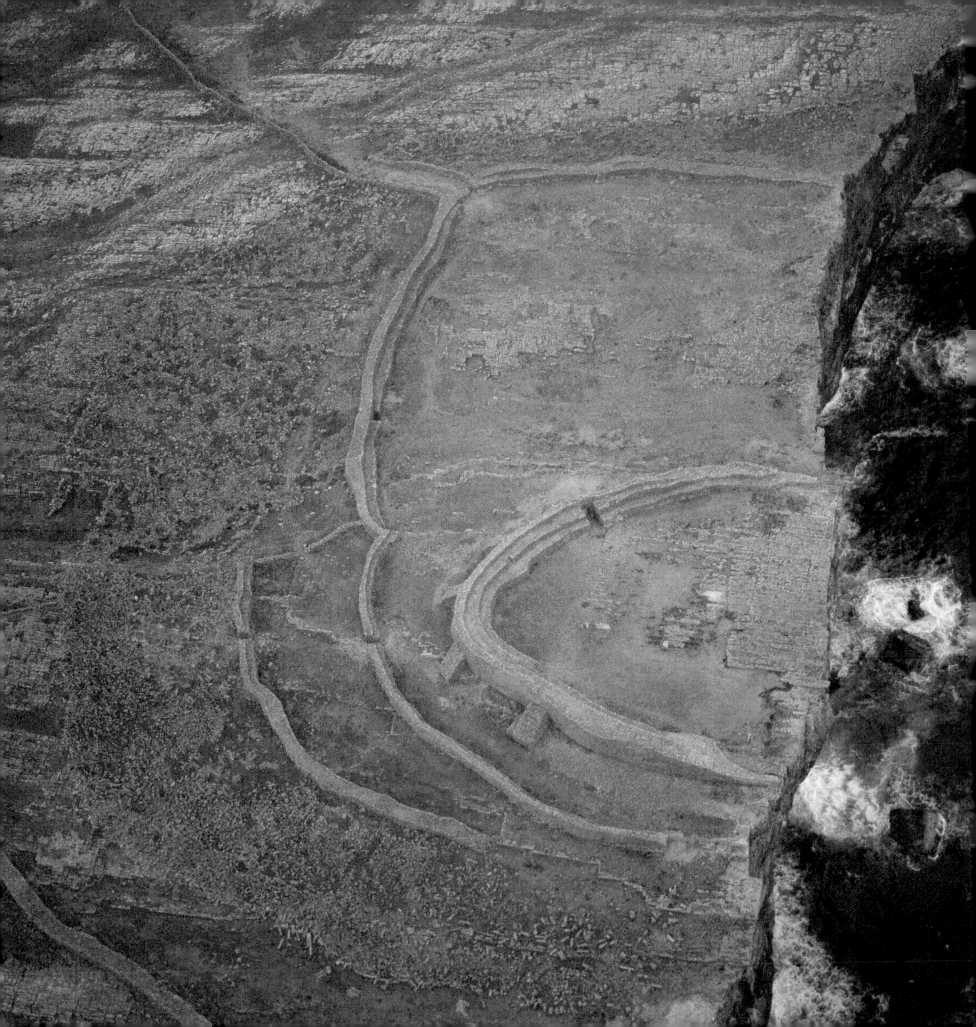

Celtic art in Britain and Ireland

Aerial view of the fortress of Dun Aonghus Aran

(Co. Galway), Ireland
Situated on a cliff-edge on the west coast of the island of Inishmore, it consists of three enclosures of dry-stone walling combined with a "chevaux-de-frise" of upright stones broad enough to ensure the optimum use of the sling against attackers. The fort is attributed by tradition to a mythical race of Fir Bholg and its name is said to preserve the memory of one of their chiefs. According to specialists it belongs to the pre-Christian Iron Age.

B ritain and Ireland did not participate in the genesis of Celtic art; indeed, it is not clear whether at that time they were even occupied by people speaking Celtic languages. A strong insular tradition lay outside the mainstream of West European development, and it is ironic that the area where Celtic languages now survive was originally the most marginal and last to be incorporated within the Celtic world.

Nevertheless, a pattern of political and trading contacts with the Continent, involving the importation of items of fine metalwork and perhaps from time to time also movements of population, had existed even in the Late Bronze Age, and areas of the eastern coast of England—the Thames Estuary, East Anglia, the Yorkshire Wolds—provided foci of interest in the new styles of the fifth and fourth centuries BC. However, few direct imports of early Celtic art are known—none until the third century, and then only at scattered find-spots in the Thames Basin, Wales and Ireland.

What is remarkable, then, is the speed and confidence with which distinctively insular styles of Celtic ornament grew up from the later third century BC onwards, on the basis of features of the continental Sword Style with local innovations in conception and treatment. Sword-scabbards, shields, and the unique piece of horse's head-armour from Torrs in Scotland, form a first generation of insular products, based on bold repoussé work and fine engraved decoration such as

101

flowing, linear scrollwork. The rise of an important East Anglican school of gold-working, using plastic designs cast in relief, was a significant innovation and it was paralleled in the production of a magnificent series of engraved bronze mirrors whose large, circular fields allowed the development of intricately filled but symmetrically balanced compositions. The use of hatching developed in the latter context as a way of defining ornament on extensive, flat surfaces. These new styles were reflected in a second generation of weaponry, such as scabbards with plastic decoration and hatching.

As the Roman frontier drew nearer, and eastern England in particular grew rich from trade across the North Sea, new forms of decorated objects became common and technological changes, such as the use of enamel, took place. Horse-gear became an important medium for display, through the rein-rings and attachments which were often decorated in colourful enamel. Vessels for drinking and serving imported wine or native brews became more common, as the aristocratic families imitated southern modes of life.

When the Romans finally conquered what is now England, the free Celtic areas beyond the frontier, in Ireland and Scotland, continued to provide contexts in which craftsmen could exercise their skills in the service of warlike masters who wished to continue the wearing of traditional symbols of wealth and power.

It was not until about 300 BC that the first elements of Celtic La Tène art from the Continent arrived in Ireland. Amongst the earliest objects is a gold torc from the west of the country, found in a bog at Clonmacnoise, Co. Offaly, which might have been imported from the Rhineland. Within a generation or two, craft centres were established, notably in the north-east of Ireland, which produced metalwork of the highest technical and artistic excellence. Such a centre must have existed at or near the site of a major hoard of metal objects found in the last century at Lisnacrogher, Co. Antrim. Here there were armouries producing spears, finely-wrought swords, and bronze scabbards which were engraved along their length with flowing, freehand vegetal designs of leafy spirals, S-scrolls and wave-tendrils. Such motifs have their ultimate background in Continental Waldalgesheim ornament and display artistic inspiration from as far away as the Middle Danube.

By the birth of Christ the introduced art style is transformed by the stamp of insular personality. Ornament becomes increasingly dependent on the compass and compositions are more formalized and geometrically arranged. In time, the trumpet curve appears and is used long after the introduction of Christianity. Ornamental design is two-dimensional or in the round, engraved in metal, bone or stone or cast or hammered in bronze and, irrespective of the medium, there is great artistic homogeneity across the country.

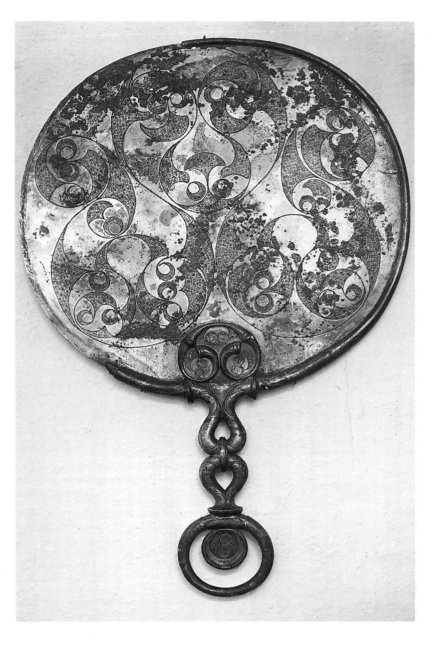

Bronze mirror
Birdlip (Gloucestershire), England, United Kingdom
1st century BC
Found in a woman's grave together with a silver gilt eye-brooch, this massive mirror, engraved on the back with a lyre motif, is one of the masterpieces of the insular style. With the decoration of flat surfaces such as this, the areas of hatched basketwork correspond to the raised elements of the relief ornament, obtained either by casting (e.g. the previous item no. 1 above) or in repoussé work (e.g. the following item). The solid handle was cast separately by the lost wax method.
Total height: 38.7 cm.
Gloucester Museum, Gloucester.

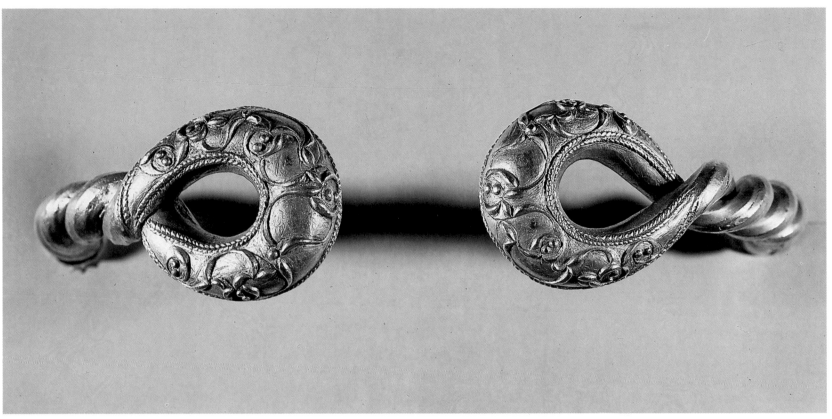

Gold torc
Ipswich (Norfolk), England,
United Kigdom
1st century BC
The two twisted bars of the body
of this torc, one of six torcs found
in a hoard, terminate in two loops
which were cast by the lost wax
method. The relief ornament on
the object defines a series of
pelta-shaped voids.
Diameter: 18 cm.
British Museum, London.

**Bronze scabbard with iron
sword**
Little Wittenham (Oxfordshire),
England, United Kingdom
1st century BC
This massive sword, found during
a pond-dredging, has a
sheet-bronze scabbard which
terminates in a cast chape. The
foreplate is decorated with fine
ladderwork and the locket
contains repoussé decoration in
the form of an inverted lyre—a
common decorative pattern for
mirrors (e.g. the previous item).
The cast shape also resembles
the workmanship of the mirror
handles.
Length: 74.5 cm.
Ashmolean Museum, Oxford.

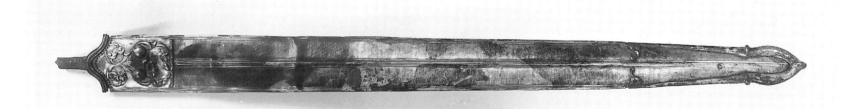

A whole range of native types appears, high-quality items undoubtedly produced under the patronage of a ruling aristocratic elite. Elegantly-cast bridle-bits of bronze are particularly common, but small dress-fasteners of bronze, frequently embellished with elaborate cast or engraved designs are also known. In Ireland, as in Britain, the use of red enamel was an important innovation of this period. Gold is rare but the superb collar from Broighter, Co. Derry, with raised scrolls and background engraving, is an outstanding masterpiece of Late La Tène craftsmanship. Impressive too, are the great, curved, sheet-bronze trumpets.

A small group of exceptional bronzes, dating to the early centuries AD, represents the climax of Irish La Tène craftsmanship. These include two fragmentary head-pieces, one from Cork, the other unlocalized—the so-called Petrie Crown—and a small, dished disc from the River Bann. On these there is raised, fine-line ornament of consummate delicacy produced, either wholly or in part, by background tooling of the bronze.

Celtic art in Ireland, as elsewhere, is essentially abstract. Birds' heads are, however, by no means infrequent and their presence may well have been imbued with votive undertones. The finest ornithomorphic renderings are on two cast-bronze cup handles, notably that from Keshcarrigan, Co. Leitrim. Animals are virtually unknown. The human form, too, is only occasionally found in metal but there is a series of carved stone heads which shows that Ireland shared with the rest of Celtic Europe a veneration for the human head. A single, crudely impressive human carving in wood from Co. Cavan serves as a reminder of what must once have existed in this material.

Ireland, never occupied by Roman legions, ensured the continuity of Celtic art into the period of developed Christianity and it was in Ireland that this art blossomed and culminated in the great masterpieces of the eighth and ninth centuries.

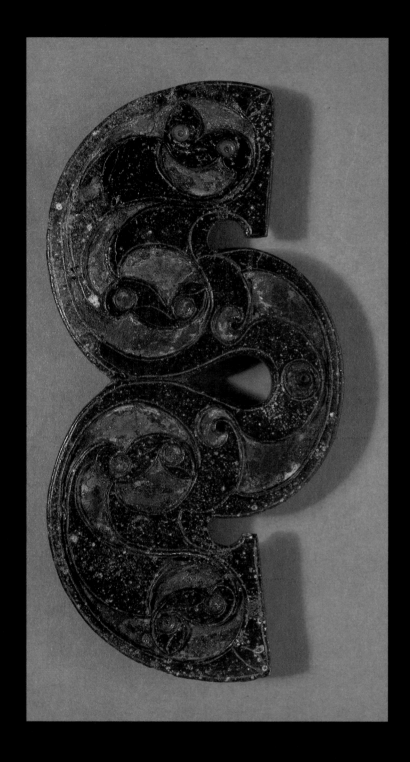

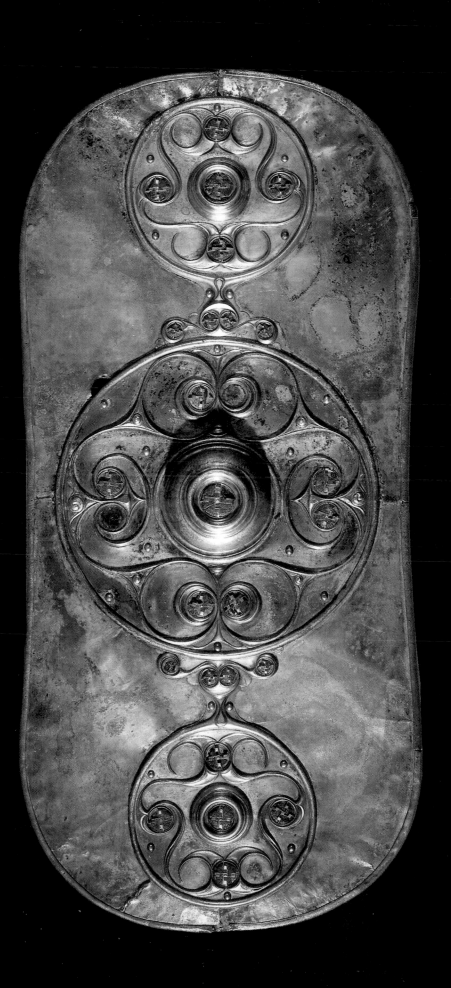

Bronze harness mount with enamel decoration
Polden Hill (Somerset), England, United Kingdom
1st century AD
This relatively late piece, made not long before the Roman conquest, was found with other pieces of horse gear. It demonstrates the way in which the use of red champlevé enamel was used to create a contrasting background on a flat surface, in the same manner as hatching and relief work.
Width: 15 cm.
British Museum, London.

Bronze shield cover with glass settings
Battersea (London), England, United Kingdom
2nd century BC-1st century AD
This parade shield, found in the River Thames, has an unusual fourfold symmetry. Its simple, well-spaced designs in broad circular fields contrast with the narrower, vertical emphasis of earlier examples. The glass roundels are used in the same way as coral studs.
Height: 78 cm.
British Museum, London.

**Bronze bridle-ring
with enamel decoration**
Ditchley (Oxfordshire), England,
United Kingdom
1st century BC
This D-shaped harness
attachment displays a
combination of enamel and relief
decoration, in particular on the
bipartite collars formed of
opposed hemispheres.
Ashmolean Museum, Oxford.

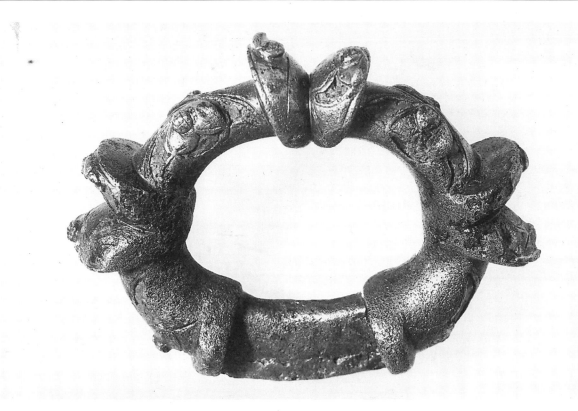

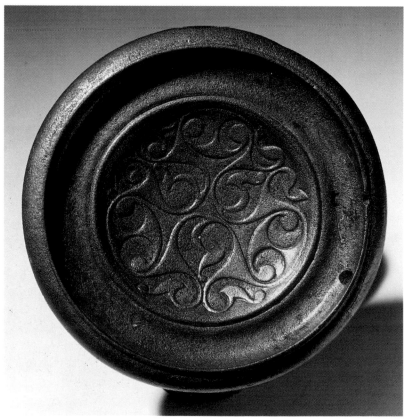

Decorative bronze knob
Brentford (Middlesex), England,
United Kingdom
3rd/1st century BC
This concave knob with a circular
panel of ornament in low relief
was probably the yoke terminal of
a chariot. Although most writers
have seen its vegetal tendrils as
closely related to the
Waldalgesheim style, its
symmetry also could suggest a
later date, perhaps contemporary
with the mirror series.
Height: 6.2 cm.
Museum of London, London.

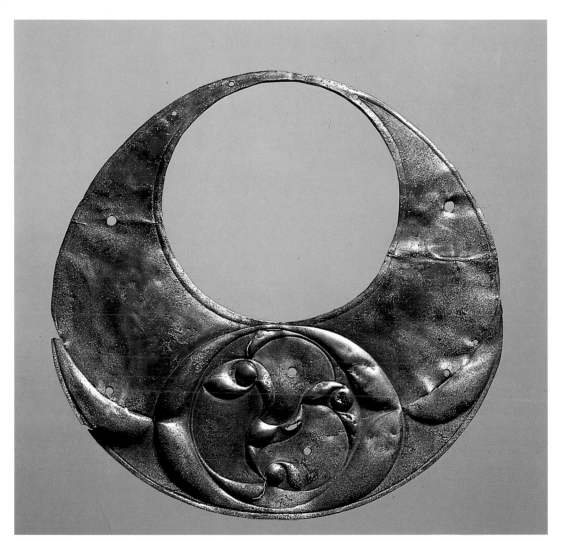

**Crescent-shaped
sheet-bronze plaque**
Llyn Cerrig Bach (Anglesey),
Wales, United Kingdom
3rd/1st centuries BC
This deceptively simple circular
field of repoussé work, consisting
of three peltate voids defined by
an irregular triskele of bird-head
motifs, is the central ornament on
a crescent-shaped sheet which
may have adorned the front of a
chariot. It came from a hoard,
consisting mainly of vehicle
fittings, found in a bog near an
ancient Celtic religious centre on
the island of Anglesey.
Diameter (decorated area):
6.7 cm.
National Museum of Wales,
Cardiff.

Bronze scabbard plate
Witham River (Lincolnshire),
England, United Kingdom
3rd/1st centuries BC
This asymmetrical plate would
have been affixed to a wooden or
leather scabbard. Repoussé work
is combined with engraved foliage
decoration and in this the plate is
comparable to that found on the
early shield-bosses or the Torrs
pony cap.
Width: 4.8 cm.
Alnwick Castle Museum, Alnwick.

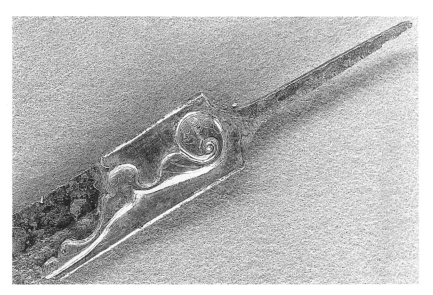

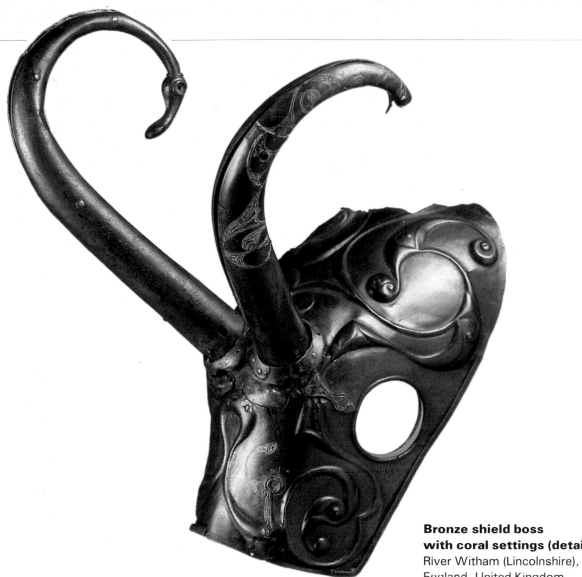

Bronze Pony Cap
Torrs (Dumfries & Galloway), Scotland, United Kingdom
3rd-1st century BC
This unique object is a pastiche of a shallow pony cap (with holes for the ears) and a pair of curved tubular terminals, probably derived from a pair of drinking horns. The ornament of the cap, decorated with disciplined repoussé scrolls, has been repaired several times. Bird-heads and engraved scrolls in the style of the early shields or of the Witham locket pattern the horns.
Length: 31 cm.
Royal Museum (formerly National Museum) of Scotland, Edinburgh.

Gold Bracelet
Snettisham (Norfolk), England, United Kingdom
1st century BC
This tubular gold bracelet displays repoussé ornament in the "Snettisham" style common to goldwork from East Anglia. The style was named after a gold torc found nearby. The mirror-image across the longitudinal axis of a running scroll, which defines a series of pelta-shaped voids, produces a balanced but dynamic pattern.
Diameter : 9.7 cm.
British Museum, London.

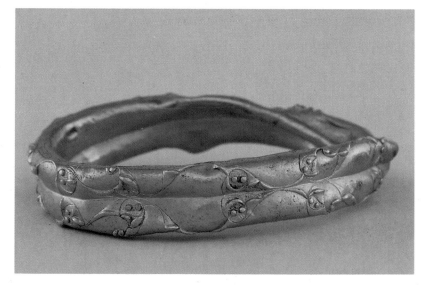

Bronze shield boss with coral settings (detail)
River Witham (Lincolnshire), England, United Kingdom
3rd-1st centuries BC
This and the following example belong to tall shields, decorated with repoussé bosses which are linked by a vertical spine to terminal roundels at the top and bottom. The high relief of the central boss, garnished with well preserved coral settings, is composed of opposing circular voids formed by a rotating scroll pattern, which creates a strong sense of movement. The terminal roundels contain engraved scrollwork in the style of the Torrs horn-terminals.
Height: 113 cm.
British Museum, London.

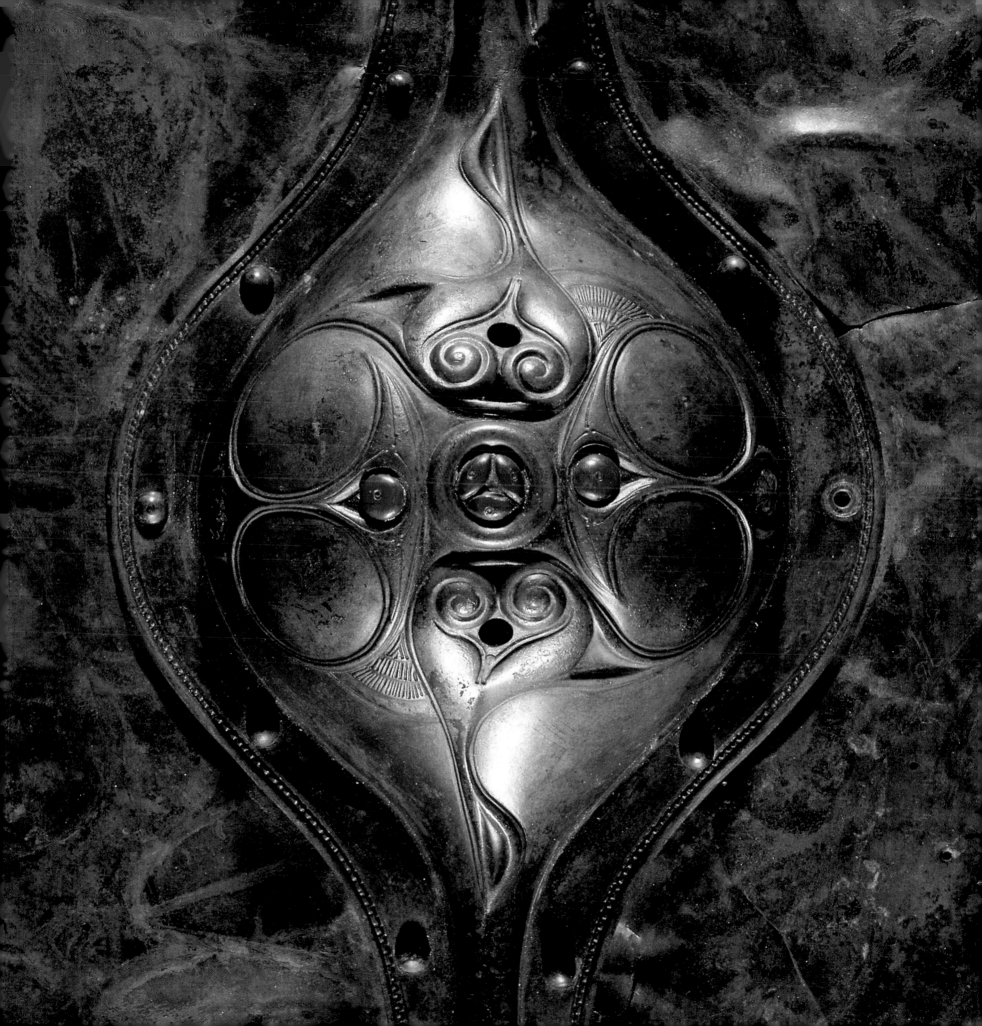

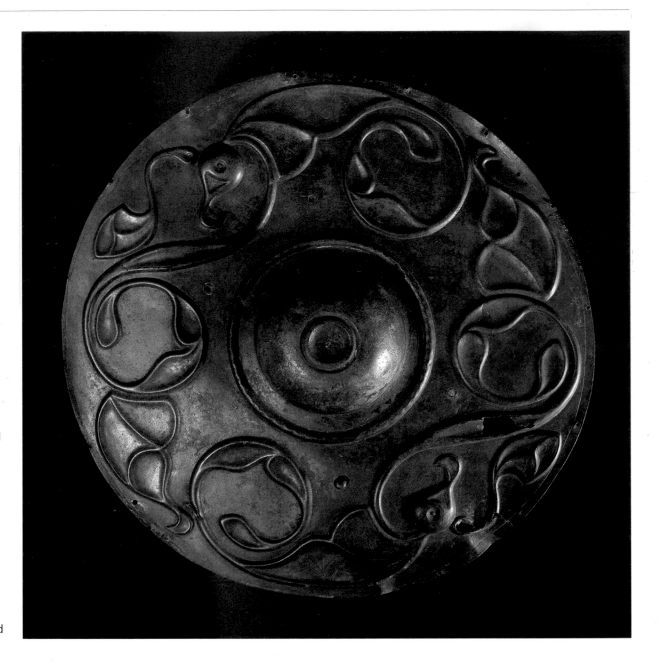

Bronze shield boss
Thames River at Wandsworth
(London) England, United
Kingdom
1 st century BC
This boss, known as the "long" or
"mask" boss to distinguish it from
another, circular example from the
same stretch of river, is decorated
with high relief repoussé work in
the form of two diagonally
opposed bird's heads which
constitute part of a rotating scroll.
This pattern ends at the top (and
probably, originally, at the
bottom) in a mask, similar in kind
to those which on other shields
(e.g. the preceding example)
grasped terminal roundels.
Length: 109 cm.
British Museum, London (Restored
replica: Ashmolean Museum,
Oxford).

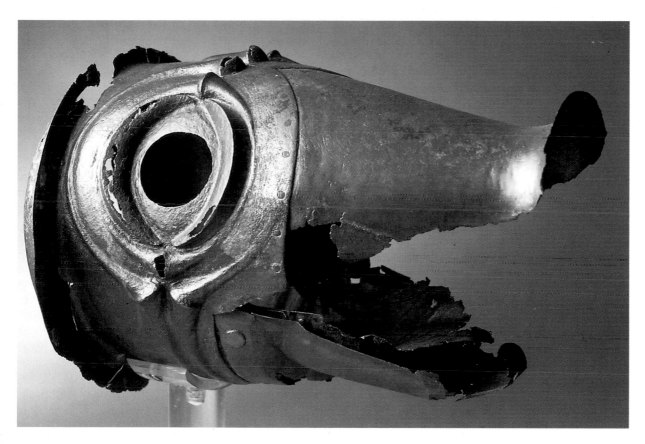

Bronze carnyx head
Deskford (Banffshire), Scotland,
United Kingdom
1st century AD
Carnyxes are wind instruments
which were used widely in Iron
Age warfare, and were
represented, for example, on the
Gundestrup cauldron. Carried
vertically, the carnyx takes the
form of a long tube, which
terminates in an animal's head.
This particular terminal represents
a boar, and when found it had a
wooden clapper in its mouth.
Length: 21 cm.
Royal Museum of Scotland,
Edinburgh.

**Bronze handle
in shape of a boar**
Hounslow (London), England,
United Kingdom
1st century BC-1st century AD
This object, cast in the lost-wax
technique, is one of a number of
such three-dimensional figures
designed to be attached to a
larger object. It was probably
the handle of a box.
Length: 8 cm.
British Museum, London.

**Wooden bucket with bronze
mounts in the form of plumed
heads**
Aylesford (Kent), England, United
Kingdom
1st century BC-1st century AD
These are bronze mounts
belonging to a wooden stave
bucket used for serving drink. The
three-footed bucket is sheathed
with three bronze bands and the
uppermost band is decorated with
repoussé work, where the
repetitive motifs indicate the use
of a stencil. The most notable
feature is the handles, solid
castings which stand up from the
rim and take the form of plumed
human heads.
Height: 30 cm.
British Museum, London.

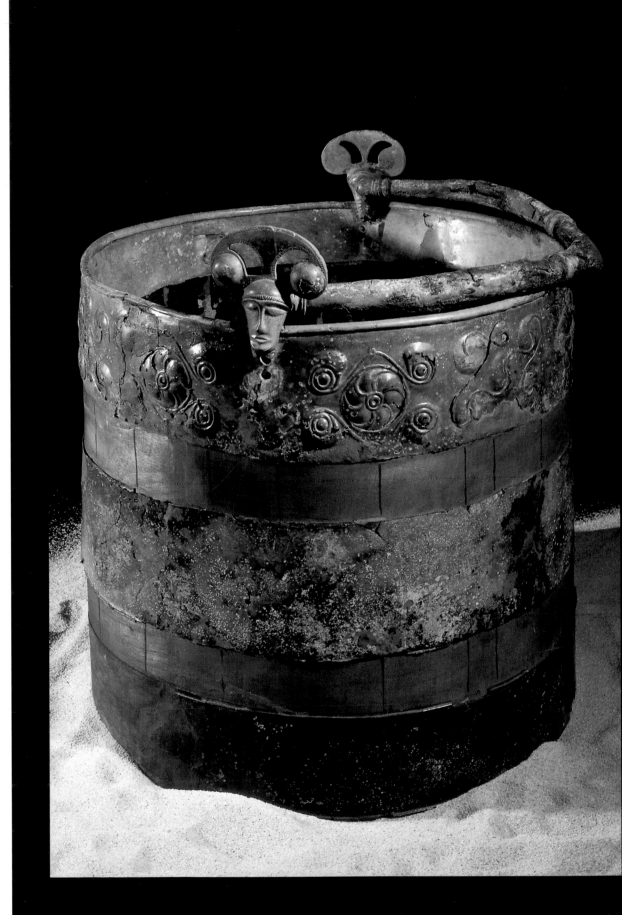

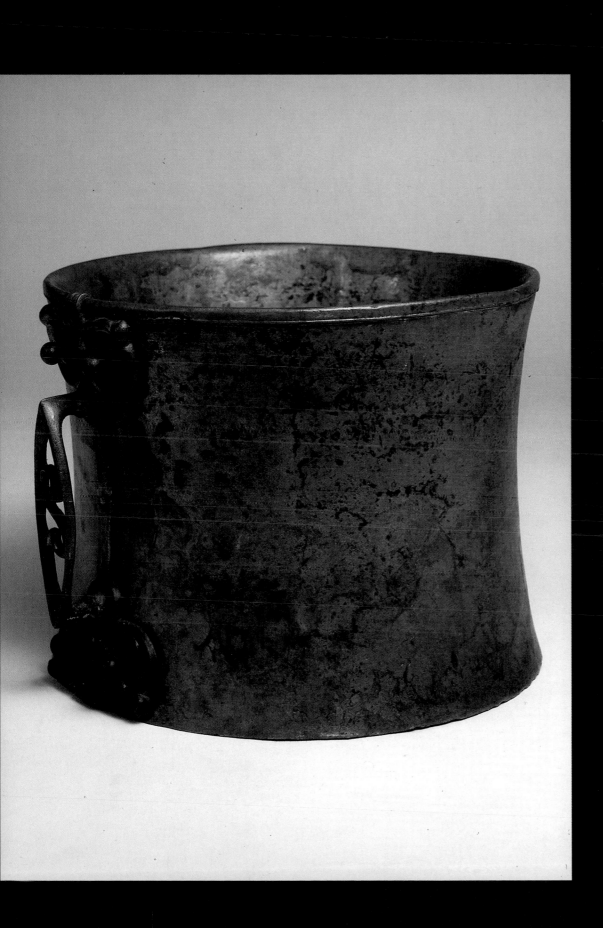

Bronze tankard casing
Trawsfynydd (Merioneth), Wales,
United Kingdom
1st century BC-1st century AD
This wooden stave tankard was
sheathed in sheet-bronze and was
completed with a cast openwork
handle attached by two pairs of
rivets.
Height: 14.3 cm.
City of Liverpool Museum,
Liverpool.

113

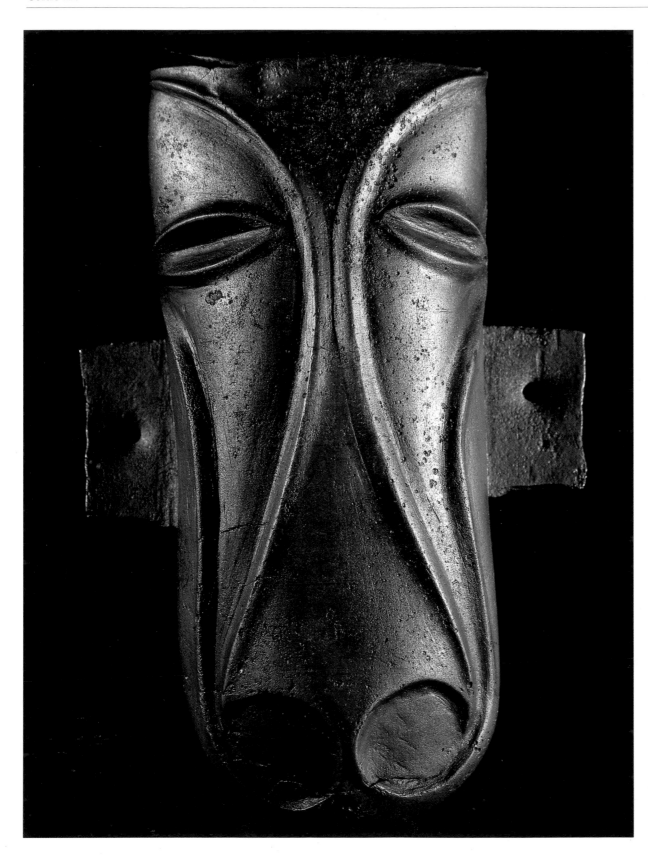

**Bronze mount
in shape of horse's head**
Stanwick (Yorkshire), England,
United Kingdom
1st century BC-1st century AD
This sheet-bronze mount with
perforated tabs was found with a
collection of horse-gear items at
the ancient Brigantian capital of
Stanwick and may well have
adorned a chariot. Its combination
of simple motifs effectively
conveys the image of a horse's
head.
Height: 11 cm.
British Museum, London.

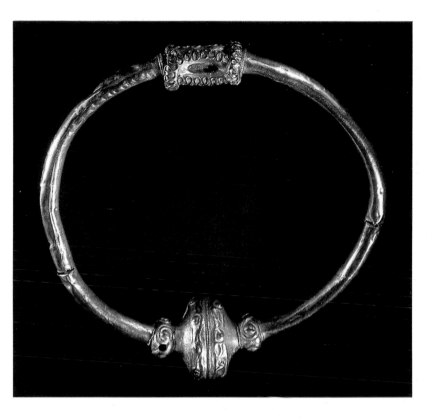

Gold torc

Clonmacnoise (Co. Offaly),
Ireland
3rd century BC
Found in a bog with a gold ribbon
torc; the buffers at the front of
this gold torc are decorated with
repoussé scrolls highlighted by
background stippling. The "box"
at back has raised, interlocking
ribs patterned with a meander
ornament of applied gold wire.
The clasp mechanism operates by
inserting one of the side tubes
into the hollow buffers and
securing it in position by inserting
a transverse pin.
Internal diameter: 12.9 cm.
National Museum of Ireland,
Dublin.

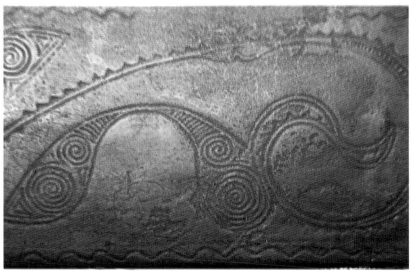

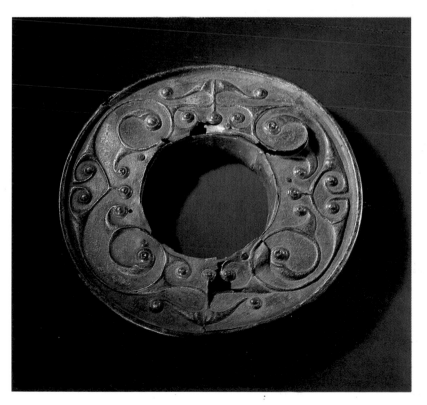

Bronze trumpet disc (detail)

Loughnashade (Co. Armagh),
Northern Ireland, United Kingdom
100BC-100 AD
This object was found in a lake
with three similar specimens
which are now lost. Raised
hammered ornament is arranged
symmetrically around the mouth
of the trumpet so that one half is
the mirror image of the other. The
design on each side is organized
around a running wave pattern
which terminates in boss-ended
spirals and sub-peltate motifs.
Diameter: 19.3 cm.
National Museum of Ireland,
Dublin.

Bronze scabbard plate

Lisnacrogher (Co. Antrim),
Northern Ireland, United Kingdom
300-100 BC
The engraved, free-hand
ornament on this scabbard plate
is based on a sequence of four
S-figures with thin tendril-like
stems which tail off, at the broken
end, into a squashed
"running-dog". Typical of the Irish
scabbards is their short length.
Total length: 49.8 cm.
Ulster Museum, Belfast.

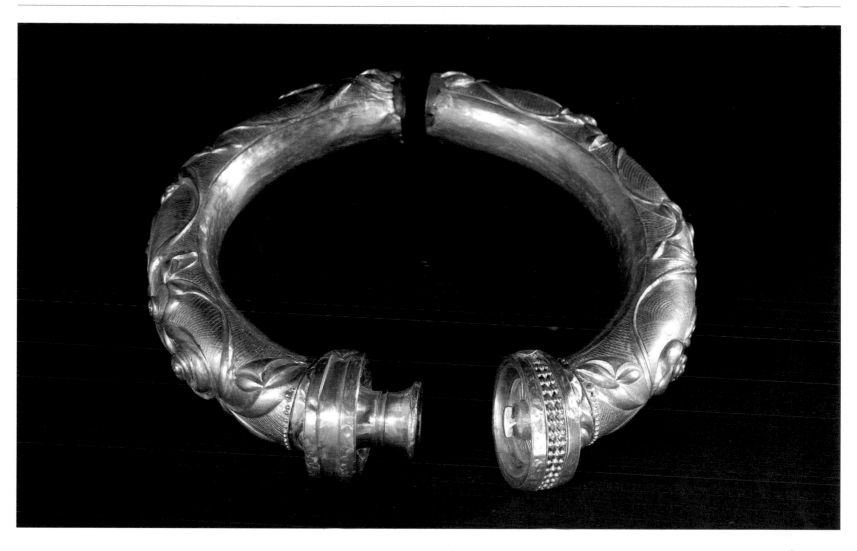

Carved standing stone
Turoe (Co. Galway), Ireland
1st century BC
The stone, worked into a
cylindrical pillar, is decorated with
a curvilinear design laid out on
four distinct panels. The
background was cut away leaving
the ornament in relief. The
free-hand decoration is based on
interlocking combinations of
spirals, triskeles, peltae,
comma-motifs and other patterns
and a simple step ornament is
incised crudely around the base.
Height above ground: c. 1.20 m.
Grounds of Turoe House,
Co. Galway.

Gold Torc
Broighter (Co. Derry), Northern
Ireland, United Kingdom
1st century BC
Found with other gold objects in
a flood plain, the relief decoration
on this gold torc is hammered on
the tubes and is constructed of
stretched and interlocking
S-scrolls in combination with
trumpet curves, snail-shell spirals
and other motifs, all of which are
set off by a background of
overlapping compass-drawn
arcs.
The terminals, one of which
retains the original granulation
imitating tiny pearls, were made
separately.
Internal diameter: 13.4 cm.
National Museum of Ireland,
Dublin.

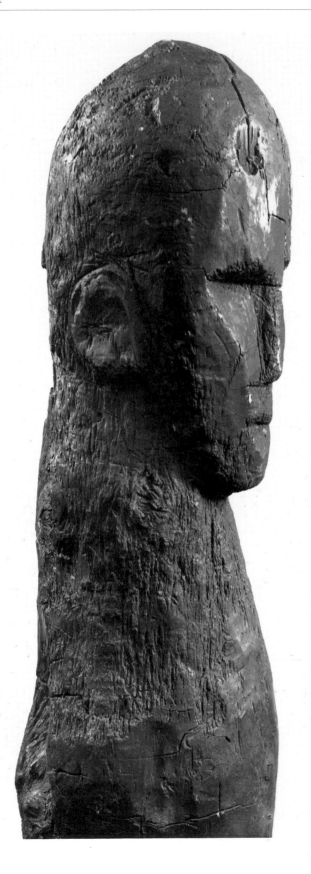

Carved wooden figure
Ralaghan (Co. Cavan), Ireland
250 BC-AD 250
Found in a bog and made of yew wood.
Height: 114 cm.
National Museum of Ireland, Dublin.

Bronze horse-bit
Provenance unknown, Ireland
300-100 BC
A detail of a portion of a mouth-piece where a stylized human face cast in the lost-wax technique decorates the end of it.
Surviving length: 13.8 cm.
National Museum of Ireland, Dublin.

Carved stone figure
Tanderagee (Co. Armagh),
Northern Ireland, United Kingdom
250 BC–AD 250
The figure, presumed to be a
Celtic deity, originally came from
the hill of Armagh where a pagan
sanctuary may have existed. The
horned god has prominent
features including an open,
screaming mouth. A sleeved arm
extends stiffly across the chest to
grasp the other which appears to
be detached from the torso.
Height: c. 60 cm.
Chapter House, Church of Ireland
Cathedral, Armagh.

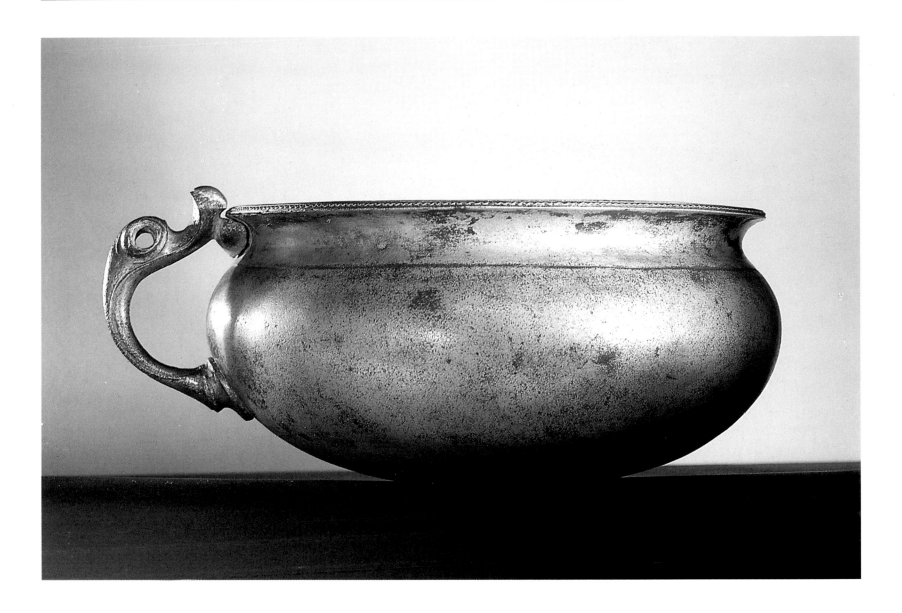

Bronze handled bowl
Keshcarrigan (Co. Leitrim), Ireland
1st century AD
This bowl, a river find, was cast
initially and then was finished on a
lathe. A reserved zig-zag pattern
decorates the rim. The handle was
cast separately in the form of a
bird's head and was soldered
onto the body of vessel.
Depth: 14.3 cm.
National Museum of Ireland,
Dublin.

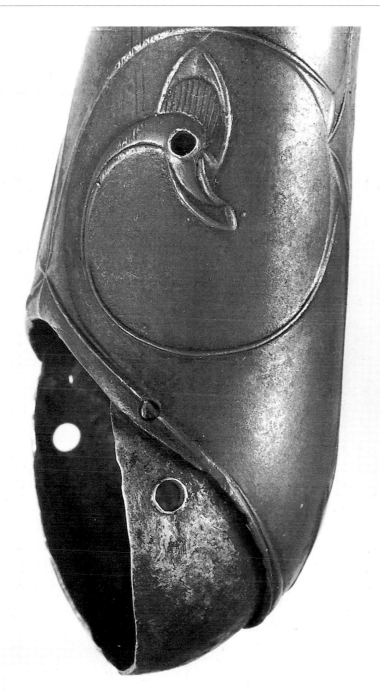

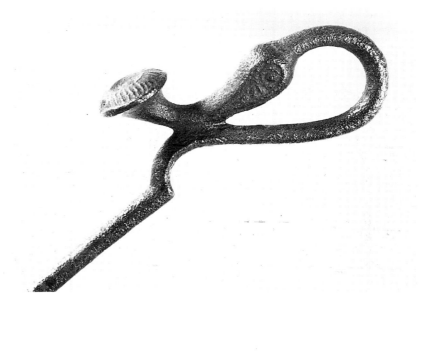

Bronze pin (detail)
Shannon River,
Ireland
200 BC-AD 200
The pin has a sharply curving shank and a bent, crook-like head in form of a stylized bird's head. A circular disc adorns the tip of beak and the eyes are represented as tiny spirals.
Total length: 8.2 cm.
National Museum of Ireland,
Dublin.

Bronze horned headpiece (detail) Provenance unknown, Ireland
1st century AD
The object, known as the "Petrie Crown" is now incomplete. In its original state, an unknown number of hollow horns were attached to circular discs and mounted on an openwork band. Made entirely of sheet-bronze, the constituent parts were adorned with a fine, raised, curvilinear ornament. On the one surviving horn is a stylized, crested bird's head. Height of horn: 10.8 cm.
National Museum of Ireland,
Dublin.

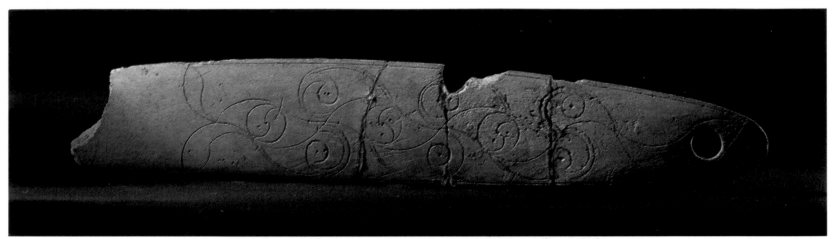

Decorated bone flake
Lough Crew, Oldcastle
(Co. Meath), Ireland
1st century AD
This bone flake was found with
numerous other fragmentary bone
flakes, both decorated and
undecorated, in a Stone Age
hilltop passage tomb. Its purpose
is unknown, although its use as a
metalwork "trial piece" is
suggested. The decoration
consists of balanced, geometric
compositions executed
exclusively with a compass.
Length: 13.4 cm.
National Museum of Ireland,
Dublin.

Decorated stone
Derrykeighan (Co. Antrim),
Northern Ireland, United Kingdom
1st century AD
Rectangular in section with two
decorated sides, the ornament on
the piece consists of geometric,
compass-drawn patterns similar
to those on the bone flakes from
Lough Crew (No. 1).
Height: 90 cm.
Ulster Museum, Belfast.

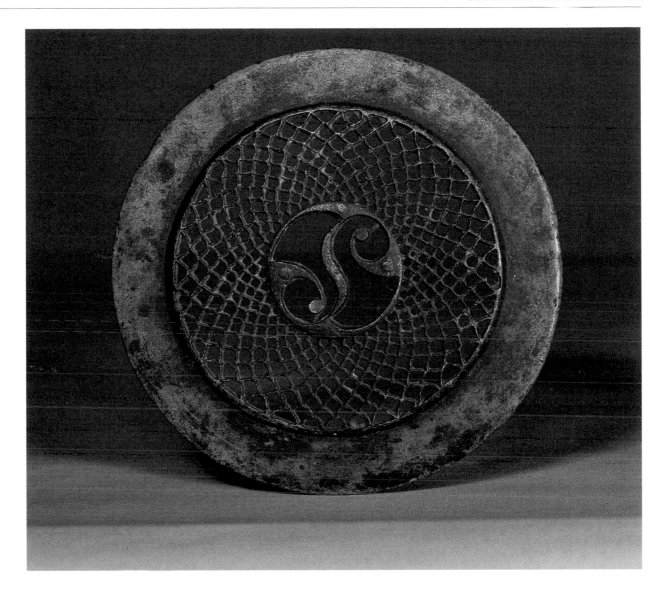

Openwork bronze mount
Cornalaragh (Co. Monaghan),
Ireland
100 BC-AD 100
A bog find. The mount, in the
form of a flattened cylinder, is
open at one end.
The closed end is decorated with
hand-cut, openwork ornament,
consisting of a central S-motif
enclosed by a large zone of
overlapping arcs.
Diameter: 7.4 cm.
National Museum of Ireland,
Dublin.

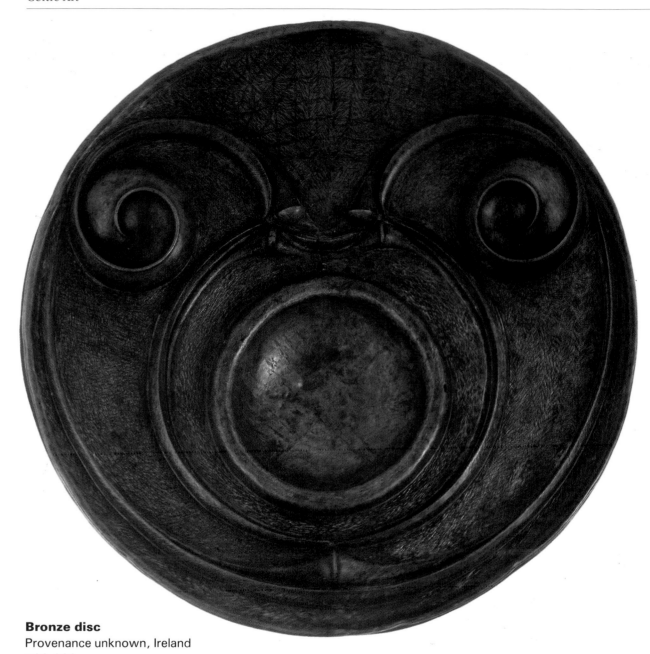

Bronze disc
Bann River (Co. Derry),
Northern Ireland,
United Kingdom
1st century AD
This cast disc, gently convex in
shape and of unknown function is
decorated with a raised fine-line
ornament produced by
hand-tooling. The design,
compass-drawn, consists of a
central whirligig from which
springs an open-armed,
spiral-ended triskele. The ends of
the triskel are formed into stylized
birds' heads.
Diameter: 10.5 cm.
Ulster Museum, Belfast.

Bronze disc
Provenance unknown, Ireland
100-200 AD
The front of this disc is gently
dished with a raised, hammered
ornament.
Spirals, arcs and trumpet curves
are set around a circular,
eccentrically-placed hollow and
the background is extensively
tooled in places to produce a
deliberate decorative effect.
Diameter: 27.2 cm.
British Museum, London.

Bronze horse-bit
Attymon (Co. Galway), Ireland
1st/2nd century AD
One of a pair, this horse-bit was
found in a bog with other harness
items. Cast decoration, composed
of opposing S-scrolls and
elongated ovals combine to form
a series of sub-peltate figures on
the side-links.
Total length: 31.6 cm.
National Museum of Ireland,
Dublin.

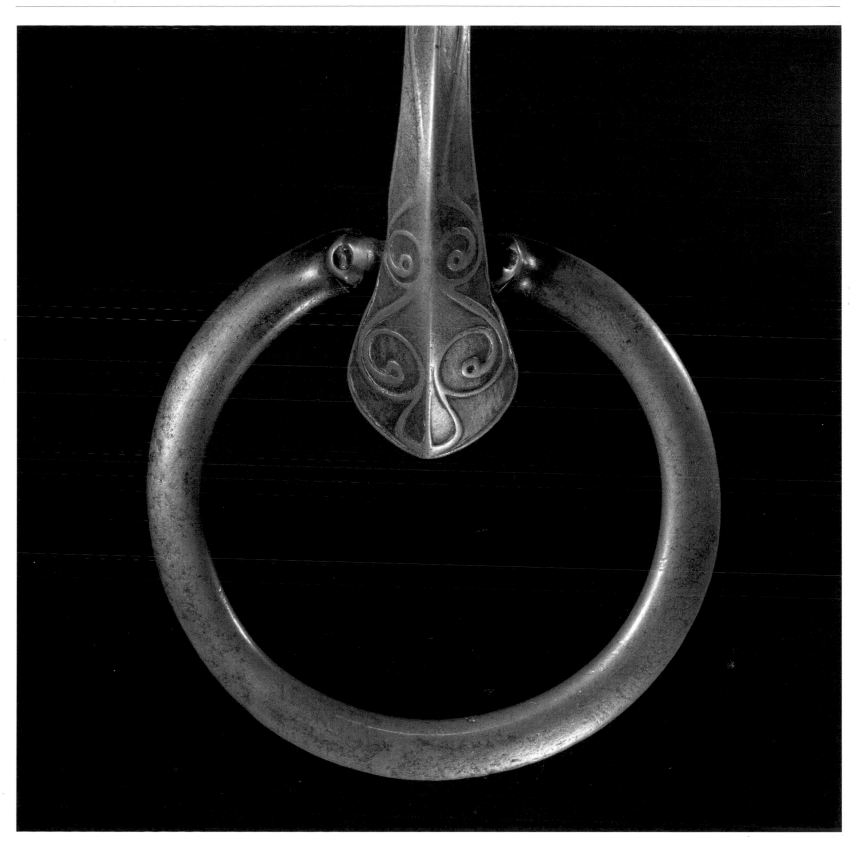

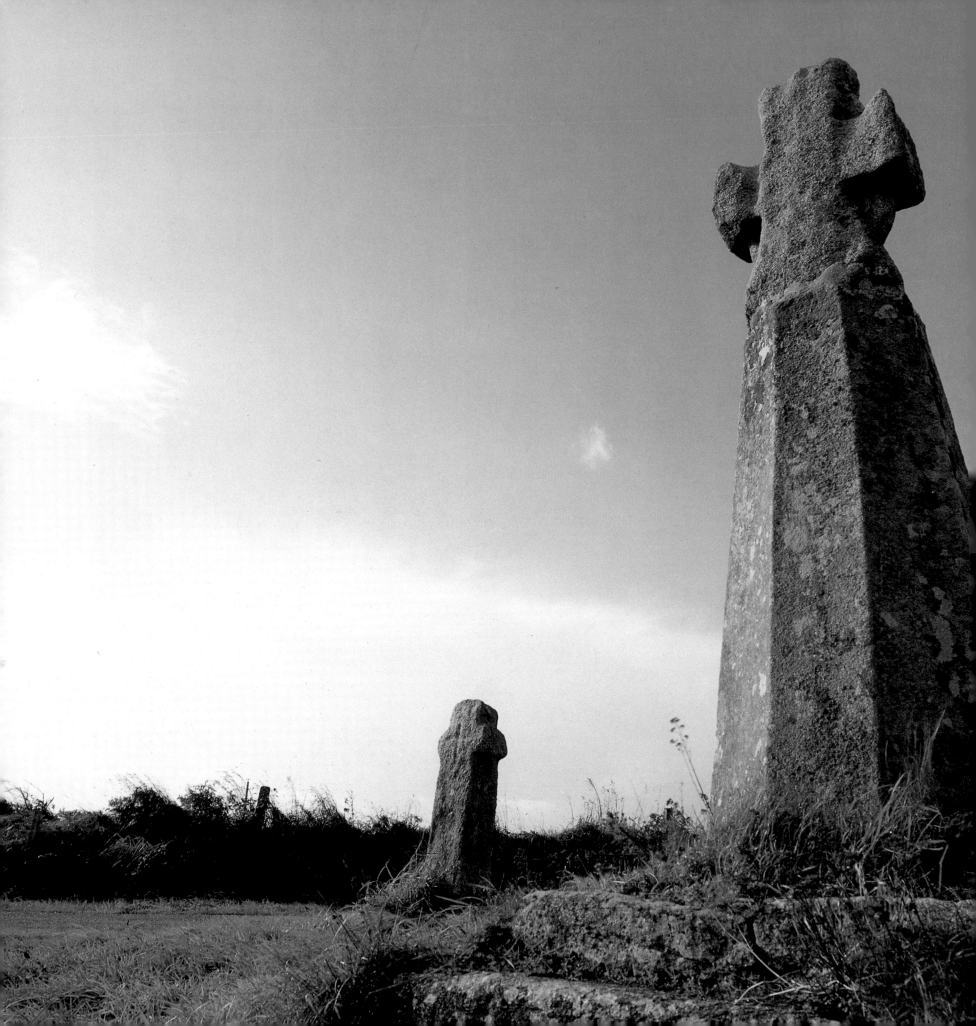

Stela of Croas-Men
Lampaul-Ploudalmézeau
(Finistère), France
Dating to the octagonal Iron Age
this stela, like many others, was
crowned by a cross following the
christianization of Brittany. It thus
transpired that the sacred
character of the monument was
perpetuated.

Aftermath: Celtic Christianity 5th to 10th century

By the mid-first century AD most of the Celtic lands including much of Britain were absorbed into the Roman Empire, and only Ireland and the north of Britain remained outside it. For most of the period the northern frontier of the Empire in Britain was Hadrian's Wall and the area bordering it was subject to massive Roman influence. Indeed, the Celtic tribes living there may have been in alliance with Rome. This region seems to have played a significant part in the development of new, partly romanized fashions amongst the Celtic peoples of the North and West. Within the province of Britain, Celtic traditions and language survived to some extent and it is probable that many of the great landowners were the romanized descendants of native leaders.

By the fourth century, the troubles which beset the Empire left the province in Britain vulnerable to attack by pirates, and in Ireland, by the Picts from Scotland and by the Germanic Saxons. The picture is very confused, however, and some of these raiders may also have served from time to time as mercenaries defending the colony and may have been settled in Britain for that very purpose. In AD 407 the legions withdrew and about AD 410 the Emperor Honorius advised the Britons to look to their own defence. This they did and it now seems clear that a high level of romanized culture was maintained by native rulers well into the sixth century. Native traditions appear to have reasserted themselves and independent Celtic-

127

speaking kingdoms emerged. Leaders from beyond Hadrian's Wall established themselves in Wales while the Irish settled in colonies in Cornwall, Wales and Western Scotland. The Irish kingdom of Dál Ríada gradually extended its influence over most of the highlands of Scotland. The Picts remained powerful throughout this period and frequently proved a threat to the rich lands to the south. The rulers of southern Britain continued to bring in and settle Germanic mercenaries to help defend their lands. This proved to be unwise as many of the mercenaries began to seize power for themselves and to bring reinforcements from their homelands and eventually conquer the area that we now know as England. The conquest was gradual and it was occasionally halted, but by the end of the sixth century the political structure of early mediaeval times had been established. The conquerors—the Anglo-Saxons as they were later called—probably absorbed much of the native population. Christianity was well-established in Roman Britain by the fifth century, but the Anglo-Saxons reintroduced paganism to the areas which they conquered. Ireland, which had remained outside the Roman Empire, maintained its traditional way of life but was christianized during the fifth century by missionaries from Britain and Gaul. The history of Celtic art at this period is confused but broadly speaking in fifth and sixth century Britain and Ireland schools of metalworking existed, depending on La Tène traditions which seem to have been preserved in a relatively pure form in the north and west of Britain and in Ireland. In southern Britain romanized traditions exerted their influence and this permeated the workshops outside the colony. Thus a modified version of the La Tène style developed.

Technological influences also came from the Roman world. Craftsmen began to experiment in working with silver although tinning and silvering may have been adopted to imitate the effect of silver which may have been in short supply. Millefiori glass came into use. The style is best referred to as Ultimate La Tène and, in the later sixth and seventh centuries with the adoption of new colours in enamelling, extremely florid effects were achieved by bronzesmiths.

Ornament was dominated by trumpet scrolls, fine spirals often designed to be seen as a reserved line of metal in a field of red enamel and this motif is best exemplified on the escutcheons of a series of vessels called "hanging bowls". The majority of these bowls are from pagan Anglo-Saxon cemeteries in eastern and southern England. Their decoration is distinctively Celtic in character and it has often been argued that they represent booty taken by the conquerors from the Celtic lands to the west. It is, however, perfectly possible that many were made by British craftsmen working locally for new, Germanic patrons. Workshops capable of producing similar material were operating in western Britain and Ireland at this

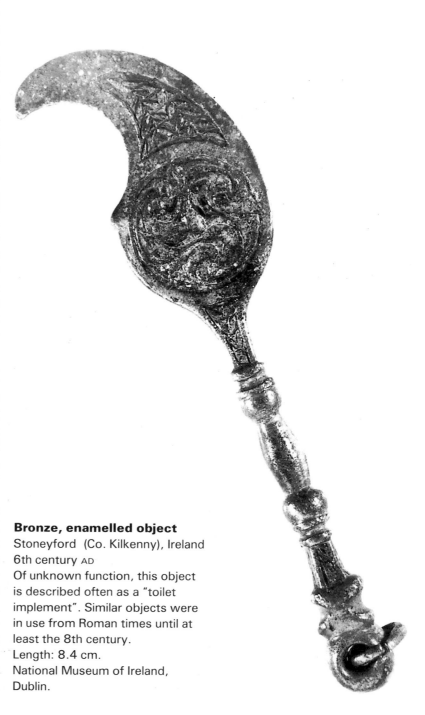

Bronze, enamelled object
Stoneyford (Co. Kilkenny), Ireland
6th century AD
Of unknown function, this object is described often as a "toilet implement". Similar objects were in use from Roman times until at least the 8th century.
Length: 8.4 cm.
National Museum of Ireland, Dublin.

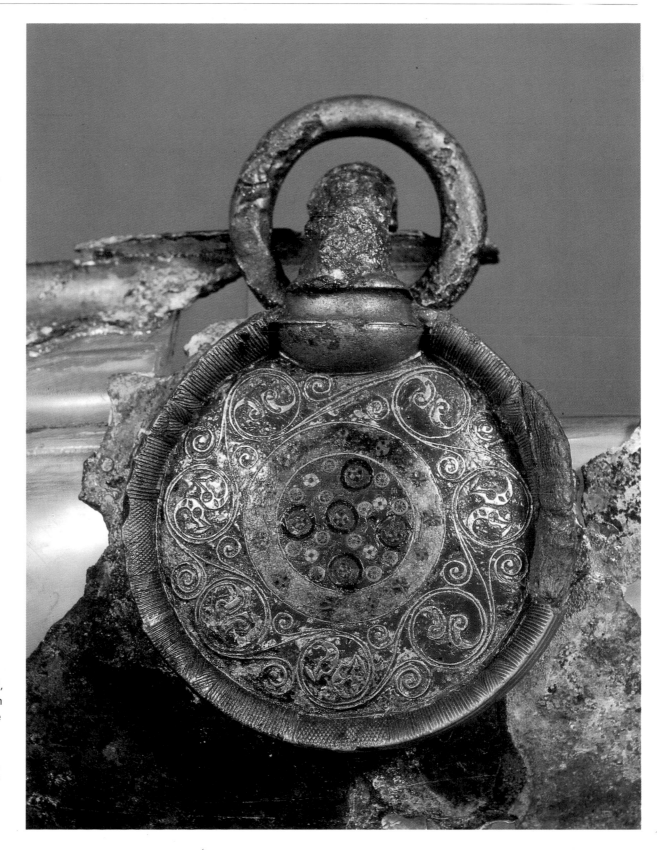

Enamelled hanging bowl mount
Sutton Hoo (Suffolk), England,
United Kingdom
Early 7th century AD
From the Anglo-Saxon ship burial,
this enamelled bronze escutcheon
decorated the outside of a bronze
hanging bowl. Curvilinear
scrollwork terminating in bird
heads is found on the centre ring,
while in the centre a peltate motif
is surrounded by millifiori discs.
Diameter: 5.5 cm.
British Museum, London.

time, but finds of bowls or bowl fragments are very rare. In Ireland, brooches and other objects carry variants of the early hanging-bowl style and this art appears on at least one piece of monumental sculpture, the Mullaghmast stone, Co. Kildare, an object which was certainly carved in the locality.

After a century or so of obscurity the Irish Church emerged into the full light of history as strongly monastic in character. With the foundation of St. Columba's monastery of Iona off the west coast of Scotland in AD 562, Irish monks entered into a missionary phase which led them to found monasteries widely in western Europe which in turn broadened the horizons of the homeland. The mission of Aidan of Iona in the 630s to the ancient kingdom of Northumbria in northern England was especially important in the later development of insular Celtic art.

The Irish missionaries in Britain came into contact with the art of the Anglo-Saxons, who practised a colourful animal style in metalwork. On the Continent, the missionaries would have seen similar jewellery amongst the Franks and Lombards and also Early Christian Mediterranean artistic traditions. All of these enabled the monastic houses to foster a new hybrid art which, with variations, was shared by manuscript illuminators, metalworkers and later, monumental sculptors, in northern Britain and Ireland. In this art, Ultimate La Tène scrollwork remained a vital decorative element, but during the seventh century, filigree, complex casting imitating deep engraving, die-stamping of decorative foils, gilding and granulation were also borrowed by Celtic craftsmen from the Germanic world and, with these, they produced dazzling and highly colourful work.

The earliest great product of this style to survive is the Gospel book painted in the later seventh century and preserved at the monastery of Durrow, Co. Offaly, Ireland, until the seventeenth century. Each Gospel is preceded by a decorative "carpet" page—one displays interlace, another animal ornament of Germanic inspiration while a third contains a complicated composition of trumpet scrolls and spirals cunningly joined together to form an elaborate pattern of linked roundels. A fourth page is composed of a pattern of crosses. The interlace and strangely stylized Evangelist symbols were derived from Mediterranean art.

The style reached maturity with the Gospels painted at Lindisfarne, Northumbria in about AD 700. Here the Celtic tradition of constructing ornament with the use of a compass is evident not only in the Ultimate La Tène compositions but also in the animal ornaments of its great cross-carpet page. In metalwork, the refinement of the Gospels is matched by the great silver brooch, from Hunterston in Ayrshire, Scotland, by the "Tara" fibula from Bettystown, Co. Meath and by the door ornaments from Donore, Co. Meath. The last two objects, housed in the National Museum of Ireland, are both eigth

Carved stone

Mullaghmast (Co. Kildare), Ireland 6th century AD?
The decoration of this standing stone is located on the four sides of the piece, and although the nature of the ornamentation differs according to the side, all the motifs belong to the Ultimate La Tène style. On one panel the spirals are executed in relief whereas on another the curvilinear pattern has been incised.
Height: 91 cm.
National Museum of Ireland, Dublin.

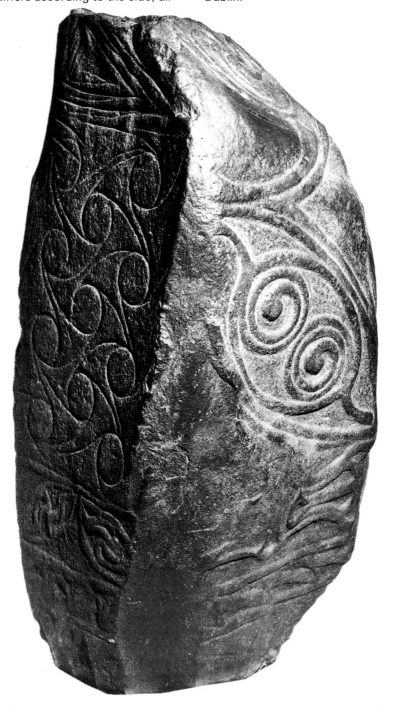

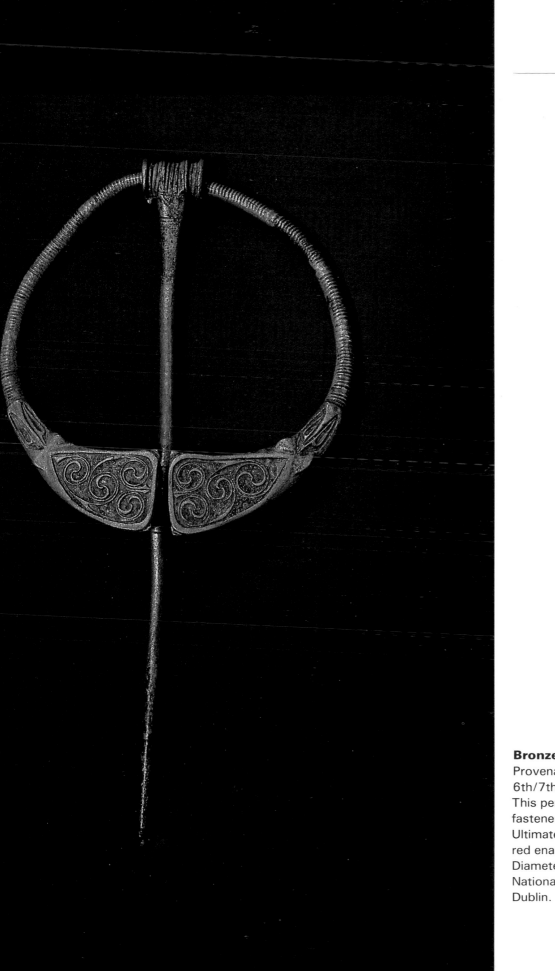

Bronze "penannular" fibula
Provenance unknown, Ireland
6th/7th century AD
This penannular or open ring cloak
fastener is decorated with
Ultimate La Tène scrollwork and
red enamel.
Diameter: 8.55 cm.
National Museum of Ireland,
Dublin.

131

century products of the Irish midlands school. The Late La Tène ornament of the manuscript and the metal objects when examined closely are found to be heavily influenced by Germanic beast motifs. The spiral endings are often no longer subtly shown bird-heads or petal-like lobes but massive snouted beast-heads, sometimes with a blunt crest and open jaws. They are severely stylized and often difficult to identify at first. A disc from the Donore find bears an elaborate composition of trumpet scrolls in tinned bronze seen as a reserve against a richly textured background. This beautiful pattern may be compared with the sophistication of the great Chi-Rho page of the Gospel book, the Book of Kells, which was preserved at the nearby monastery of Kells, Co. Meath for many centuries.

The Book of Kells owes much to the art of Pictland and its decoration echoes a magnificent series of carved slabs in Scotland. The latter, like the manuscript, are not dated with certainty but many would appear to be eighth or ninth century in date. They are characterized by animal ornament, figured scenes, often with hunting or processional themes, and frequently with elaborate Ultimate La Tène compositions of outstanding virtuosity. The slab from Hilton of Cadbole, Ross-shire, Scotland is an accomplished rendering of the repertoire which also includes the inhabited vine scroll of Mediterranean origin, interlace and a series of enigmatic symbols. The virtuosity of Pictish art can be seen also in the metalwork from the great hoard from St. Ninian's Isle, hidden about AD 800 and in the carved wooden box from Birsay, Orkney. The art of Kells has its metal equivalents in Ireland on the great Ardagh Chalice, Co. Limerick, and on the paten from Derrynaflan, Co. Tipperary both dating to the eighth century. There are extremely elaborate Ultimate La Tène compositions in stamped silver on the contemporary Moylough Belt Shrine from Co. Sligo, Ireland.

The interaction of Celtic and Anglo-Saxon traditions begun in the seventh century continued into the eighth and ninth centuries and Ultimate La Tène decoration occurs on some Anglo-Saxon monuments, for example, the carved stone frieze of the Church of Breedon-on-the-Hill at Leicestershire, England, and on the Gandersheim ivory casket now preserved at Braunschweig, Germany, but originally imported from England. In the eighth and, perhaps, early ninth century it survives in Anglo-Saxon manuscripts for example, in the Codex Aureus now in the Royal Library, Stockholm, in the Barberini Gospels in the Vatican Library and in the psalter, Cotton Vespasian AI, in the British Library. Mediterranean influences such as the occasional use of the vine-scroll motif on Irish sculptures were transmitted to Celtic craftsmen via Anglo-Saxon England.

The Viking raids on Britain and Ireland began in the later eighth century AD and there is no doubt that they were very

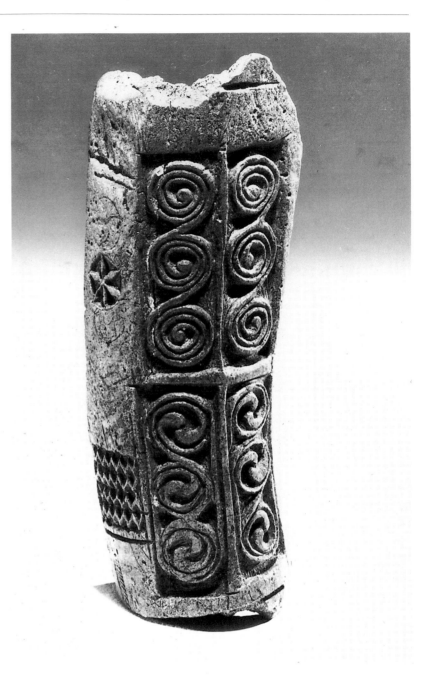

Carved antler "trial piece"
Dooey (Co. Donegal), Ireland
6th-7th century AD?
Possibly used by a craftsman as a "trial piece", this antler came from a settlement.
Length: 12 cm.
National Museum of Ireland, Dublin.

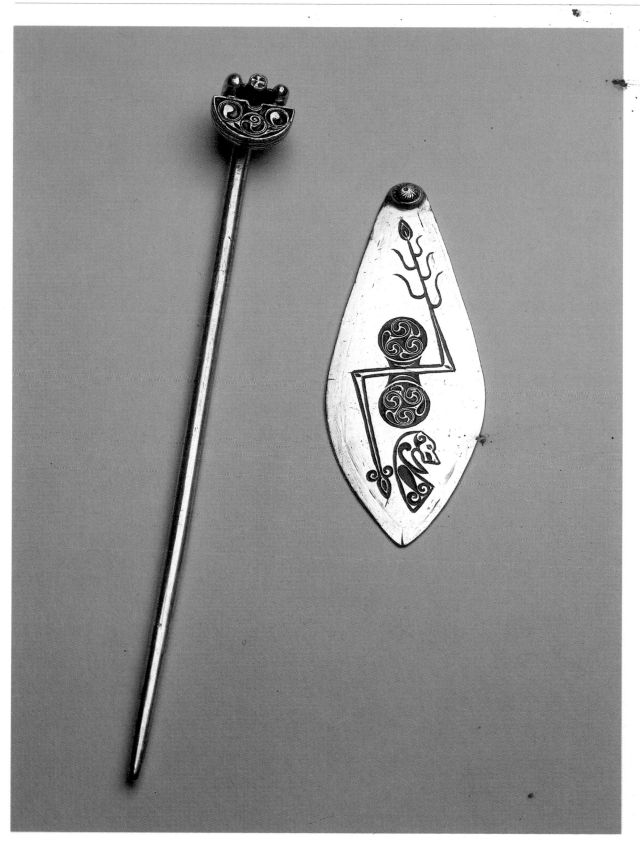

Pictish silver objects
Norrie's Law (Fife), Scotland,
United Kingdom
Possibly 6th-7th century AD
The decoration of the silver
plaque is a combination of
Ultimate La Tène repoussé
scrollwork and typical Pictish
symbols of uncertain significance.
Length: 9.1 cm.
Royal Museum of Scotland,
Edinburgh.

disruptive. A decline in quality of workmanship is detectable on major metalwork pieces such as the Derrynaflan Chalice. Numerous metal objects of Irish, Scottish and Northumbrian manufacture have been found in Viking graves in Norway and testify in part to the destructive effects of the early raids.

Irish sculpture—in the form of the ringed High Crosses—reaches a high standard in the later eighth and ninth centuries. Many of the crosses are devoted to Christian scriptural themes but one early group, probably mostly ninth century in date, is dominated by abstract interlace ornament, Ultimate La Tène animal interlace, and key- and fret-patterns. Pure ornament plays a major part also on the crosses with figured scenes and frequently occurs in the form of bossed fleshy scrolls, as on Muiredach's Cross, Monasterboice, Ireland, of the early tenth century. The use of panels of Ultimate La Tène scrollwork kept the tradition alive in stone well into the tenth century but in metalwork it was already in decline and examples are very rare after c. AD 900. The Ultimate La Tène style is entirely absent from the metalwork of the later eleventh and twelfth centuries, and only rarely appears in stone. This change in taste seems to have coincided with alterations in craft organization and patronage. However, the survival of the style over such a long period was due to the conservative spirit of the Celtic artist which encouraged a last flowering and thus enhanced the cultural heritage of Europe.

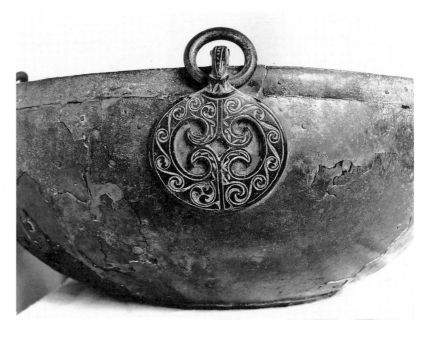

Bronze hanging bowl
Baginton (Warwickshire), England, United Kingdom
6th century AD
This hanging bowl displays enamelled Late La Tène decoration and is from an Anglo-Saxon cemetery.
Diameter of bowl: 30.5 cm.
Herbert Museum and Art Gallery, Coventry.

Bronze enamelled hanging bowl, (Winchester), England, United Kingdom
6th century AD
From an Anglo-Saxon grave, this hanging bowl displays Late La Tène decoration.
British Museum, London.

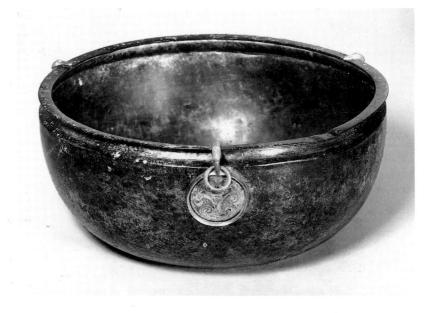

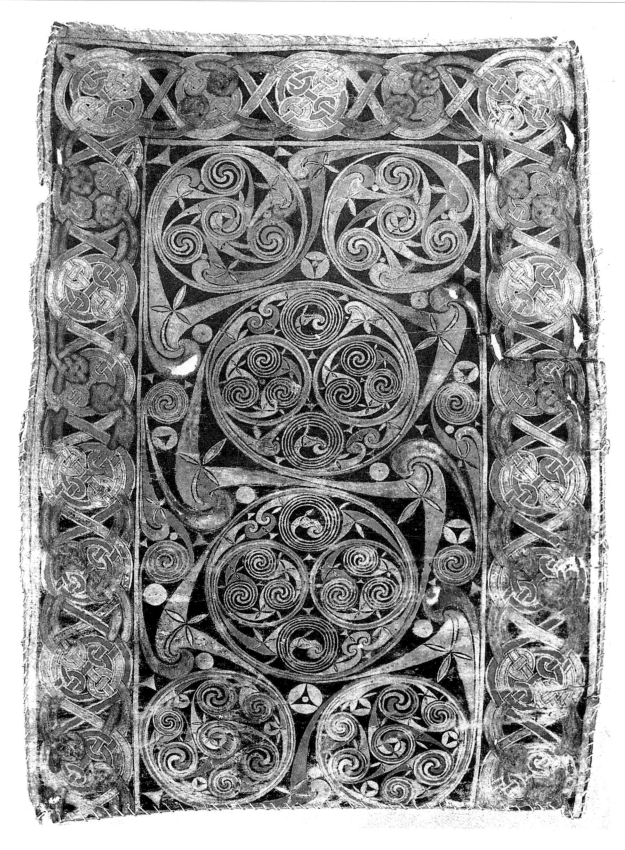

"Carpet" page, Book of Durrow
Durrow (Co. Offaly), Ireland
Later 7th century AD
One of the display folia placed at the beginning of each gospel in the manuscript, this "carpet" page contains an interlace ribbon frame which surrounds the central area, which is composed of Ultimate La Tène motifs in yellow, green and red against a black background.
Trinity College Library, Dublin.

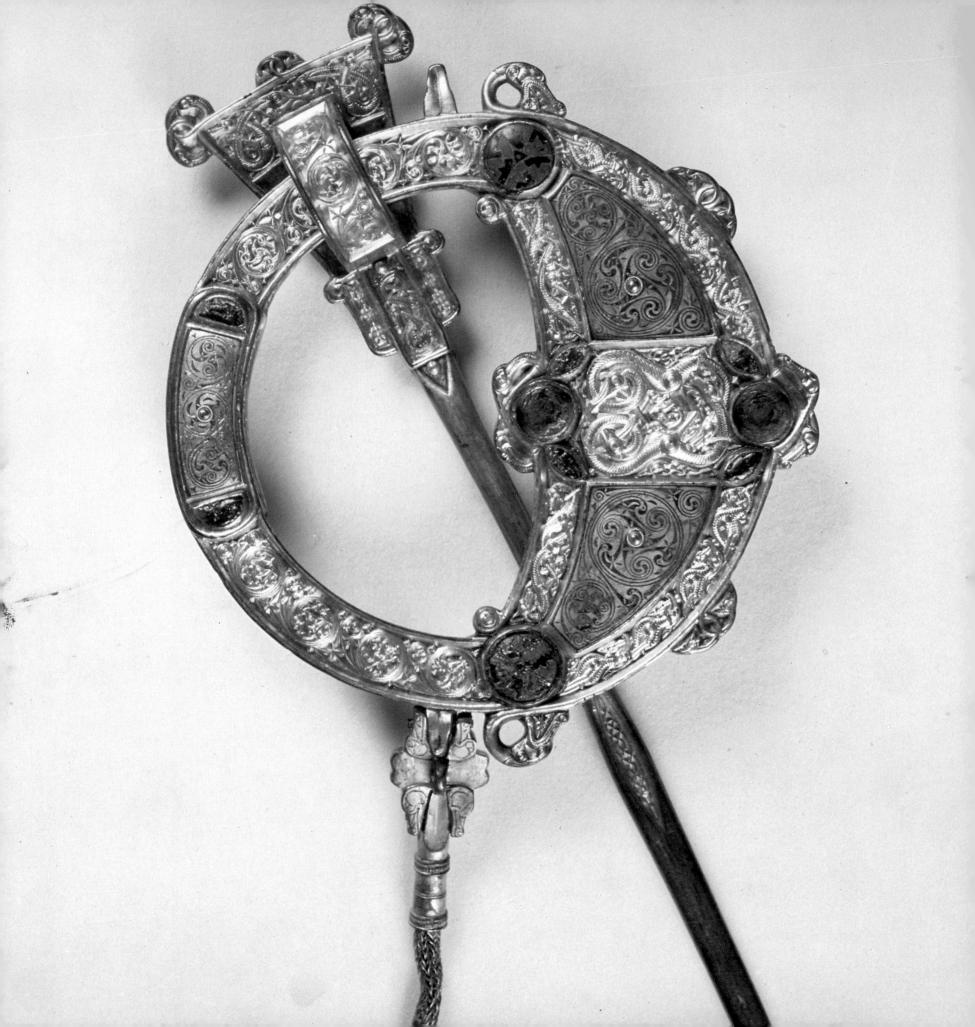

The "Tara" fibula, reverse
Bettystown (Co. Meath), Ireland
Early 8th century AD
A cast gilt-silver brooch
decorated with animal interlace,
enamelling, filigree, engraving.
Plaques with Ultimate La Tène
motifs (spirals, triskeles etc.) were
inserted into areas of chip-carved
interlaced beasts.
Total lenght: 22.2 cm.
National Museum of Ireland,
Dublin.

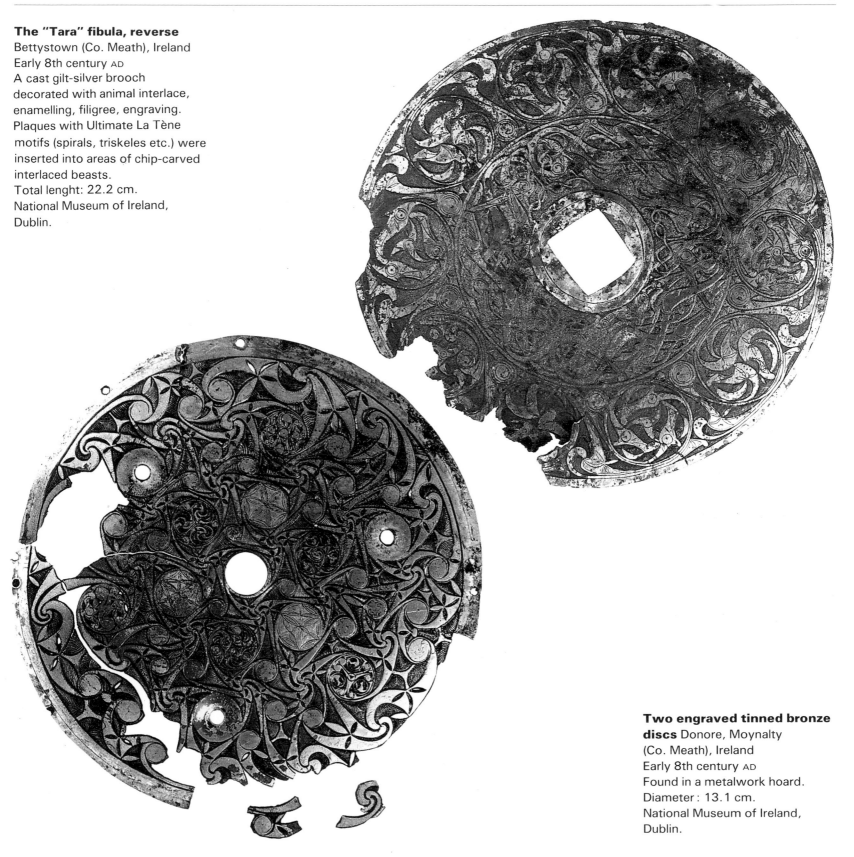

**Two engraved tinned bronze
discs** Donore, Moynalty
(Co. Meath), Ireland
Early 8th century AD
Found in a metalwork hoard.
Diameter: 13.1 cm.
National Museum of Ireland,
Dublin.

137

**Gilt-bronze, openwork
crucifixion plaque**
Rinnagan, St. John's near
Athlone
(Co. Westmeath), Ireland
8th century AD
Possibly a book-cover, this
crucifixion plaque portrays a large
central Christ with two angels
above, and Stephaton and
Longinus below. The clothed
nature of the crucified Christ
provides an extra area for all-over
decoration. Large peltas with relief
spiral motifs form a breast-plate,
while angular zig-zag and interlace
pattern the skirt of Christ's robe.
Triskeles, spirals and hatching
decorate the angels' wings and
the outer robes of the two figures
below.
Height: 21.1 cm.
National Museum of Ireland,
Dublin.

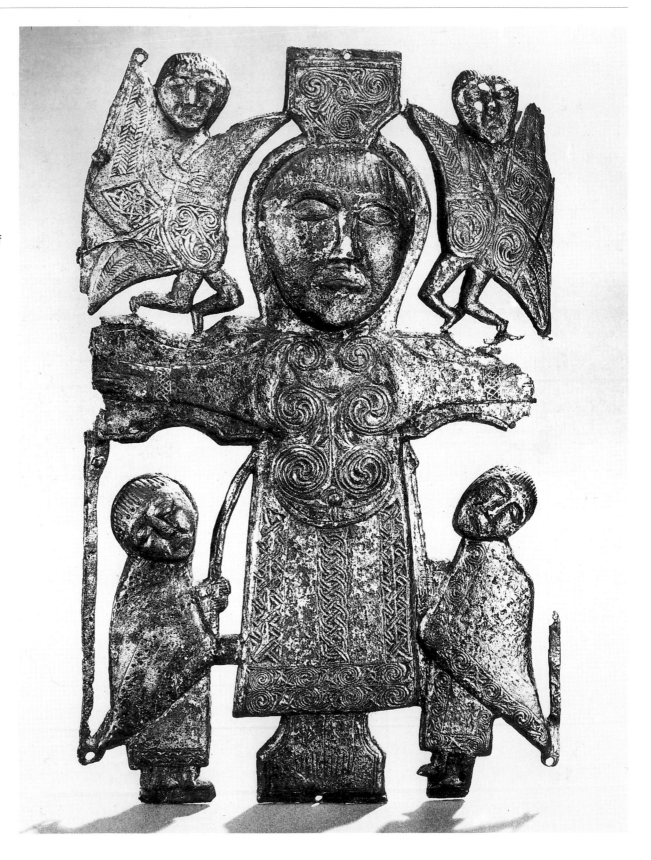

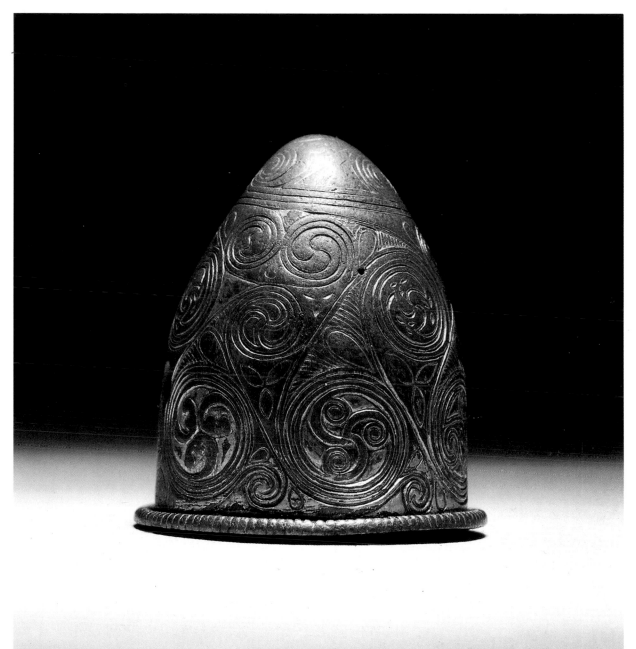

Gilt-silver cone
St. Ninian's Isle, Shetland,
Scotland, United Kingdom
8th century AD
Of unknown use, possibly the
cone is a garment fastener. It was
found in a Pictish hoard deposited
found in a Pictish hoard deposited
c. AD 800 in an ancient church.
Royal Museum of Scotland,
Edinburgh.

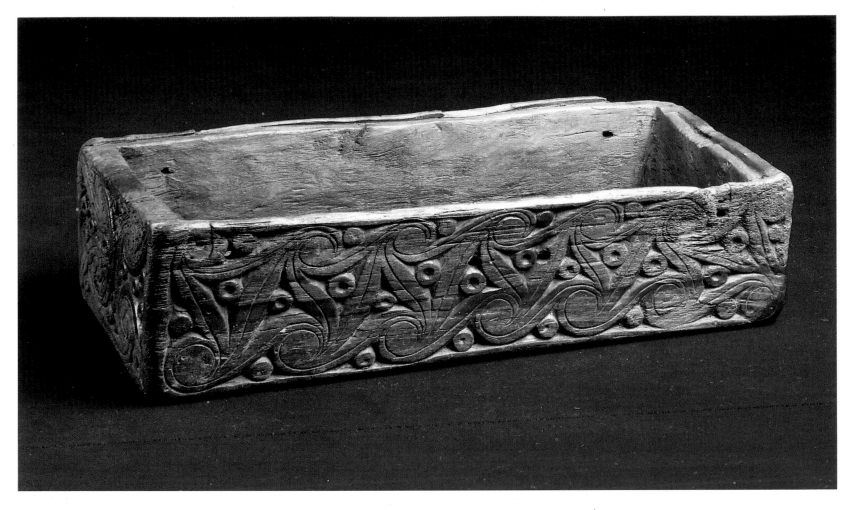

Carved wooden box
Birsay (Orkney), Scotland,
United Kingdom
8th-10th century AD
It contained the tools of
a leatherworker.
Length: 30 cm.
Royal Museum of Scotland,
Edinburgh.

Pictish carved stone
Hilton of Cadboll (Rosshire),
Scotland, United Kingdom
8th-9th century AD
Edinburgh, Royal Scottish
Museum.

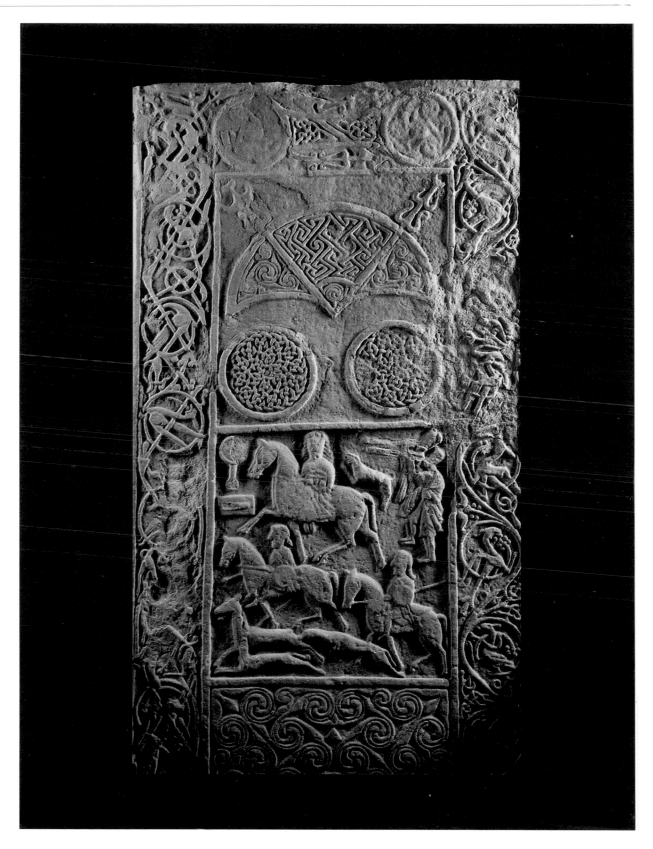

The Hunterston Brooch
Ayrshire, Scotland, United
Kingdom
Early 8th century AD
Silver-gilt with filigree ornament.
Width: 11.7 cm.
Royal Museum of Scotland,
Edinburgh.

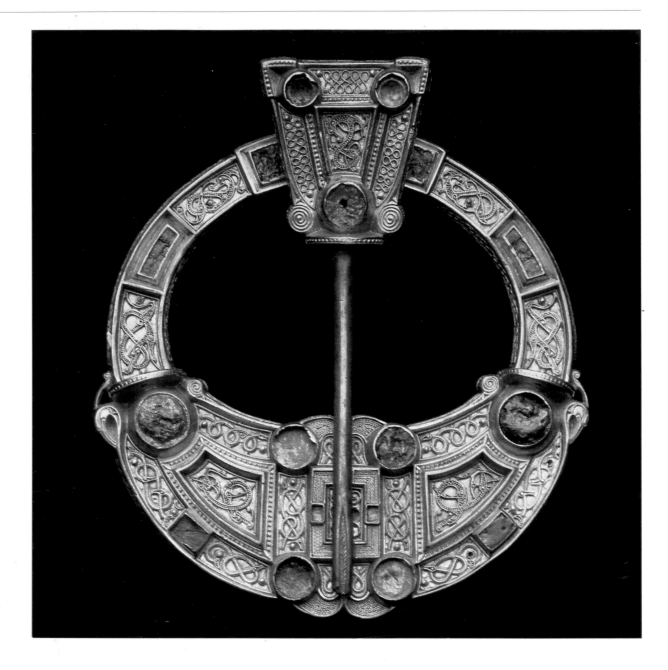

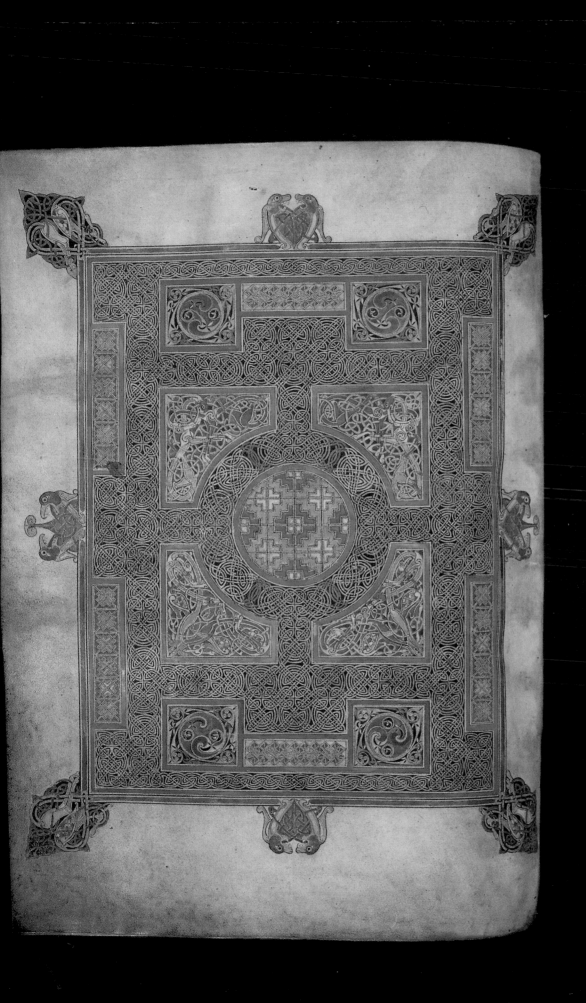

"Carpet" page, Lindisfarne Gospels

Lindisfarne (Northumbria),
England, United Kingdom
Early 8th century AD
This "carpet" page is an example
of the intricacy and ornateness
achieved by artists in the early
eighth century. The simplicity of
the Book of Durrow "carpet" page
(discussed above) is here
forgotten as highly precise
patterns and intricately woven
motifs predominate. The
decoration consists not only of
Ultimate La Tène elements, but
also of interlace, both ribbon and
animal, which derive from
Germanic sources.
British Library, London.

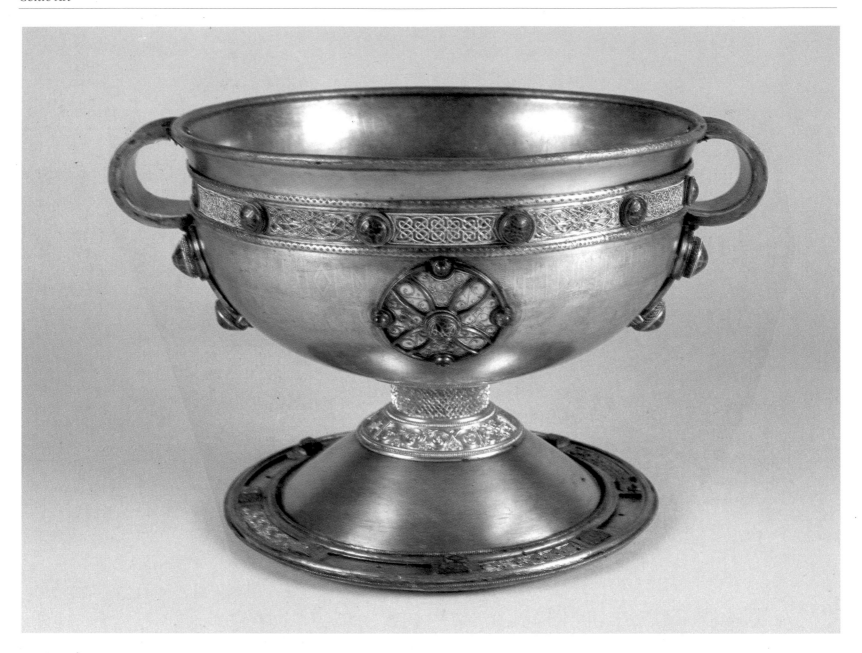

Silver chalice
Ardagh (Co. Limerick), Ireland
8th century AD
Found in a hoard, the decoration of the Ardagh Chalice is organized according to a system of panels along the bowl girdle, knob, handles and foot. As on the "Tara" brooch, various techniques and various materials are employed (filigree, chip-carving, enamelwork and millifiori for example). Animal interlace is found on the bowl girdle as is an inscription with the names of the Apostles, and Ultimate La Tène ornament is located on the escutcheons.
Height: 15 cm.
National Museum of Ireland, Dublin.

Carved stone cross
Ahenny (Co. Tipperary), Ireland
9th century AD
Located in a graveyard at Ahenny,
the decoration of this cross
displays similar motifs to those
found on metalwork objects for
example, rope mouldings, spirals,
foliage patterns and interlace.
Height: c. 3.70 m.

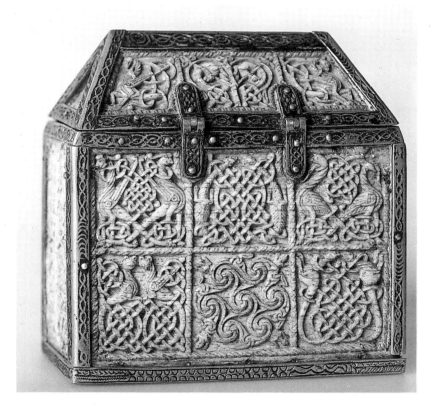

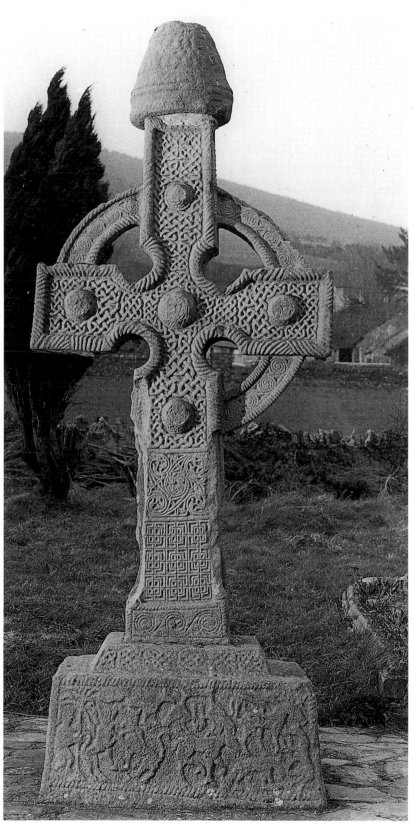

Carved ivory casket
Gandersheim, Federal Republic
of Germany
Late 8th century AD
Of Anglo-Saxon workmanship,
this reliquary decorated with
figurative scenes incorporates
Ultimate La Tène elements.
Herzog Anton-Ulrich Museum,
Braunschweig.

Carved stone friezes
Breedon-on-the-Hill
(Leicestershire), England,
United Kingdom
Late 8th century AD
Located in the Anglo-Saxon
Church.

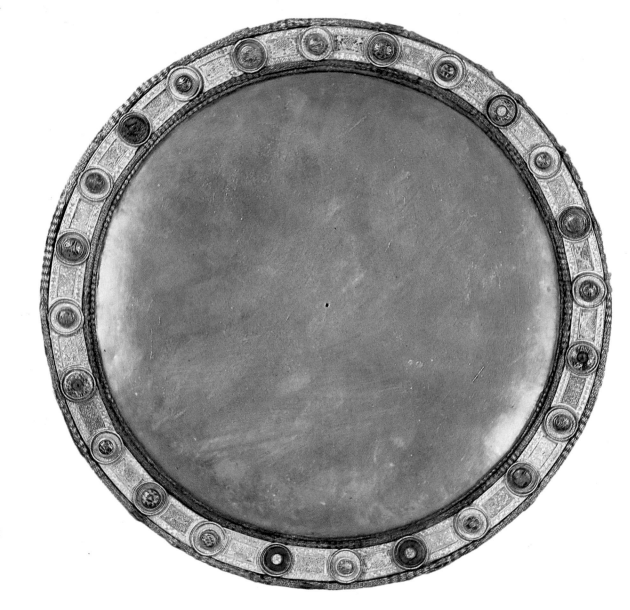

Silver paten
Derrynaflan (Co. Tipperary),
Ireland
8th century AD
Gold filigree and enamel ornament
decorate the paten.
Diameter: 35.7-36.8 cm
National Museum of Ireland,
Dublin.

146

The *Chi-Rho*
(Monogram of Christ)
Book of Kells
(Co. Meath), Ireland
Late 8th-9th century AD
Even more elaborate than the
Lindesfarne Gospels, the Book of
Kells is taken to mark the high
point of Celtic manuscript
illumination. In this manuscript the
Chi-Rho is given a page to itself,
and the decoration consists of
panels of animal or ribbon
interlace, areas of Ultimate La
Tène ornament, human faces,
animals, etc., all executed with
the utmost precision.
Trinity College Library, Dublin.

Bronze Bowl
Jaaten, Hetland parish, Rogaland,
Norway
8th century AD?
Bears Ultimate La Tène
decoration. Re-used as a
weighing-scales box. Irish
workmanship?
Diameter: 10.5 cm.
Bergen Historisk Museum,
Bergen.

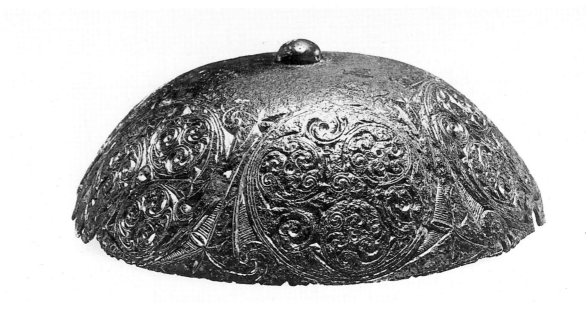

Bronze censer
Vinjum, Vangen Parish, Sogn of
Fjordane, Norway
8th century AD
Found in a woman's grave of the
ninth century, the censer is
decorated with simple interlace,
animal interlace and Ultimate La
Tène scrollwork.
Diameter: 12.5 cm.
Bergens Historisk Museum,
Bergen.

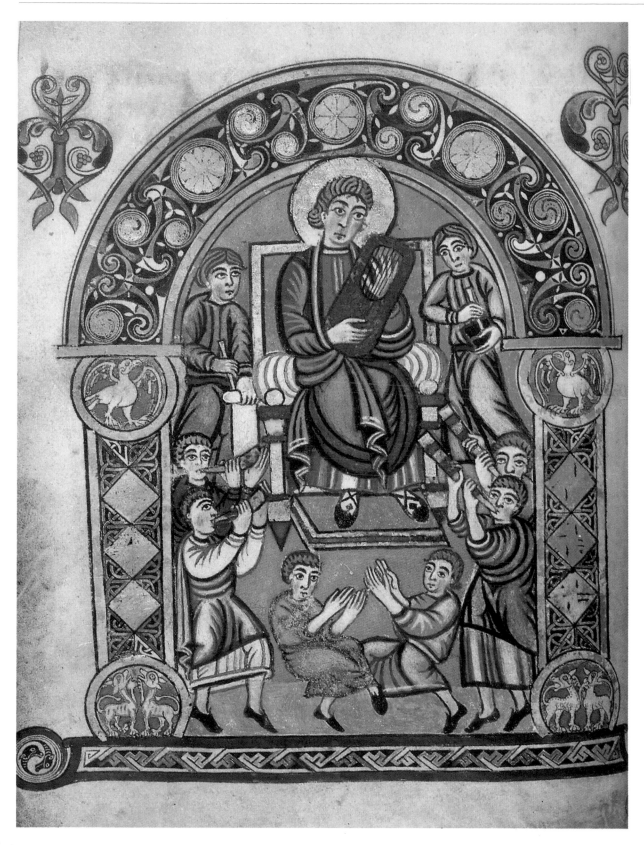

Anglo-Saxon manuscript
Cotton Vespasian, A.I.
Late 8th century AD
This folio portrays King David and
Musicians.
British Library, London.

Carved High Cross
Monasterboice (Co. Louth), Ireland
Early 10th century AD
According to an inscription on the
plinth, this cross was erected by
Abbot Muiredach. Decorated on
both faces with narrative scenes
from the Old and New
Testaments, the novelty of this
cross lies in the fact that it
appears to be an iconographic
programme relating the theme of
Redemption. The base, although
weathered, has abstract
ornament.
Total height: 5.50 cm.

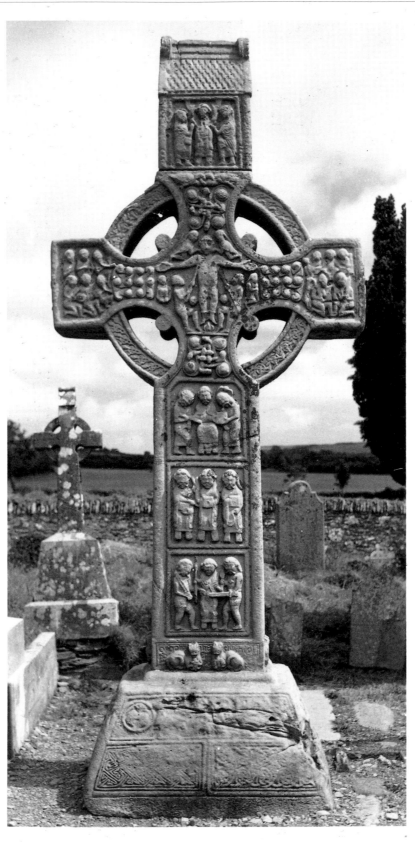

**Book reliquary, the *Soiscél
Molaise*** (Gospel of St. Molaise),
Devenish (Co. Fermanagh), Ireland
Late 8th century AD, restored and
re-ornamented in first quarter of
11th century.
The garment of the eleventh
century Evangelist, upper left, is
decorated with Ultimate La Tène
scrollwork.
National Museum of Ireland,
Dublin.

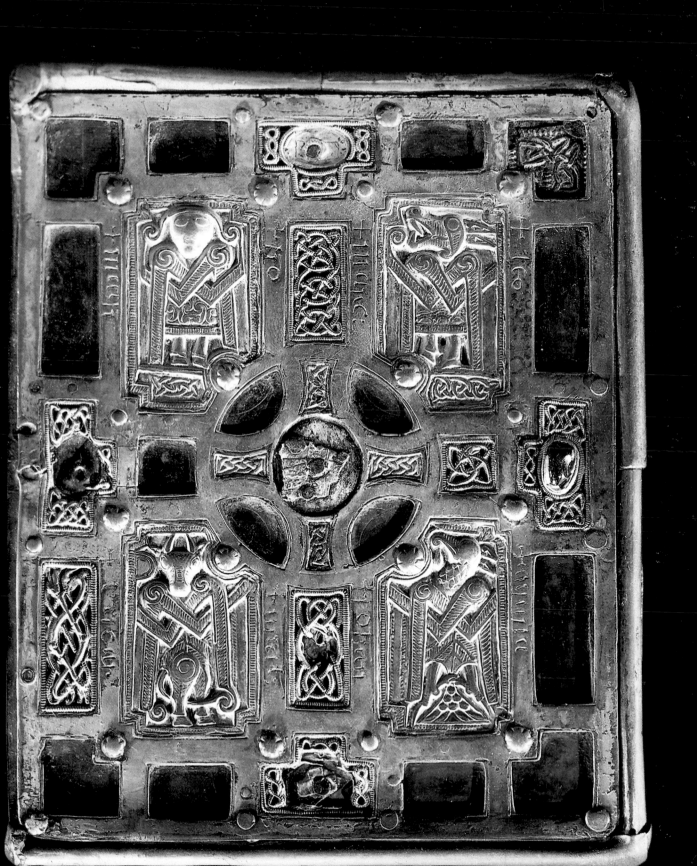

General conclusions: the unity of Celtic art

Celtic art was the first to blossom across all of Europe, from Ireland to the Black Sea. It differs from the art of Antiquity in its decoration where curves of Greek, Etruscan and Roman plant motifs predominate, in its amalgamation of naturalistic elements, employed in imaginary combinations, and in its metamorphosis of living or abstract subjects. The development of this tendency towards abstraction ultimately leads to the transformation of the faces depicted on the coins into compositions resembling those seen in modern contemporary art.

The unity of Celtic art is witnessed by the many objects preserved in museums, which were made on the Continent from the end of the fifth century to the end of the first century BC, and in the British Isles up to and including the Christian era. This unity is explained and demonstrated in several ways. Geographically, middle Europe, between the Nordic plains and the hilly Mediterranean regions, has a temperate climate which favours not only the mysteries of the forest with its powerful and fearsome animals (deer, wolves, wild boar and snakes), but also the wealth from agriculture and stock raising, a bountiful water supply and ample resources of iron and stone. This climate is conducive to mists and clouds which beget changing, weird and monstrous forms.

The sharing of one language from one end of Europe to the other reflected the common origins of the tribes that spoke it, and their works of art were infused with the same kind of spirit, which was inclined to transform living things into fleeting images. The Celts, the invaders who had become settled and who were united by their language, thus revealed a unity that was particularly propitious to artistic creation.

Celtic art, like all art, was inspired by religion. The paganism of the Celts was somewhat different from that of the Greeks and the Romans and it was backed by the authority of the druids, who were the guardians of religion, writing, teaching, the calendar and culture. Their polytheism, although less advanced than that of the Romans, manifested itself through animal powers, various monsters and collective goddesses. Gods and demigods were depicted only to a limited extent and in the coins this is just beginning to be recognized.

The choice of subjects also was marked by unity. Quadrupeds, birds, fish and reptiles, often precisely represented, merge with plant motifs, which lend themselves to transformations. Compositions which combined the animal and vegetal world were preferred to those depicting the human body. In fact, there are few examples of a faithful and detailed representation of the human body. But these subjects often combine to form an imaginary being, sometimes monstrous, as though everything in the world were metaphysically linked. The treatment of these subjects is a source of bafflement for, in each case, the Celts present us with riddles.

The materials and techniques used by the Celts also give rise to a kind of unity. Their art, as it has come down to us in the absence of permanent architecture, consists of hard or hardened objects: metal (iron, bronze, gold and silver), stone, wood, leather, glass and clay. There is no painting (except on pottery), no wax, no wickerwork and virtually no weaving. Iron engraving and abstract sculpture in bronze both derive from the Celts who combined the techniques of engraving and sculpting most effectively. Their strong point was the creation of tiny sculptures, particularly for the embossed engraving of coinage.

Celtic art then, is pre-eminently European. Before the advent of Christianity, central Europe had never known any other art which was adapted, as Celtic art was, to its geography and temperate climate, to a people speaking the same language and expressing both a free spirit and a propensity for transmutation and abstraction. Celtic art also was adapted to a particular setting and to rich and precious materials. A French geographer, Étienne Le Lannou, speaking of the vast, extensive territory that constitutes Europe, rich in natural resources, has described it as a "promised land". Celtic art is an early, modest, but curious and striking, expression of this bountiful unity.

Silver cauldron, Gundestrup, Denmark
1st century BC
The famous silver cauldron, found dismantled in a marsh at Gundestrup in 1891, is the richest iconographic document which yields information about Celtic art and religion. Furthermore, it is the only object of such artistic importance to have survived intact. It displays the fluidity of style characteristic of the Celts of central or western Europe, and the combination of changing motifs which eventually become abstract compositions. It attests to an art which essentially existed in the eastern zones of the Celtic world.

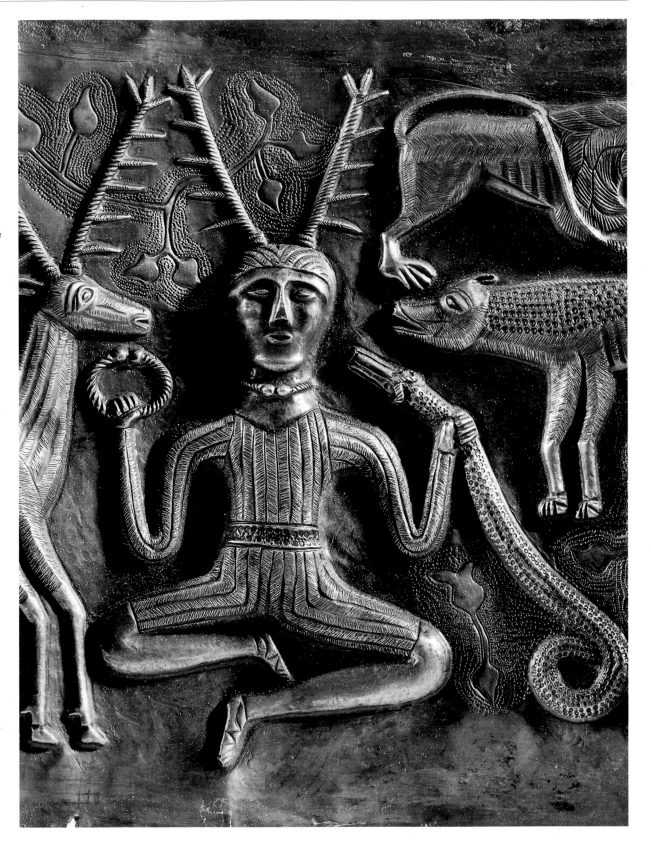

The seven centre plates portray various well-known Celtic divinities in a simple and direct style. The iconography of three of the five inner plates is also derived from Celtic mythology.

Cernunnos, the god of the deer forest, brandishes a serpent with a ram's head; *Taranis,* the all-powerfull god of the sky, is surrounded by beasts and a helmeted warrior holding a wheel; finally, in front of a giant (perhaps a divinity) who is drowning a figure in a basin of water (human sacrifice?), a procession of mounted and marching warriors carrying shields, and trumpeters is depicted. The base plate of the cauldron portrays a bull surrounded by a hunter(?) and two dogs. Thus, an amalgamation of religious and social themes proper to the Celtic world is portrayed on this cauldron, but in a style which has many non-Celtic elements. Max. diameter: 0.69 m.
National Museet, Copenhagen.

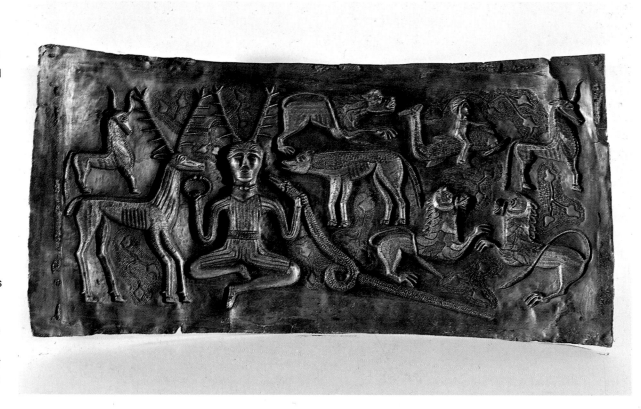

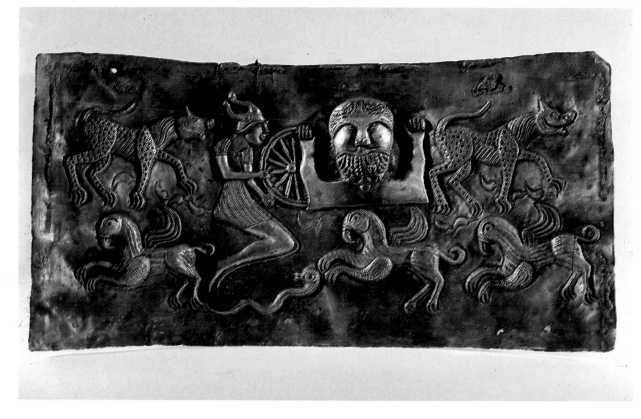

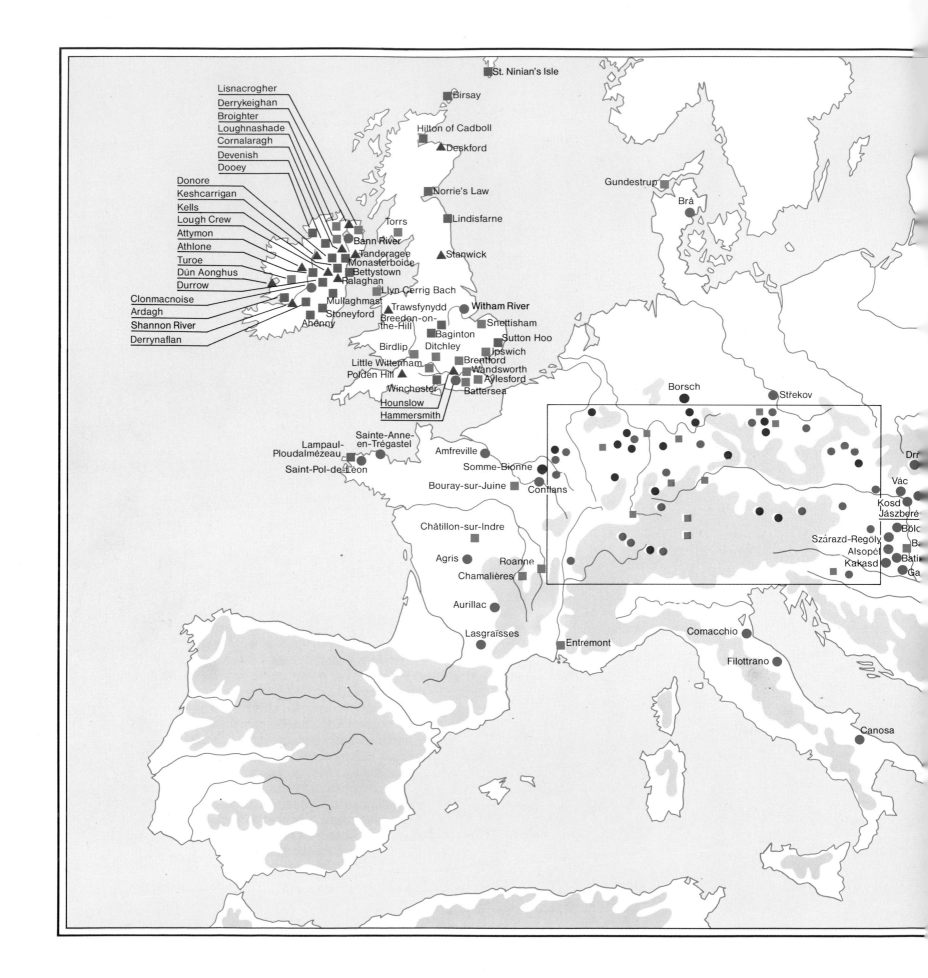

St. Ninian's Isle

Birsay

Hilton of Cadboll
Deskford

Gundestrup
Brå

Lisnacrogher
Derrykeighan
Broighter
Loughnashade
Cornalaragh
Devenish
Dooey

Norrie's Law

Torrs
Lindisfarne

Donore
Keshcarrigan
Kells
Lough Crew
Attymon
Athlone
Turoe
Dún Aonghus
Durrow
Clonmacnoise
Ardagh
Shannon River
Derrynaflan

Bann River
Tanderagee
Monasterboice
Bettystown
Ralaghan
Mullaghmast
Stoneyford
Ahenny

Stanwick

Llyn Cerrig Bach
Trawsfynydd
Breeden-on-the-Hill
Baginton
Birdlip
Ditchley
Little Wittenham
Polden Hill
Winchester

Witham River
Snettisham
Sutton Hoo
Ipswich
Brentford
Wandsworth
Aylesford
Battersea
Hounslow
Hammersmith

Lampaul-
Ploudalmézeau
Saint-Pol-de-Léon

Sainte-Anne-
en-Trégastel

Amfreville

Somme-Bionne

Bouray-sur-Juine
Conflans

Borsch
Střekov

Drr
Vác
Kosd
Jászberé

Châtillon-sur-Indre

Agris
Roanne
Chamalières

Szárazd-Regöly
Alsopé
Kakasd

Bölc
Ba
Bati
Ga

Aurillac

Lasgraïsses

Entremont

Comacchio

Filottrano

Canosa

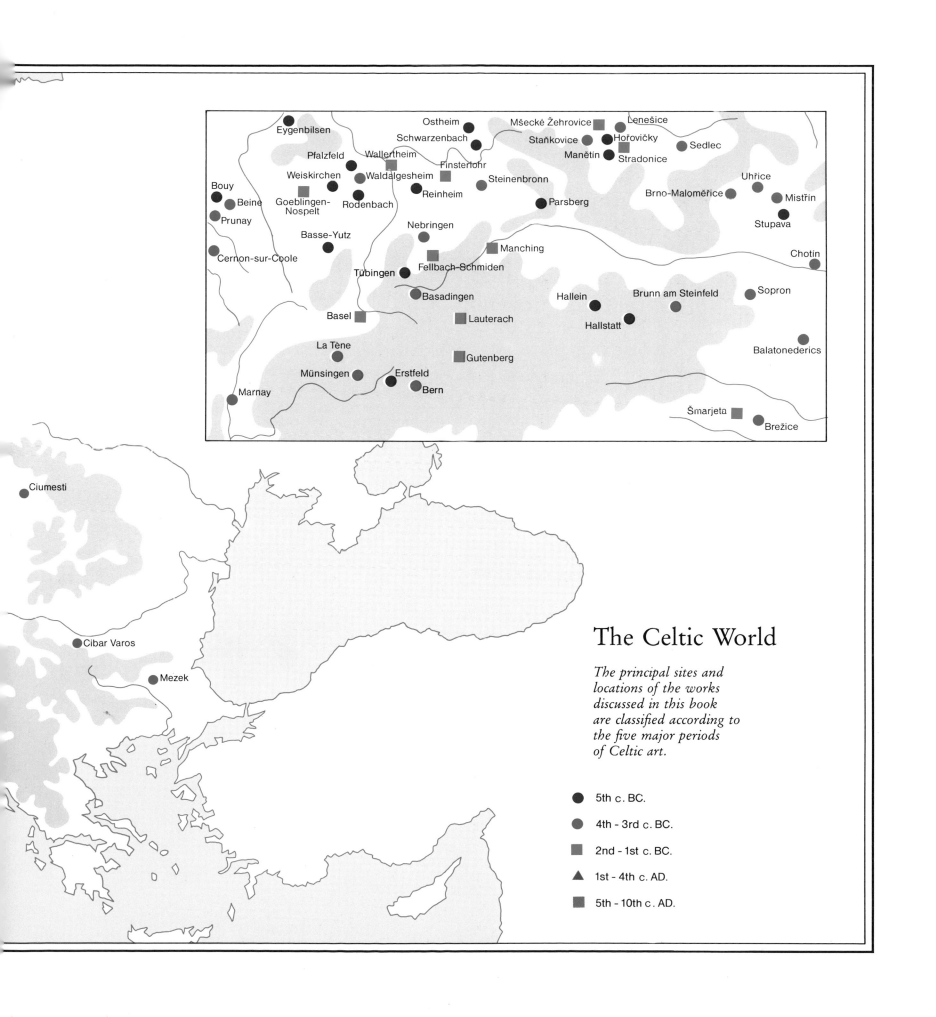

Eygenbilsen
Ostheim
Mšecké Žehrovice
Lenešice
Schwarzenbach
Staňkovice
Hořovičky
Sedlec
Pfalzfeld
Wallertheim
Manětín
Stradonice
Weiskirchen
Waldalgesheim
Finsterlohr
Uhřice
Bouy
Brno-Maloměřice
Mistřin
Beine
Goeblingen-
Nospelt
Rodenbach
Reinheim
Steinenbronn
Prunay
Stupava
Basse-Yutz
Nebringen
Chotín
Cernon-sur-Coole
Manching
Tübingen
Fellbach-Schmiden
Sopron
Basadingen
Hallein
Brunn am Steinfeld
Basel
Lauterach
Hallstatt
La Tène
Gutenberg
Balatonederics
Münsingen
Erstfeld
Marnay
Bern
Šmarjeta
Brežice

Ciumesti

Cibar Varos

Mezek

The Celtic World

*The principal sites and
locations of the works
discussed in this book
are classified according to
the five major periods
of Celtic art.*

● 5th c. BC.

● 4th - 3rd c. BC.

■ 2nd - 1st c. BC.

▲ 1st - 4th c. AD.

■ 5th - 10th c. AD.

DATES	PERIODS	CELTIC ART
500 BC		
	Early La Tène	**Early Style** "Orientalizing" themes and motifs, derived from the Etruscan repertoire. Compass decoration. Compositions with axial symmetry. Mask-fibulae, ring ornaments of gold, chariot fittings, phalerae, belt-hooks, scabbards, sculptures, wine flagons.
400		
		Waldalgesheim Style or Continuous Vegetal Style Added to the earlier elements are borrowings from the Greek repertoire of Italy: foliage and the "pelta" (the Celtic palmette) become popular. Added to compositions with axial symmetry are compositions displaying a rotating symmetry. Coral becomes popular and enamel in first used. Helmets, scabbards, chariot fittings, torcs and bracelets, fibulae with vegetal decoration, wine flagons, "red-figure" pottery.
300		
	Middle La Tène	**Plastic Style and Sword styles** Golden age of "plastic metamorphosis" (combinations of human, animal, vegetal and abstract forms). Hellenistic influences. Complex compositions combining different forms of symmetry. Climax of *lost wax* casting, "Pseudo-filigree" and "pastillage", ornaments of multi-coloured glass. Scabbards, torcs, bracelets and anklets, fibulae, chariot fittings, Brno-Maloměřice flagon, Brå cauldron.
200		
	Late La Tène	**Late Celtic art of the Oppida period** Influences of Roman art and technology. Painted pottery, sculpture of the south of France, Gaulish representations in sheet bronze, wooden sculptures. Climax of the art of the coinage.
100		
BC	Roman Imperial Period	
100		
400		
500 AD	Early Medieval	

	c. 450	Herodotus mentions Celts in western Europe and at the source of the Danube.
	400	Celtic invasions of northern Italy with displacement of the Etruscans
	387/386	Celts defeat the Romans at the Allia river and occupy Rome
	335	Alexander the Great receives a Celtic delegation during a campaign in the Balkans
Autonomous development of insular art (3rd to 1st century BC) Clonmacnois torc, scabbards, shields.	295	Senones defeated at Sentinum by the Romans
	283	Final Roman victory over Senones
	280	Celts invade Macedonia
	279	Sack of Delphi
	278/277	Celtic (Galatian) migration to Asia Minor
	275	Comprehensive defeat of the Celts in Asia Minor by Antiochos I
	c. 233/232	Attalos I defeats the Celts in Asia Minor
	225	Major Roman victory over Boii and Insubres at Telamon
	c. 213	Probable end of the kingdom of Tylis
	205	Roman conquest of Spain complete
	194	Defeat of Boii and Insubres near Mediolanum (Milan)
	125	Establishment of Roman provinces
	c. 120	Incursions by the Germanic Cimbri and Teutones into the territory of the Celts
Autonomous development of insular art Complex compositions with compass elaborations, multicoloured champlevé enamel. Gold torcs, mirrors, scabbards, shields. Harness fittings.	c. 86	Significant Roman victory over the Scordisci
	c. 70	Germanic leader Ariovistus enters eastern Gaul
	58-51	Caesar's Gallic wars
	c. 50	Dacians defeat the Boii
	15	Alpine campaign of Drusus and Tiberius
	43	Emperor Claudius commences the Roman occupation of Britain
	78-86	Campaigns of Agricola in Britain. Roman frontier established on the river Clyde and on the Firth of Forth
	367-369	Significant Saxon incursion into Britain
	407	Constantine III begins definitive withdrawal of Roman troops from Britain
Christian art of the insular Celts Influences from the animal art of the Germanic peoples. Penannular brooches, liturgical vessels, shrines and other religious objects, carved stone crosses, illuminated manuscripts.	432	Patrick sent as bishop to Ireland
	441/442	Angles, Saxons and Jutes invade Britain
	c. 450	Pressure from invading Saxons brings about migration of Celts from Britain to Armorica

159

Glossary

Anklet Leg ornament, generally worn in pairs, which was in all probability a symbol of social rank among the many Celtic groups in which it occurs. Examples dating from before the fourth century BC are decorated solely with geometric ornament. In the following century anklets in the Danubian region, composed of a series of hollow, oval elements decorated in high relief, constitute one of the major achievements of the "Plastic Style" of Celtic art.

Anthropomorphic In human form. In the context of La Tène art the term applies above all to certain fibulae of the fifth century BC (the so called "mask fibulae"), to the handles of Danubian *kantharoi* (see below) of the third century BC and to the hilts of swords throughout the whole of the La Tène period.

Blank Metal disc—of gold, silver or bronze—having a fixed weight, which was placed between fixed and movable die-stamps and transformed into a coin.

Boii A powerful Celtic tribe, probably originating in that region of central Europe which corresponds today with Bohemia and the neighbouring region of Bavaria. Around 400 BC these people almost completely abandoned their ancestral territories and migrated to Italy where they settled in the region between the Po and the Appenines, in the vicinity of modern Bologna. At war with Rome throughout the third century BC, they were definitively defeated by them in 191 BC and went back to central Europe. There they successfully repulsed the Cimbri and Teutones around 120 BC and gave their name to Bohemia (the *Boiohaemum* "land of the Boii" of the Antique authors). Another branch, established in Pannonia in the vicinity of the modern city of Bratislava, was crushed by a Dacian incursion around the middle of the following century.

Calendar Unique and quite distinct from the calendars of the Greeks and Romans, it is known through two surviving examples on bronze plaques made in Gaul (Coligny and Villards d'Héria), during the Roman Imperial period, although they were by then no longer used in everyday life and are likely to have been used for ritual purposes. This type of calendar is extremely elaborate, and is an ingenious adaptation of a lunar calendar to a solar year.

Carnyx Celtic war trumpet played in an upright position. The bell end is generally in the form of a boar's head, an animal which was venerated by the Celts for its courage and which was associated with an important divinity.

Cauldron Container which, among the Celts, probably served a ritual function, at least the richly ornamented examples, which are sometimes of considerable size. They are often present on coins in association with other symbolic items.

Celtiberians Celtic peoples of the Iberian Peninsula, probably established there from the beginning of the first millennium BC. Because they were isolated from the Celtic foci of central Europe which developed the Hallstatt and La Tène cultures, their cultural evolution was quite different and it is not till the early third century BC that clear La Tène influences can be traced to them.

Celtoligurians Name given to peoples in Provence and modern Piédmont, considered as the descendants of an ancient Ligurian substratum celticized at a date difficult to establish but probably before the middle of the last pre-Christian millennium.

Cernunnos Antlered god of the Celts. Known from numerous representations, the "horned" god ("Cornu": hence the name) is so-named on a Parisian bas-relief from the Gallo-Roman period.

Chariot The Celts were known as excellent charioteers and their vehicles were highly regarded. The commonest form, the light, two-wheeled chariot drawn by two horses, was used for war, races, festive occasions and processions. They sometimes accompanied the deceased to the grave, especially in the fifth and early fourth centuries BC. Naturally, it is only the metal fittings (linch-pins, axle-mounts, yoke-fittings, etc.) which survive.

Compass A few examples with movable arms are known; it was used by the La Tène Celts from the fifth century BC onwards to construct the outlines of complex decoration or to create such by engraving them directly onto metal or bone. Their considerable virtuosity in this technique is well illustrated by the British mirrors of the first century BC.

Continuous Vegetal Style Term introduced by V. Kruta to describe the trend which transforms Celtic art as a result of borrowings from the Greek repertoire in Italy, most notably the introduction of foliate patterns, in the fourth century BC. It includes the idea of the "Waldalgesheim Style" of P. Jacobsthal but extends it by including all those objects which are older than the material of the Waldalgesheim tomb.

Coral This coloured material, probably mainly imported from the Bay of Naples, was very popular among the Celts, particularly in the fourth and early third centuries BC before direct contacts were interrupted by the Roman advance. Coral, initially introduced into the Hallstatt world at the end of the sixth century BC, was without doubt highly regarded for the magical properties which it was believed to possess.

Die Unit of solid bronze in which was engraved on a concave surface the obverse image of the coin (fixed die, secured in a length of wood) or the reverse image (a movable die, held in the hand, which was struck with a mallet in the course of stamping).

Dragons The term "dragon" is used in La Tène art to describe the monstrous creatures, matched in contrasting pairs, which are the guardians of the Tree of Life and appear with particular frequency on sword scabbards.

Drinking horn Part of the ceremonial drinking service found in the so-called princely graves from the sixth century BC onwards. It is generally made from the horn of an ox decorated with metal fittings, but several examples made entirely of metal are also known.

Early Style The first phase of Celtic art (second half of the fifth and early fourth century BC) as defined by P. Jacobsthal in 1944. The French equivalent is defined by P.-M. Duval as the *"Premier style"*.

Electrum Alloy of gold and silver used for certain issues of Celtic coinage subsequent to a reduction in the original weight of fine gold.

Embossing Technique of shaping metal which consists of pressing it into a negative form created in a block of metal. This process, the reverse of the technique of stamping, is likely to have been used by the Celts to produce extremely refined designs on iron objects.

Enamel The Celts were excellent enamel-workers. The oldest use of this material, however, dates no earlier than the beginning of the fourth century BC and consists exclusively of a red glass paste. Most often enamel appears in the form of discs which are an imitation of coral studs and are riveted onto the object. Thereafter follow the first attempts at the inlay of this type of enamel into specially prepared panels on the object. This is the beginning of the technique known as *champlevé* which reaches a peak in Britain and Ireland in the first century BC.

Ensign Military emblem which among the Celts seems above all to have consisted of figures of animals, most especially of boars, carried on a long pole. They are known from Classical representations, notably shown as trophies of Celtic weapons. Some of the figures which survive display attachments that may well indicate that they were used in this way.

Fibula Type of safety pin used to fasten garments. The La Tène fibula consisted of a pin attached to one end of a bow by a spring which held it closed against the opposite end of the bow. The latter end was extended with a "foot" which was ornamented with a pearl- or disc-shaped stud. In the fifth century BC La Tène fibulae indicating high status were often adorned with figurative elements such as masks in the form of humans or monster- and animal-heads. Fibulae of the following century were decorated with plant-like motifs. Insular fibulae served the same function as those on the Continent but are, in general, closer in form to that of our modern brooches.

Filigree Technique of gold – working using gold or silver wire which is polished, beaded or twisted and soldered onto a metal surface as decoration. The Celts seem not to have mastered this technique, but to have imitated it in bronze using the lost wax method. This process is called false- or pseudo-filigree.

Foliage Plant motif borrowed by the Celts from the ornamental repertoire of the Greeks in the fourth century BC. La Tène foliage is usually characterized by the transformation of the half-palmettes which sprout triangular elements with rounded sides, similar to the central part of the La Tène triskele.

Galatians Greek version of the name for the Gauls, which can be traced from the beginning of the third century BC. Today the name is confined to the Celtic groups which established themselves in Asia Minor in 278 BC and who formed the "Galatian Community".

Gaulish Adjective deriving from the Latin name "Galli", used by the Antique authors as a synonym for the more ancient term "Celtae" (Greek "Keltoi") and equivalent to the Greek "Galatae". Differing from its ethnic meaning, the geographic derivative of the name, "Gallia" (Gaul) designates the two regions inhabited by those Celts with whom the first Romans came in contact: Cisalpine Gaul (northern Italy apart from the Venetic and Ligurian territories) and Transalpine Gaul (more or less the territory of modern France). Generally, when the adjective "Gaulish" is used today, a connection with those particular areas of the Celtic world is understood, "celtic" being regarded as a more general term.

Granulation Technique of gold – working which consists of soldering minute drops of a precious metal onto a surface. The Celts seem to have been capable of only a fairly crude imitation in bronze, produced by the lost-wax technique. This process is sometimes called "pastillage".

Greek Fret Frieze of angular meander ornament fairly common in the La Tène artistic repertoire.

Griffin Fantastical animal with the body of a winged lion, the head of an eagle and the ears of a horse. It came to the Celts from an oriental source, probably via Italy,

in the fifth century BC. The pair of griffins which guards the Tree of Life provides us with the emblematic "dragon-pair" motif which decorates a large number of La Tène scabbards.

Hallstatt Cemetery situated above the lake of the same name in the Salzkammergut region of Austria. Its principal period of use was during the seventh and sixth centuries BC. It owes its wealth and importance to the exploitation of the nearby salt-mines by the inhabitants of the region, and has been recognized since the middle of the last century; and in 1872 its name was given to the first phase of the European Iron Age. The term is used today to describe the cultural remains of the earliest Iron Age, dating between c. 700 BC to c.450 BC, and extending, north of the Alps, from Champagne to the western limits of the Carpathian basin.

Hoards Celtic hoards of objects are most often of a votive character. They consist of offerings accumulated and deposited in a sacred place—a spring, a lake, a river, a marsh, a mountain or an artifically-built sanctuary. They display considerable variety but the most widespread types are hoards of ornaments (notably those with torcs associated with coins) hoards of weapons (often deliberately damaged before deposition) and hoards of tools.

Insubres Major Celtic tribe which inhabited the region of modern Lombardy. The Insubres were, in all probability, descended from the Celtic peoples who were settled in this region well before the sixth century BC where the

oldest known inscriptions in the Celtic language have been found. The Insubres, allied with the Boii, resisted the northward advance of the Romans. Once defeated, they nonetheless retained a form of autonomy under Roman control. In 80 BC Roman rights were bestowed on them and their territory, along with the rest of Cisalpine Gaul, was incorporated into the Italian state in 42 BC.

Interlace The braid, or intertwined bands or simple interlace of angular or curvilinear form, are frequently recurring motifs in La Tène art of the fifth century BC. The most complex variations, inspired by foliage patterns of Greek origin, appear in the following century. They were once considered as diagnostic of the Waldalgesheim Style but in fact constitute only one element of that style. It is these motifs which are the direct antecedents of the art found on the decorated sword scabbards and other objects of the third century BC.

Kantharos Greek type of drinking vessel furnished with two large handles. In a La Tène context the term is used above all to describe Danubian forms of the third century BC which were inspired by Hellenistic prototypes and which often possess zoomorphic or anthropomorphic handles.

La Tène A lakeside site in Switzerland, located where the river Thielle diverges from Lake Neuchâtel. Around the middle of the last century a significant collection of objects was discovered there, including weapons, tools and ornaments. Thorough excavations of the site

have revealed the presence of two bridges. The fact that a quantity of objects was found at this spot suggests that it was used for ritual purposes. In 1872 the second phase of the European Iron Age was named after it. Today it is most often used adjectivally to describe the cultural remains of the second Iron Age, which occurs approximately between 450 BC and 10 BC, and the term refers to the so-called historic Celts, the direct descendents of the Hallstatt peoples of the preceding phase.

Linch-pin Metal chariot fitting which held the wheel in position on the axle. It consists of a rod, generally of iron, with an expanded head. The latter, often cast in bronze onto the rod, sometimes bears a figural representation such as that of a divinity along with his attributes or of a fantastic animal taken from the Celtic repertoire.

Lord of the Animals Theme of distant oriental origin which was adopted by the Celts in the fifth century BC almost certainly from north Italy. It is represented as a figure, generally in standing position, with outstretched arms, placed between a pair of animals which are usually fantastical in appearance.

Lost wax Casting technique which consists of creating in wax a positive model of the object, then coating it in fine heat-resistant clay, heating the negative mould thus created so that the wax flows out through prepared openings and replacing it with molten metal. The necessity of breaking the mould in order to extract the finished object explains the rarity of direct evidence for this process

of manufacture which was capable of producing complex and delicate relief forms as well as engraved lines.

Lotus Floral motif of distant oriental origin, probably adopted by the Celts of the fifth century BC from northern Italy. It most frequently occurs in bands in which lotus flowers alternate with palmettes. This would have been attractive to the Celts as it could also have been interpreted as a band of doubled mistletoe leaves.

Lyre Pair of opposing S-figures, most often enclosing a palmette. This is, in fact, the most stylized version of the two monstrous, snake-bodied guardians of the Tree of Life.

Mirror Celtic mirror, inspired by prototypes from the Mediterranean and best known in Britain, were discs of bronze which usually had a handle of the same material. One face was carefully polished, the other was decorated with engraved ornament, generally produced by means of a compass and almost always executed in such a manner as to create an interplay of light on the hatched and the polished zones.

Mistletoe This evergreen parasitic plant was venerated by the Celts who considered it as an attribute or even the incarnation of an important divinity. The double mistletoe-leaf motif, composed in two parts of rounded comma shape joined at their tips, is especially widespread during the fifth century BC. At that time it becomes the symbol of a major god whose head is often crowned by this motif.

163

Noricum Antique name for a Celtic kingdom of the second and first centuries BC which was located in the eastern Alps and the neighbouring regions. Its center was probably the town of *Noreia* (near Neumarkt in Styria) which derived its wealth, at least in part, from the deposits of good quality iron ore in the region.

Oppidum Celtic population centre of urban character, characterized by the concentration, within one fortified enclosure, of mercantile activities (specialist crafts and market), religious activities (central sanctuary) and administrative activities (assembly of notables and of magistrates) in a tribal confederation *(civitas)*. Lesser oppida probably served only some of these functions or else the functions were accessible only to part of the population. The oldest oppida probably date back to the middle of the second century BC but in some cases they were preceded by older settlements of moderately large dimensions.

Palmette One of the most essential motifs in Celtic art borrowed from the Etruscans in the fifth century BC. Of distant oriental origin, it is the schematic representation of the Tree of Life. As such it often occurs between two guardian monsters or between a pair of opposed S-figures (a lyre) which are a stylized rendition of it. For the Celts the palmette was an attribute of divinity. In the fifth century BC they used it to crown the head or to cover the face of the divinity. In the following century they directly transformed it into the stylized outline of the face. The specifically Celtic version of the palmette, the product of the

fusion of its leaves with the scrolls which form its base, is referred to by specialists as a "pelta".

Paten Sacred vessel of flattened shape used with the chalice in the celebration of the Christian Eucharist.

Pelta Celtic version of the Mediterranean palmette, produced by the fusion of its leaves with the scrolls which formed its base. Specialists have employed this term because of its resemblance to the shields of the Amazons in Classical iconography. This motif occurs frequently in the artistic repertoire of the Celts and is known as early as the fifth century BC and arises again in the much later illuminations of the Irish manuscripts.

Phalera Ornamental metal fitting which decorated the harness of both draught and mounted horses. It was most often used to cover the crossing and junction of the straps. The most frequent shape is circular.

"Philip" Name given to the gold staters of Philip II of Macedon (359-336 BC), a highly valued coinage which enjoyed a long period of circulation and which was re-issued numerous times after the death of Philip. It was used especially to pay mercenaries, many of whom were Celts, and it was so popular and widespread that it could almost be referred to as the "Antique dollar". The earliest coinage of the western Celts derived from this prototype and most of the designs on the Gaulis coins come from it.

Plastic metamorphosis Term employed by P.-M. Duval and V.

Kruta to describe the transient shapes which accompany animal, human, vegetal or abstract forms in compositions in which the overall meaning is impossible to discern. Such ambiguous representation, which is unique to the Celts, first appears in La Tène art of the fourth century BC and becomes very popular in the following century.

Plastic Style One of the styles of Celtic art. A term invented by P. Jacobsthal (1944) to describe La Tène art executed in relief dating to the third century BC. Its two-dimensional equivalent is the Sword Style.

Red Figure Ware Specifically Greek pottery which appears during the first half of the fifth century BC; the term is applied in La Tène areas to a series of vessels in Champagne, manufactured in the vicinity of Reims in the second half of the fourth century BC. Designs were made by applying a dark paint to the lighter-coloured surface thereby emphasizing their outline.

S-motif This is one of the most basic, widely-dispersed elements in La Tène art and is used either as a single motif or in a wide variety of compositions. Its remarkable popularity is probably due to the great symbolic significance which the Celts attached to it.

Scabbard The long sword, used for slashing and thrusting, the weapon *par excellence* of the La Tène Celtic warrior, was carried in a metal scabbard which was usually iron but occasionally bronze. The front plate (and also, in rare examples, the back plate) is often decorated with engraved, repoussé or stamped ornament,

typical of the emblematic dragon-pair which occurs at the mouth of the scabbard.

Scordisci Powerful tribal confederation, predominantly Celtic, formed by one part of the returning "Great Migration" of 278 BC, in the Danubian region of modern Yugoslavia.

Senones Celtic people, probably originally from north-east Gaul, who figured prominently in the invasion of Italy at the beginning of the fourth century BC and who were most likely the leaders in the expedition against Rome in 387/386 BC. Their oldest graves, dated to the middle of the fourth century BC, have produced decorated La Tène objects (scabbards, torcs) which provide vital evidence concerning the genesis of the new "plant style" decoration which came out of direct contact with the Graeco-Etruscan world. They were decisively conquered by the Romans in 283 BC. The Senones Caesar encountered in the Yonne river basin, and whose name is enshrined in the town of Sens, were probably survivors of the original nucleus.

Shield boss Metal piece which protected the central portion of the shield, in the place where the handle was attached, thus enabling the shield to be held and manoeuvered.

Stamped pottery A type of pottery which is produced by making an impression before baking, using dies of varying forms. This technique, introduced early in the fifth century BC, probably from north Italy, attained great popularity in certain regions

(Armorica, Danubian areas) and remained current there for several centuries.

Stamping Technique used to decorate metal and pottery. A punch sculpted in relief was generally used to stamp the sheet metal from the back so that the decoration appeared in relief on the front, slightly worn in comparison with that on the punch. On pottery, of course, only a direct impression was possible so that the designs produced are always concave.

Standard Emblem of war, which is represented by a kind of rectangular banner frequently found on Gaulish coins.

Sword Style One of the styles of Celtic art as defined by P. Jacobsthal (1944) to include materials of the third century BC. It comes after the Waldalgesheim Style and its principal components (Hungarian, Swiss), in fact, constitute the two-dimensional element of the third great period of Celtic art along with two other contemporary manifestations: the Plastic Style (three-dimensional creations) and the "Cheshire Cat Style", a somewhat esoteric term which alludes to one of the figures in Lewis Carroll's book *Alice in Wonderland*. It corresponds to the type of representation which today is called "Plastic Metamorphosis".

Telamon Roman victory over a coalition of Boii and Insubres, reinforced by mercenaries from north of the Alps, which took place in the territory of the Etruscans in 225 BC.

Torc Rigid metal—either bronze, gold or silver—which was so widespread among the Celts that it is regarded as the typical costume ornament of this people. The torcs of females accompanied their owners to the grave and are thus well known. Such was not the case with the torcs of males which are known solely through figural representations and votive examples. Torcs are sometimes referred to as "neckrings".

Tree of Life Theme of essentially oriental origin, adopted by the Celts in the fifth century BC probably via northern Italy. Generally represented in its emblematic form, the palmette, the Tree of Life is sometimes flanked by monstrous guardians: griffins or serpents with heads of birds of prey or of rams, or fantastic birds. The most stylized version of this theme, the palmette framed by S motifs, is one of the basic elements in the Celtic artistic repertoire.

Triskele Tripartite, rotary motif made up of three scrolls turning in the same direction. The La Tène triskele is characterized by its central form in the shape of a triangle with concave sides.

Trumpet curve Characteristic motif found in insular Celtic art, so-named because of its resemblance to the bell-end of a hunting horn.

Tylis Celtic kingdom in Thrace (in the territory of modern Bulgaria) established in 278 BC by one branch of the "Great Migration". Its demise is linked, in all probability, with the movement of Celtic contingents to Asia Minor in 218 BC.

Waldalgesheim Site in the Rhineland at which a richly-furnished royal tomb dating to the last third of the fourth century BC was found. Among its contents were numerous objects of high quality displaying the new plant style of the period. Thus P. Jacobsthal used the name of this tomb to describe his second phase in the evolution of Celtic art.

Writing The first Celts to write in their own language, using a unit adapted from the Etruscan alphabet to suit their purposes, were those who lived in the region known today as Lombardy. Thus far the oldest known documents date to the sixth century BC. The Celts then adopted the Greek alphabet, a fact that can be traced from the south of France to central Europe. Finally, they used the Latin alphabet. The Celtiberians borrowed their alphabet from the Iberian world. The Celts in Ireland invented an original version of the Latin alphabet consisting of groups of vertical and diagonal notches set on either side of an axis. This is known as the Ogham script.

Yin-yang This Chinese term is sometimes applied to a La Tène motif which in an S-figure divides a hemisphere or circle into two parts. In contrast to the Chinese emblematic motif, the two halves are never treated differently.

Zoomorphic In animal form.

Bibliography

CELTIC IRON AGE

L'art Celtique en Gaule 1983-4: Collections des Musées de Provence. catalogue, Ministère de la Culture: Direction des Musées de France, 1983.

Brailsford, J.W., *Early Celtic Masterpieces from Britain in the British Museum,* British Museum Publications, London, 1975.

Cunliffe, B., *The Celtic World,* London, 1981.
French translation: *L'Univers des Celtes,* Paris.

Duval, A., *L'art celtique de la Gaule au Musée des Antiquités nationales,* Paris, 1989.

Duval, P.-M., *Les Celtes,* Gallimard, Paris, 1977.

Duval, P.-M. and Hawkes, C.F.C. (eds), *Celtic Art in Ancient Europe: Five prehistoric centuries, L'art celtique en Europe protohistorique,* London, New York, San Francisco, 1976.

Duval, P.-M. and Kruta, V., *L'art celtique de la période d'expansion, IVe et IIIe siècles avant notre ère,* Geneva-Paris, 1982.

"L'expansion des Celtes de la Gaule vers l'Orient", *Histoire et Archéologie, Les Dossiers,* No. 77, Paris, 1983.

Filip, J., *Celtic Civilisation and its Heritage,* Prague, 1977.

Fox, C., *Pattern and Purpose: a Survey of Early Celtic Art in Britain,* Cardiff, 1958.

Kruta, V. *Les Celtes,* Paris, 5e ed., 1990.

Jacobsthal, P., *Early Celtic Art,* 2 vols., Oxford, 1944 (Reprinted 1969).

Furger-Gunti, A. *Die Helvetier. Kulturgeschichte eines keltenvolkes,* Zurich, 1984.

Kruta, V., Lessing, E., Szabó, M., *Les Celtes,* Paris, 1978.

Kruta, V., Forman, W., *Les Celtes en Occident,* Paris, 1985.
English translation: *The Celts of the West,* London, 1985.

Die Kelten in Mitteleuropa: Kultur-Kunst-Wissenschaft, Salzburg, 1980.

Megaw, J.V.S., *Art of the European Iron Age,* Bath, 1970.

Megaw, J.V.S. and R., *Early Celtic Art in Britain and Ireland,* Princes Risborough, 1986.

Megaw, R. and V., *Celtic Art,* London, 1989.

Powell, T.G.E., *The Celts,* London, 1958.
French Translation: *Les Celtes, Paris, 1961.*

Raftery, B., A Catalogue of Irish Iron Age Antiquities, Marburg, 1983.

Raftery, B., *La Tène in Ireland. Problems of Origin and Chronology,* Marburg, 1984.

Ryan, M., (ed.), *Treasures of Ireland, Irish Art 3000 B.C.-1500 A.D.,* Dublin, 1983.
Trésors d'Irlande (Exhibition Catalogue), Association française d'action artistique, Paris, 1982.

Stead, I.M., *Celtic Art in Britain before the Roman Conquest,* London, 1985.

Szabó, M., *Sur les traces des Celtes en Hongrie,* Budapest, 1971.

English translation: *The Celtic Heritage in Hungary,* Budapest, 1971

Trésors des Princes Celtes, Paris, 1987.

COINS

Allen, D.F., *The Coins of the Ancient Celts,* ed. D. Nash, Edinburgh, 1980.

Blanchet, A., *Traité des monnaies gauloises,* Paris, 1905, Bologna, 1971.

Castelin, K., *Die Goldprägung der Kelten in den Römischen Ländern,* Graz, 1965.

Catalogue of the Celtic Coins in the British Museum I, London, 1987.

Colbert de Beaulieu, J.-B., "Traité de numismatique celtique, I." *Méthodologie des ensembles,* Paris, 1973.

Duval, P.-M., *Monnaies gauloises et mythes celtiques,* Paris, 1987.

Forrer, R., *Keltische Numismatik der Rhein- und Donauländer,* Revised edition by K. Castelin, Graz, 1968.

Scheers, S., *Traité de numismatique celtique, II, La Gaule Belgique,* Paris, 1977.

THE BEGINNING OF THE CHRISTIAN PERIOD

Alexander, J.J.C., *A Survey of Manuscripts Illuminated in the British Isles, Insular Manuscripts 6th to the 9th century,* London, 1978.

Backhouse, J., *The Lindisfarne Gospels,* Oxford, 1981.

Bruce-Mitford, R., et al., *The Sutton Hoo Ship Burial,* vols., London, 1975, 1978, 1983.

Campbell, J., (ed.), *The Anglo-Saxons,* Oxford, 1982.

De Paor, M. and L., *Early Christian Ireland,* London, 1958 (repr. 1978).

Henderson, I., *The Picts,* London, 1967.

Henry, F., *L'Art Irlandais,* Paris, 1963-64.

Henry, F., *Irish Art in the Early Christian Period to A.D. 800,* London, 1965.

Henry, F., *Irish Art during the Viking Invasions,* London, 1967.

Henry, F., *Irish Art during the Romanesque Period,* London, 1970.

Ireland and Insular Art, A.D. 500-1200, ed. M. Ryan, Dublin, 1987.

Mahr, A., *Christian Art in Ancient Ireland,* vol. I, Dublin, 1932.

Nordenfalk, C., *Celtic and Anglo-Saxon Painting,* London, 1977.

Raftery, J., (ed.), *Christian Art in Ancient Ireland,* vol. II, Dublin, 1941.

Ryan, M., (ed.), *Treasures of Ireland, Irish Art 3000 B.C.-1500 A.D.,* Dublin, 1983. German Translation: *Irische Kunst aus drei Jahrtausenden, Thesaurus Hiberniae,* Mainz, 1983. French Translation: *Trésors d'Irlande* (Exhibition Catalogue), Association française d'action artistique, Paris, 1982.

Ryan, M., (ed.), *The Derrynaflan Hoard. A Preliminary Account,* Dublin, 1983.

Speake, G. *Anglo-Saxon Animal Art and its Germanic Background,* Oxford, 1980.

Wamers, E., *Insularer Metallschmuck in Wikingerzeitlichen Gräbern Nord-europas,* Neumünster, 1985.

Wilson, D. M., *Anglo-Saxon Art from the Seventh Century to the Norman Conquest,* London, 1984.

Index

PHOTOGRAPH CREDITS

Pages 6-7, 14 : Paris, Erich Lessing/Magnum ; 16 : Bratislava, Pandr Paul ; 17 top : Trèves, Rheinisches Landesmuseum ; 17 bottom : Paris, Gallimard — L'Univers des Formes — La Photothèque ; 18 : Nuremberg, Germanisches Nationalmuseum ; 19 top : A.C.L. Bruxelles ; 19 bottom : Berlin, Antikenmuseum, Staatliche Museen Preussischer Kulturbesitz, photo Isolde Luckert ; 20 : London, British Museum ; 21 top left : Paris, Venceslas Kruta ; 21 top right, and bottom : Iéna, Collections of the l'Université Friedrich Schiller ; 22 left : Trèves, Rheinisches Landesmuseum ; 22 right : Bonn, Rheinisches Landesmuseum ; 23 top : Paris, Venceslas Kruta ; 23 bottom : Sarrebruck, Landesmuseum für Ur-und Frühgeschichte ; 24 : Paris, Erich Lessing/Magnum ; 25 : Zurich, Schweizerisches Landesmuseum ; 26-27 : Paris, Erich Lessing/Magnum ; 28 left : Iéna, Collections of the University Friedrich Schiller ; 28 right : Salzbourg, Museum Carolino Augusteum ; 29 : Paris, Erich Lessing/Magnum ; 30 : London, Werner Forman Archive ; 31, 32 : Paris, Erich Lessing/Magnum ; 34 : Berlin, Antikenmuseum, Staatliche Museen Preussischer Kulturbesitz, photo Ingrid Geske ; 35 top : Ancône, Soprintendenza Archeologica delle Marche ; 35 bottom, 36, 37 : Bonn, Rheinisches Landesmuseum ; 38 : Paris, Erich Lessing/Magnum ; 39 : Angoulême, Musée Municipal ; 40 : London, British Museum ; 41 left : Reims, Musée Saint-Rémi, photo J. Driol ; 41 right : Reims, Musée Saint-Rémi, photo R. Meulle ; 42 : Berne, Bernisches Historisches Museum, photo S. Rebsamen ; 43 top : Bonn, Rheinisches Landesmuseum ; 43 bottom left : Asparn an der Zaya, Museum für Urgeschichte des Landes Niederösterreich ; 43 bottom right : Reims, Musée Saint-Rémi. Photo R. Meulle ; 44 : Morlaix, Musée des Jacobins ; 45 left : Paris, Eric Lessing/Magnum ; 45 right : Sofia, Narodnija Archeologiceski Muzej ; 46 left : Sopron, Liszt Ferenc Muzeum ; 46 right : Frankfurt, Neuffer Archives, Römisch-Germanische Kommission ; 47 : Paris, Erich Lessing/Magnum ; 48 : Stuttgart, Württembergisches Landesmuseum ; 49 : Paris, Gallimard - L'Univers des Formes - La Photothèque ; 50 : London, British Museum ; 51 left : Chalon-sur-Saône, Musée Denon ; 51 right : Budapest, Magyar Nemzandi Muzeum, photo Kardos Judit ; 52 : Paris, Erich Lessing/Magnum ; 53 left : Bratislava, Pandr Paul ; 53 right : Troyes, Musée des Beaux-Arts et d'Archéologie ; 54 left : Vienne, Naturhistorisches Museum ; 54 centre : Budapest, Magyar Nemzandi Muzeum, photo Kardos Judit ; 54 right : Brezice, Posavski Muzej ; 55 left : Neuchâtel, Musée cantonal d'Archéologie, photo Y. André ; 55 centre : Zurich, Schweizerisches Landesmuseum ; 55 right : Neuchâtel, Musée cantonal d'Archéologie ; 56 top : Toulouse, Musée des Augustins, photo Yan ; 56 bottom : Budapest, Magyar Nemzandi Muzeum, photo Kardos Judit ; 57 left : Paris, Erich Lessing/Magnum ; 57 right : Paris, Bibliothèque Nationale ; 58-59 : Stuttgart, Württembergisches Landesmuseum ; 60 top : Louny, Okresni Muzeum ; 60 bottom : Litomerice, Okresni Muzeum ; 61 : Paris, Erich Lessing/Magnum ; 62 top : Paris, Réunion des Musées Nationaux ; 62 bottom : Zatec, Polànkovo Muzeum ; 63 top left : Paris, Réunion des Musées Nationaux ; 63 top right : Brno, Moravské Muzeum ; 63 bottom : Sofia, Narodnija Archeologiceski Muzej ; 64 top : Szolnok, Damjanich Muzeum, photo Kozma Karoly ; 64 bottom : Moesgard, Holbjerg, Forhistorik Museum ; 65 : Paris, Erich Lessing/Magnum ; 66 : Bratislava, Pandr Paul ; 67 top : Budapest, Magyar Nemzandi Muzeum, photo Dabasi Andras ; 67 bottom : Brno, Moravské Muzeum ; 68 top left : Budapest, Magyar Nemzandi Muzeum, photo Kardos Judit ; 68 top right : Szekszard, Béri B. Adam Muzeum, photo Dr. Gaal Attila ; 68 bottom : Paris, Miklos Szabo ; 69 top left : Szolnok, Damjanich Muzeum, photo Kozma Karoly ; 69 top right : Vac, Vak Bottyan Muzeum ; 69 bottom : Vienne, Naturhistorisches Museum ; 70, 71 : London, British Museum ; 72, 73 left : Paris, Bibliothèque Nationale ; 73 right : Paul-Marie Duval ; 74, 75 top and bottom left : Paris, Bibliothèque Nationale ; 75 bottom right : Paul-Marie Duval ; 76, 77, 78 top : Paris, Bibliothèque Nationale ; 78 bottom left : Rennes, Musée de Brandagne ; 78 bottom right : Paul-Marie Duval ; 79 top left and bottom : Paris, Bibliothèque Nationale ; 79 top right : Paul-Marie Duval ; 80 top left : Paris, Bibliothèque Nationale ; 80 top right and bottom : Zagreb, National Museum ; 81 : Paris, Bibliothèque Nationale ; 82, 1st and 4th columns : Paris, Bibliothèque Nationale, 2nd and 3rd columns : Paul-Marie Duval ; 83, 1st column, top : London, British Museum, 1st column, bottom and 2nd column : Paris, Bibliothèque Nationale ; 84 : Paris, Erich Lessing/Magnum ; 86 : Vienne, Naturhistorisches Museum ; 87 : Paris, Erich Lessing/Magnum ; 88 top : Bâle, Historisches Museum, photo M. Babey ; 88 bottom : Berne, Bernisches Historisches Museum ; 89 : Paris, Erich Lessing/Magnum ; 90 top : Ljubljana, Narodni Muzej ; 90 bottom : Bienne, Museum Schwab, 90 right : Nantes, Musée Thomas Dobrée, photo Ch. Hemon ; 91 top left : Paris, Erich Lessing/Magnum ; 91 top right : Munich, Prähistorische Staatssammlung ; 91 bottom : Mayence, Mittelrheinisches Landesmuseum ; 92 : Vaduz, Liechtensteinisches Landesmuseum ; 93 : Paris, Erich Lessing/Magnum ; 94 : Stuttgart, Württembergisches Landesmuseum ; 95, 96, 97 : Paris, Erich Lessing/Magnum ; 98 left : Roanne, Musée Joseph Déchelandte ; 98 right : Clermont-Ferrand, Musée Bargoin, photo Bayle ; 99 left : Luxembourg, Musée de l'État ; 99 right : Réunion des Musées Nationaux ; 100 : London, Werner Forman Archive ; 102 : Gloucester Museum ; 103 top : London, British Museum ; 103 bottom : Oxford, Ashmolean Museum ; 104-105 : London, British Museum ; 106 top : Oxford, Ashmolean Museum ; 106 bottom : Paris, Gallimard - L'Univers des Formes - La Photothèque ; 107 top : Cardiff, National Museum of Wales ; 107 bottom : Alnwick, Castle Museum ; 108 top : Edinburg, Royal Scottish Museum ; 108 bottom , 109 : London, British Museum ; 110 : London, Werner Forman Archive ; 111 : Edinburg, Royal Scottish Museum ; 112 : London, British Museum ; 113 : Liverpool, City of Liverpool Museum ; 114 : Paris, Erich Lessing/Magnum ; 115 top left : London, Werner Forman Archive ; 115 top right : Belfast, Ulster Museum ; 115 bottom, 116, 117 : London, Werner Forman Archive ; 118, 119 : Dublin, National Museum of Ireland ; 120 : London, Werner Forman Archive ; 121 : Dublin, National Museum of Ireland ; 122 top : London, Werner Forman Archive ; 122 bottom : Belfast, Ulster Museum ; 123 : London, Werner Forman Archive ; 124 left : London, British Museum ; 124 right : Belfast, Ulster Museum ; 125, 126 : London, Werner Forman Archive ; 128 : Dublin, National Museum of Ireland ; 129 : London, British Museum ; 130 : Dublin, National Museum of Ireland ; 131 : London, Werner Forman Archive ; 132 : Dublin, National Museum of Ireland ; 133 : Edinburg, Royal Scottish Museum ; 134 top : Coventry, Herbert Art Gallery and Museum ; 134 bottom : London, British Museum ; 135 : Dublin, Trinity College Library ; 136, 137, 138 : Dublin, National Museum of Ireland ; 139, 140, 141, 142 : Edinburg, Royal Scottish Museum ; 143 : London, British Library ; 144 : Dublin, National Museum of Ireland ; 145 left : Braunschweig, Herzog Anton-Ulrich Museum ; 145 right : Dublin, Irish Tourist Board, Bord Failte ; 146 top : London, Courtauld Institute of Art, Conway Library ; 146 bottom : Dublin, National Museum of Ireland ; 147 : Dublin, Trinity College Library ; 148 : Bergen, Historisk Museum, photo Ann-Mari Olsen ; 149 : London, British Library ; 150 : Dublin, National Parks and Monuments Service ; 151 : Dublin, National Museum of Ireland ; 154, 155 : Paris, Erich Lessing/Magnum.